Pinhole Photography Rediscovering a Historic Technique

Eric Renner

Focal Press

Boston • London

Focal Press is an imprint of Butterworth-Heinemann

Copyright © 1995 by Butterworth-Heinemann

A member of the Reed Elsevier group

All rights reserved.

No part of this publication may be reproduced, stored in a retrieval system, or transmitted in any form or by any means, electronic, mechanical, photocopying, recording, or otherwise, without the prior written permission of the publisher.

Recognizing the importance of preserving what has been written,
Butterworth–Heinemann prints its books on acid-free paper whenever possible.

Library of Congress Cataloging-in-Publication Data

Renner, Eric.

Pinhole photography: rediscovering a historic technique / Eric Renner.

p. cm.

Includes bibliographic references and index.

ISBN 0-240-80231-4

1. Photography, Pinhole. I. Title.

TR268.R46 1995

94-41212

771—dc20

CIP

British Library Cataloguing-in-Publication Data

A catalogue record for this book is available from the British Library.

The publisher offers special discounts on bulk orders of this book. For information, please contact:

Manager of Special Sales
Butterworth–Heinemann
313 Washington Street
Newton, MA 02158–1626

Tel: 617-928-2500 Fax: 617-928-2620

For information on all Focal Press publications available, contact our World Wide Web home page at: http://www.bh.com/fp

Printed in the United States of America 109876543

Pinhole Photography

In memory of my parents Josie and Richie Renner

Another and more remarkable property of light is that when rays come from different, or even opposite, directions each produces its effect without disturbances from the other. Thus several observers are able, all at the same time, to look at different objects through one single opening; and two individuals can look into each other's eyes at the same instant.

CHRISTIAAN HUYGENS Traite de la lumière, 1690

and of my grandmother

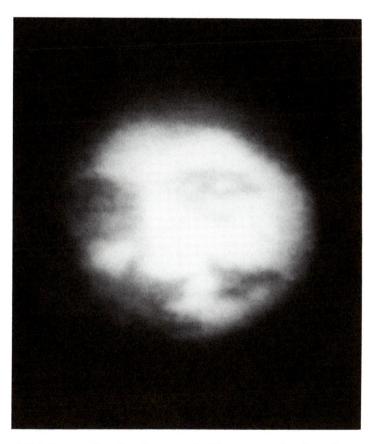

© Eric Renner, Grandma Becomes the Moon, 1976. A 16" \times 20" pinhole photograph. From the collection of the photographer.

	~	
,		

Contents

	Preface ix
	Acknowledgments xv
1	Pinhole's History in Science 1
	Holed Stones 1 Early Pinhole Optics—Eclipes, Telling Time, and Optical Phenomena 1
	The Pinhole in the Wave Theory of Light 10 The Pinhole in Photography 14 The Pinhole and the Eye 17 Twentieth-Century Pinhole Imaging
•	in High-Energy Physics 18
2	Pinhole's History in Art 23
	Brunelleschi's Pinhole Perspective Device 23 Alberti's First Diffraction Camera 25 Alberti's Intersector 28 Leonardo Da Vinci 31
	Anamorphosis—The Deception of the Eye 36
	The First Pinhole Photographs 38
	Pinhole's Popularity in Early "Pictorialism" 41
	August Strindberg 44 Pinhole's Demise in the Early Twentieth Century 47
3	Pinhole's Revival in Art: The 1960s and 1970s 49
	Rehirth 49

67

68

4 Pinhole's Revival in Art: The 1980s

The Peter Pan Principle, or "I Can Fly" 67 Pinhole Photographers, Their Cameras, and Images

5 The How-To of Pinhole Photography 103

Making a Simple Pinhole Camera Loading the Pinhole Camera Making a Photograph Additional Mistakes 113 Additional Possibilities 115 Optimal Pinhole Formulas Making A Pinhole Turret 121 Pinhole Camera Geometries **Exposure Times** 133 Additional Technical Information Additional Hints for Building Pinhole Cameras 139

6 Transforming the Pinhole Image: Extensions and Alternatives 141

Slit Imaging 143 Zone Plates 145

7 Eye, Image, Camera, Mind: Into the 1990s 157

The Shifting Image of Reality 157

List of Suppliers 169

Index 171

Preface

It baffles me that the pinhole aperture's contribution to the history of art and science has remained so unrecognized. That is the reason for this book.

Twenty-six years ago I started making pinhole photographs, not knowing that anyone else in the world might also be doing the same thing. Nor did I know the pinhole was a *primary* instrument or tool like a mirror or a wheel. The contents of this book explain the importance of pinhole in the history of art and science. Brunelleschi, da Vinci, Dürer, Raphael, Kepler, Newton, Descartes—all used the pinhole as the starting point for some of their theories.

After a few years of making pinhole photographs, I began meeting other people also using pinhole. One, Phil Pocock, head of the Canadian Parliament's Science Policy Committee, showed me his *stop-action* pinhole images (Figure P.2a) and camera (Figure P.2b),

invented and produced in one afternoon! His camera was a 35mm film canister with a piece of 35mm Tri-X film placed inside. A revolving second canister became the shutter. With a flick of his wrist, Pocock could make a non-blurred image of his daughter Joanna, jumping from a chair. At that moment, amazed at his camera and photographs, I knew someone should be collecting this exceptional yet relatively obscure material.

In 1984, I founded Pinhole Resource, a nonprofit photographic archive. Within the first year of receiving photographs, I decided to publish *Pinhole Journal*, and the first issue appeared in December 1985.

Figure P.1 Engraving on the title page of Isaac Newton's Opticks, 1740 Latin Edition. In the etching, the seated person is viewing through a pinhole in a pinhole perspective device.

Through *Pinhole Journal*'s existence, more pinhole photographers around the world discovered Pinhole Resource. Since that first issue, almost two thousand photographs have been contributed to Pinhole Resource. Truly it is an honor for me to open the mail, to see images and enthusiastic letters, such as this beautiful letter with literary allusions from Peeter Laurits of Estonia:

Tallinn, July 31, 1988

A photograph is always invisible; it is not it that we see.

ROLAND BARTHES

Usually, a photograph is considered a document, a miniature copy of "reality." To my mind, the photograph's relation to "reality" is strange. They look so much like a piece of the world our senses can grasp, but they have none of its qualities other than visibility. Flat, motionless objects without sound and smell, form the world from their own similar dreams. They have mainly an associative bond, a loose rhyme with our "reality." As far as a photograph is invisible for us and we try to look through it at the objects and events depicted, we can never get quite close to that spectral world.

Taking pinhole pictures can draw us very near to the photograph's essence. The phantasmal quality of these images can be felt more easily. Anything can serve as a camera, anything can serve as a pinhole. If we took the pain to reflect, we would easily notice that the world around us is full of "pinhole cameras." At least symbolically, it is made up of them. Thus moth holes in a worn-out coat, tiny apertures in foliage. Keyholes are windows between different worlds: light and dark (remember the mirrors in Vonnegut's *Breakfast of Champions*). We live in a labyrinth of shadows and projections, between mirrors. Our every act and

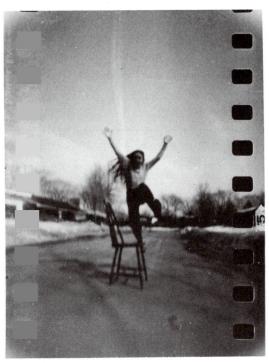

Figure P.2a © Philip Pocock, Joanna Jumping, 1975. An 8" x 10" pinhole photograph, from 35mm Tri-X film placed in an aluminum film container. From the collection of the photographer.

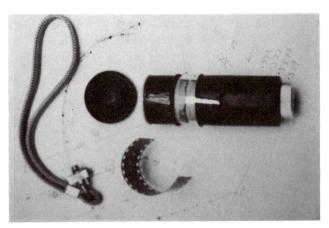

Figure P.2b © Philip Pocock, Pinhole Stop-action Camera, 1975. A lens photo from the collection of the photographer.

expression has a myriad of doubles and every one of them has a life of its own. The world looks like an enormous compound eye, looking at us, through us, over us. What is seen? Nobody knows that. Nobody has ever asked.

Quite an awkward way of getting the answer is to put sensitive sheets behind tiny holes. I have enjoyed myself in such a way for a whole week. I have made use of such everyday vessels as an old bag [Figure P.3b], a drawer and a candy box, trying not to move them from their usual places. As a result I have got a series of silver mummies of the ever-changing atmospheres and moods in my room [Figure P.3a]. On the seventh day I started to feel like an intruder. Our kingdom is not of these worlds. I felt dizzy thinking about these countless visions without the seer, this kaleidoscope of projections we live in, the visions of the visions of the visions. But the thing that struck me most was the realization that every photographic image in itself is a pinhole pricked in time, a window between past and present, exposing our minds to the ghosts of lost moments, mixing memory and desire, breeding lilacs out of dead land, stirring dull roots with spring rain.

I must confess that I have not yet thrown away my camera and get paid as a photographer still. Do not mind the illiteracy of my letter, please, my clumsiness in linguistic thickets is in direct accordance with my awe of the labyrinth of light and time.¹

Or consider this letter from Steven Pippin of London, England, describing his "archival" pinhole technique (conservators are going to love this):

25/9/91 London

The slides enclosed show a commercial washing machine (a Wascomat Senior) fitted with a push-on aluminum shutter device. This contains a leaf shutter mechanism, operated with a cable attachment. behind which is the pinhole. There is also a micro switch which operates the flash attachment. The exposure time was 30 minutes. The film used was Kodak Ektapan 4162, 11" x 14". After the exposure was complete, the developer was introduced into the machine via the soapsuds compartment and the machine was turned on. The machine's "warm wash" cycle was the closest to the film's normal developing temperature. On completion of the wash cycle the machine was left to make one rinse and then the fixer was added. The machine's final rinse made sure that the film was free of any chemicals and then spun dry the film. The resulting image (which is a contact print from the original) is very badly damaged. This is due to the machine's very vigorous wash action, and on some occasions it completely destroyed the image.2

Why pinhole? For everyone doing pinhole there is a slightly different answer. The variety in pinhole cameras and personal imagery

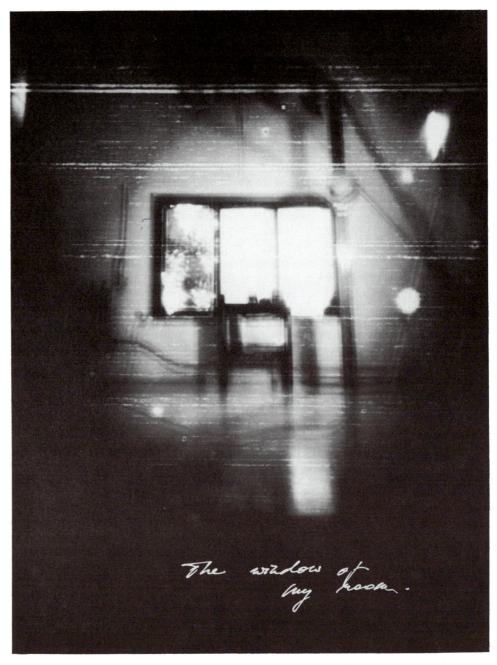

Figure P.3a © Peeter Laurits, Window of My Room, 1988. An $8^{1}/2$ " x $11^{1}/2$ " pinhole photograph made with a bag camera. From the collection at Pinhole Resource.

is unlimited. Why not use a small matchbox, as Paul Cimon does for his 35mm exposures? Why not use five- to ten-minute exposures, as Sarah Van Keuren does to make portraits? Why not put Ilfochrome Classic color paper (designed to be used under an enlarger, not in outside light) right in the camera, as Willie Anne Wright does? Why not make images using the holes in "Saltine" crackers as apertures, as Paolo Gioli does?

Why pinhole? Because pinhole is intuitive. Pinhole fits a certain kind of sensibility. A certain kind of feeling exists in every image, more or less. That feeling, I believe, relates directly to the very enigmatic piece of matter (or is it non-matter?) known as a person's soul. Of course, this is an elusive demand to place upon every pinhole photograph and not something that anyone can obtain simply by using pinhole cameras, yet I do believe somehow this connection exists.

I think most people use a pinhole camera because the image is a more personal, direct, and obtainable link to a universal mental picture of the beyond. Time and living have never been particularly easy concepts for me to understand, yet constructing pinhole cameras and creating pinhole photographs somehow makes these concepts more accessible. I've always been excited to see just what my pinhole camera will do, with a certain amount of help from those sources beyond my conscious faculties, for I never fully know what's going to be in the image—there's the surprise I look forward to! It seems I am somehow

closer to my own person by allowing the image to be something over which I don't have full control.

NOTES

- Peeter Laurits, "Letter to the Editor,"
 Pinhole Journal 5(2):2. Literary allusions: "Lilacs out of the dead land,"
 "stirring dull roots with spring rain,"
 from T. S. Eliot's *The Waste Land*,
 1922. "I must confess I have not thrown away. . ." from Henry David
 Thoreau, *Walden*, 1854.
- 2. Steven Pippin, personal communication with the author, 25 September 1991.

Figure P.3b © *Peeter Laurits*, Worn Out Bag Pinhole Camera, 1988. A lens photo from the collection at Pinhole Resource.

	•		

Acknowledgments

There are probably a thousand artists working with pinhole throughout the world and an equal number of scientists using pinhole in high-energy studies. I am hesitant to try to list all of those artists and scientists who have generously shared their photographs for this book or who have also given images to Pinhole Resource, for I am sure to leave too many people unmentioned. The photographs and text in the following chapters name some of these people. Suffice it to say, a most sincere thanks to everyone who has contributed photographs and articles to Pinhole Resource. Their contributions have been the inspiration for this book.

A debt of gratitude goes to the following eight people—sharing their work has been invaluable to Pinhole Resource and to this book. To the late Maurice Pirenne, who understood that the pinhole was a perspective imaging device used throughout the last six centuries in art; to Ken Connors, for his efforts to communicate scientific information about pinhole and zone plates; to Stan Page, who collected all of the published articles on pinhole (since 1850); to pinhole photographers Paolo Gioli, Dominique Stroobant, and Larry Bullis; and to Richard Vallon and Russ Young, who supplied much of the information in chapter 6 on zone plates.

I would also like to sincerely thank Margaret Drower of England, who helped with the information on Flinders Petrie in chapter 2; Jan-Erik Lundström of Sweden who translated August Strindberg's writings on pinhole that appear in chapter 2; James Hugunin of Chicago, who wrote passages on contemporary pinhole photographers in "Notes Toward a Stenopaesthetic," published by the Center for Contemporary Arts of Santa Fe in their *International Pinhole Photography Exhibition Catalogue* (1989) and partially reprinted in chapter 4; and Emily Brady, my editor of the first draft; and Valerie Cimino, Marie Lee, and Marilyn Rash of Focal Press.

Most of all, I thank Nancy Spencer for her immense help. Without Nancy, this book would not exist. Chapter 5, "The How-To of Pinhole Photography," was coauthored by Nancy Spencer.

I have made extensive use of quotes and written material from artists and scientists who have used the pinhole. Quoting their own words seemed the most direct way to communicate their ideas.

Pinhole's History in Science

HOLED STONES

An aperture is an opening—a place of transformation, symbolically feminine. Many ancient cultures have similar emergence legends designating a hole in the earth or a hole in the sky as the sacred place of origin where their forebears first appeared.

A long, large stone placed vertically appeared visually like a structure rooted deeply in Mother Earth. This same large stone, with a hole in it (Figures 1.1a, 1.1b, 1.1c), was used ritualistically to reenact the transformation of birth. A baby who passed through the hole received regenerated birth energy. The East Indian definition for a holed stone was "gate of deliverance."

EARLY PINHOLE OPTICS—ECLIPSES, TELLING TIME, AND OPTICAL PHENOMENA

Pinhole images are everywhere. Without a doubt, early humans were able to see pinhole images of the sun on the ground (Figure 1.2) under tree canopy—the images most obvious during a solar eclipse, when the sun is seen as a crescent. Every eclipse seen in the accompanying lens photograph (Figure 1.3) is actually a pinhole image of the sun. Pinholes are created naturally by chinks in overlapped leaves. Hardwoods, such as maples, have leaves that work best. When there is not an eclipse, these same leaves cast pinhole images of the full solar disc as circular spots onto the ground (Figure 1.4). Present-day soil physicists study these pinhole images to determine amounts of sunshine hitting the earth.

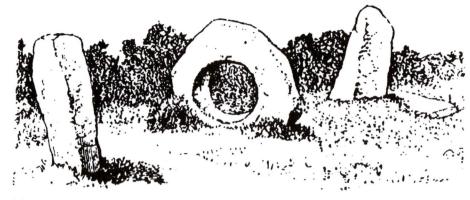

1.1a

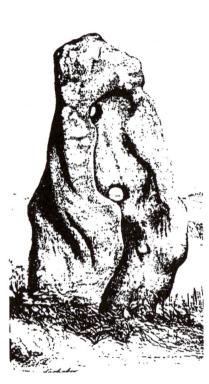

1.1c

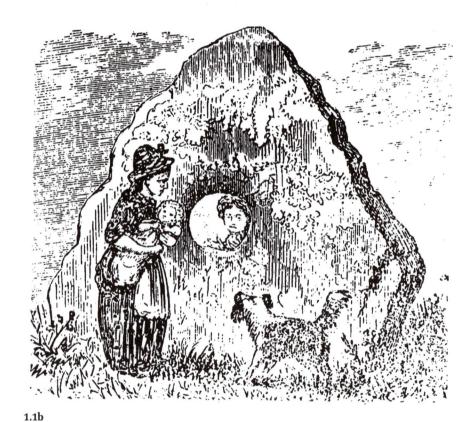

Figure 1.1a Men-an-tol Stones in West Cornwall, drawn by John Thomas Blight, 1856.

Figure 1.1b The Tolvan Stone of Constantine in Cornwall depicts one of the last places where the pre-Christian rites of baptism survived. Babies were passed nine times through the hole in the stone and then laid to sleep on a grassy knoll. The stone is about nine feet tall. Drawn by Joseph Blight, 1873.

Figure 1.1c The Clach-a-Charra Stone at Onich, Lochaber, Inverness-shire, artist unknown. Shown in the Proceedings of the Society of Antiquaries of Scotland (1864–66).

People have always needed to tell time. A straight stick known as a gnomon, placed vertically in the ground, will cast a shadow from the sun. Since the shadow is longer in winter and shorter in summer, the top of the shadow cast from the tip of the stick becomes a very basic solar clock. Adding a metal disc pierced with a pinhole at the top of the stick gives a more precise measure, since a bright point is created on the ground above the shadow. This bright point is a pinhole image of the sun. The metal disc with a pinhole is known as a "shadow definer"; the entire instrument as a "pierced gnomon" (Figure 1.5). Since prehistory, some primitive tribes have used this early type of sundial, even into the beginning of this century.

Most likely the earliest recorded description of pinhole optics, although cryptic in nature, comes from Mo Ti in China, circa 4000 B.C., which is translated as follows:

CANON: The turning over of the shadow is because the criss-cross has a point from which it is prolonged with the shadow.

EXPLANATION: The light's entry into the curve is like the shooting of arrows from a bow. The entry of that which comes from below is upward, the entry of that which comes from high up is downward. The legs cover the light from below, and therefore form a shadow above; the head covers the light from above, and therefore forms a shadow below. This is because at a certain distance there is a point which coincides with the light; therefore the revolution of the shadow is on the inside. ¹

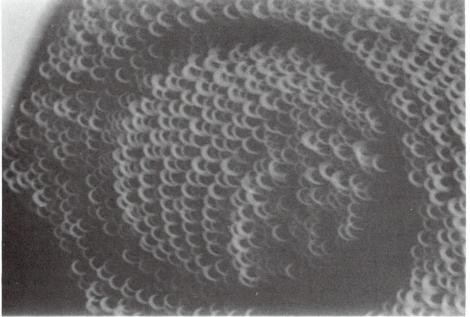

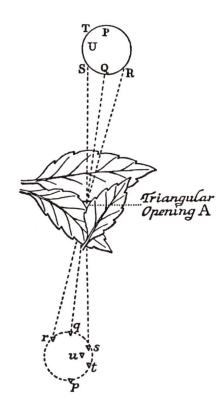

Figure 1.2 Sun's Image Projected through Chinks in Leaves. The upper circle represents the sun and the lower circle its image on the ground; even though the pinhole is triangular, the image is round. Drawing by Sir William Bragg, The Universe of Light, 1933.

Figure 1.3 © Nancy Spencer and Eric Renner, Pinhole Images of the Solar Eclipse May 10, 1994, lens photograph. Pinhole images of the solar eclipse have been projected through holes in a straw hat. From the collection at Pinhole Resource.

Figure 1.4 Engraving of Sun's Images Seen in the Forest Shade. From Guillemin's La Lumière, 1882.

In the west, the first recorded description of the pinhole comes much later, from Aristotle, circa 330 B.C., in *Problems XV*:

#6: Why is it when the sun passes through quadrilaterals, as for instance in wickerwork, it does not produce figures rectangular in shape but circular?

Here, too, is the first recorded description of viewing an eclipse using a pinhole:

#11: Why is it that in an eclipse of the sun, if one looks at it through a sieve or through leaves, such as a plane tree or other broad-leaved tree, or if one joins the fingers of one hand over the fingers of the other [Figure 1.6], the rays are crescent shaped when they reach the earth? Is it for the same reason as that when light shines through a rectangular peep-hole, it appears circular in the form of a cone?²

Aristotle's question in #6 above became known in optics as "Aristotle's problem." The problem was first solved by Franciscus Maurolycus (1494–1575) in *Photosmi de lumine et umbra* (1521).

An appreciation for the high degree of sophistication in understanding pinhole optics can be gained by studying Figure 1.7, a rarely published light ray diagram constructed by Anthemius of Tralles in 555 A.D.

Anthemius wrote:

Similarly, by the same construction on the straight line ΔB , we shall show that the summer ray $B\Xi$ which falls on the plane mirror on M ΞO it will be reflected to A along the straight line ΞA . If then we suppose a hole placed symmetrically about the point B as centre, all the rays falling through the hole, that is through the point B, upon the continuous mirrors already described will be reflected to A.

One of the greatest optical scientists of all time, Ibn al-Haitham (965–1039 A.D.) from Egypt, known in the west as Alhazen, showed the pinhole to be an *instrument*—one that could be placed in the shutter of a darkened laboratory for use in examining solitary light rays. Alhazen's book, *Kitab al-Manazir* (Optical thesaurus), was published around 1020 A.D. Alhazen says in "Theorum 29":

Light and colour penetrate transparent bodies separately: That lights and colours are not mixed in the air or in transparent bodies is shown by the following. When in one place several candles are put at various different points, all opposite an opening leading into a dark place (locus obscuras), with a wall or an opaque body opposite the opening, the lights (luces) of these candles appear on the body or that wall separately and corresponding in number to the candles. Each one of them appears opposite one candle on a line passing through the opening.⁴

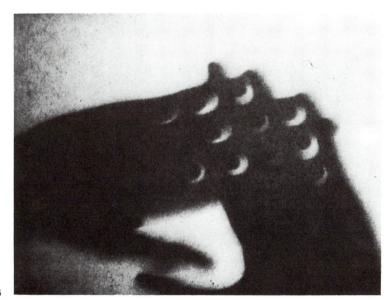

Figure 1.5 Pierced Gnomon. Drawing by author after Rene R. J. Rohr's Sundials, 1965.

Figure 1.6 © David Stork, Pinhole Images of Partially Eclipsed Sun. Hands are held on top of one another, so that pinholes occur between overlapping fingers; hands shown are actually a shadow on the ground. From the collection at Pinhole Resource.

Figure 1.7 Anthemius of Tralles, Ray Diagram.

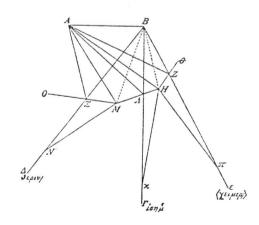

1.6

In centuries to follow, optical scientists were inspired by Alhazen's use of the pinhole. For these scientists, the pinhole, too, became a starting point—a primary tool for studying sunlight projected from a small aperture. For instance, the scientists Theodoric of Freiberg (1250–1311) and Kamal al-Din al-Farisi (d.1320) from Persia analyzed sunlight coming from a small pinhole directed on a waterfilled glass globe to explain the rainbow's complicated color principles (Figure 1.8a). Both scientists, although thousands of miles apart, worked simultaneously; both admired Alhazen's pinhole ideas. Some centuries later, this same experiment was rediscovered and reinvestigated independently by Antonio de Dominis (1564–1624) and René Descartes (1596–1650) (Figure 1.8b), and Johannes Kepler (1571–1630) (Figure 1.8c).

By the latter part of the fifteenth century, some cathedrals in Italy had a large aperture placed in the arched ceiling for telling time. In 1475, at the age of seventy-eight, the Renaissance mathematician and astronomer Paolo Toscanelli placed a bronze ring with an aperture (Figure 1.9a) at the juncture of Filippo Brunelleschi's dome and lantern in the Cathedral of Florence—still in use today. A solar image is projected through this hole on sunny days, visible on the cathedral's floor. At noon, as the sun traverses the sky, this solar image bisects a "noon-mark," a meridian line placed north-south on the floor (Figure 1.9b). This pinhole is also used architecturally to see if the building has shifted.

Figure 1.8a Kamal al-Din al-Farisi, Ray Diagram. Sunlight refracted into a water-filled glass globe (acting like a raindrop), then internally reflected back to the eye of the viewer. Tanquh al-Manazir, 1310.

Figure 1.8b René Descartes, Diagram showing the formation of the rainbow. Les Meteores, 1637.

Figure 1.8c Johannes Kepler, Diagram showing light from the pinhole entering a glass globe filled with water. Ad Vitellionem Paralipomena, 1604.

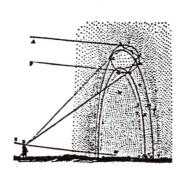

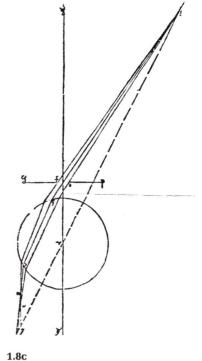

1.8b

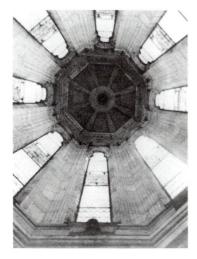

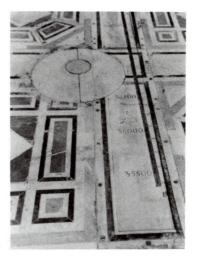

1.9a

Figure 1.9a View Upward into the Lantern, Cathedral of Florence. The bronze ring

with pinhole is the rounded shape at bottom of photograph in front of window. Lens photograph by Pinky Bass, from the collection at Pinhole Resource.

Figure 1.9b Detail of Noon-mark on the Floor, Cathedral of Florence. Lens photograph by Pinky Bass, from the collection at Pinhole Resource.

In the Basilica di San Petronio in Bologna, there still exists a pinhole (Figure 1.10a) in the ceiling—120 feet above the marbled floor—onto which is projected an image of the sun twelve inches in diameter (Figure 1.10b). William Livingston, a solar astronomer from Kitt Peak Observatory, in studying the San Petronio solar image transiting the floor, has calculated that the solar image moves its own diameter in 120 seconds, or 1/10th of an inch per second. It is actually feasible to set your watch—or back then, your water clock—to a one second accuracy!⁵

The meridian line is thirty yards in length. Since the sun is higher in the sky in the summer and lower in the winter, ecclesiastical holidays, shown as inscriptions along the meridian line, are lit by the solar disc on the correct day, as long as it's sunny.

A variety of figures representing wind are painted on the ceiling of the Tower of Winds in the Vatican Observatory in Rome. Within the ceiling is a pinhole that casts a solar image onto the tower's floor; the image also crosses a meridian line "noon-mark." In 1580, using this pinhole image of the sun, Papal astronomers showed Pope Gregory XIII that the spring equinox fell incorrectly on March 11 rather than March 21. This was because the Julian calendar's year had $365\frac{1}{4}$ days, or 11 minutes 14 seconds longer than the true solar year. This difference led to a gradual change in the calendar date of the equinox so that by 1580 it fell ten days earlier than it should have occurred.

Figure 1.10a View Upward, Basilica di San Petronio, Bologna. Pinhole in ray figure, center right. Lens photograph by W. Livingston, courtesy of the National Optical Astronomy Observatories, Tucson.

Figure 1.10b Projected Solar Image, Basilica di San Petronio, Bologna. Solar image is crossing the noon-mark on marbled floor; some distortion results from the camera angle. Lens photograph by W. Livingston, courtesy of the National Optical Astronomy Observatories, Tucson.

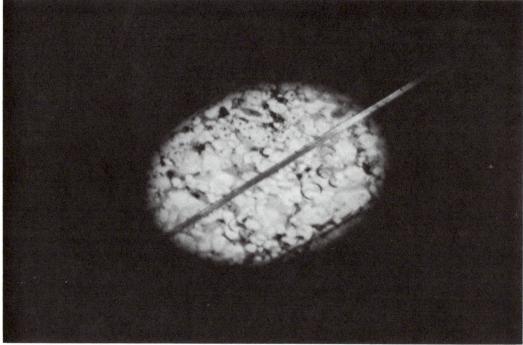

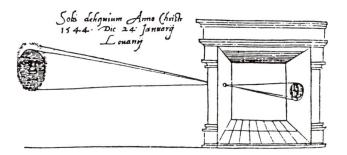

Figure 1.11 Gemma Frisius, Observing the Solar Eclipse, 24 January 1544, apparently the first published illustration of a camera obscura, in De Radio Astronomica et Geometrico, 1545.

By 1582, after careful consideration, Pope Gregory XIII corrected the Julian calendar by 10 days, thus creating his new Gregorian calendar. The Pope decreed that October 5 in the outmoded Julian calendar would become October 15 in the new Gregorian calendar, so that the March equinox of 1583 fell on the correct day, March 21. We now live by the Gregorian calendar that was created through the use of a pinhole image. Under the Julian calendar, a single day was gained in about 400 years. To correct this discrepancy, the Gregorian calendar omits the additional day in February in century years not divisible by 400. Thus, 1600 was a leap year, but 1700, 1800, and 1900 were common years. The year 2000 will be a leap year.

The astronomer Gemma Frisius (1508–1555) used the pinhole in his darkened room to study the solar eclipse of 1544 (Figure 1.11). Room and eclipse are figured in *De Radio Astronomica et Geometrico* (1545); this is apparently the first published illustration of a pinhole camera obscura. The term camera obscura was coined by Johannes Kepler (1571–1630)—camera meaning room and obscura meaning dark. After about 1570, a camera obscura referred to a box, tent, or room with a *lens* aperture used by artists to draw the landscape. A lens made the image brighter than a pinhole and focused it to a specific distance from the lens. Many fascinating camera obscuras are shown in John Hammond's *The Camera Obscura: A Chronicle* (1981, Adam Hilger Ltd.).

Gemma Frisius also used his *camera obscura* to study sunspots—small dark areas that appear from time to time on the sun. That Frisius could actually observe these sunspots by viewing the pinhole's projected solar image (Figure 1.12) was proven by the twentieth-century solar astronomer Ronald Giovanelli from Australia, who duplicated Frisius's apparatus and experiment.⁶

Figure 1.12 © Ronald Giovanelli, Pinhole Images of the Sun, showing a sunspot. From Secrets of the Sun (1984) by the late Ronald Giovanelli. Reproduced by permission, Cambridge University Press.

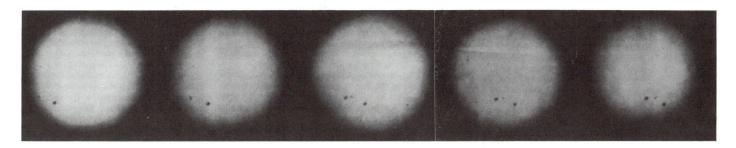

In a 1689 drawing by Cornelius Meyer, it can be seen that pinholes were used in spectacles (Figure 1.13). Each lens was opaque, and a pinhole was placed in the middle, offering the viewer who might have been nearsighted a sharper view. An explanation of how this works can be found in this chapter under the section "The Pinhole and the Eye."

Evidently, Eskimos have known of the advantages of pinhole glasses for many centuries, as illustrated by the following from *A Yellow Raft in Blue Water* by Michael Dorris:

In school I had been warned about snow blindness. I remember learning the Eskimos wore goggles made out of a seal's stomach. They stretched swatches of it across a frame and used a bone needle to punch pinholes to look through. Without protection people saw strange things, saw too much, too wide.⁷

THE PINHOLE IN THE WAVE THEORY OF LIGHT

Optical scientists also investigated optical properties within the cone of light issuing from the pinhole. Over the centuries, these studies were to be paramount for proving the wave theory of light. Paragraphs that follow provide a very brief chronological documentation of scientists' experiments with diffraction and interference phenomena inherent in wave theory. Their discoveries are profound.

Figure 1.13 Cornelius Meyer, Spectacles for All Manners of Sight, drawing, 1689. Note that the man on the left is wearing pinhole glasses, shown in a detail on lower right.

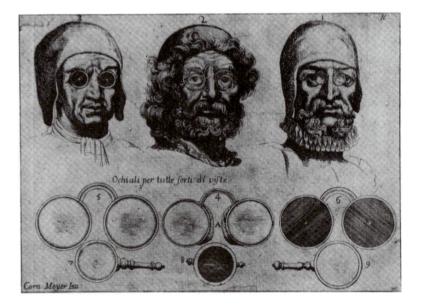

Diffraction

The first accurate description of diffraction, where light actually bends after grazing an edge (Figure 1.14), comes from Francesco Grimaldi (1618–1663), published in 1665 in his *Physico-mathesis de lumine, coloribus, et iride.* ⁸

In Grimaldi's experiment, light from the sun entered his darkened laboratory through a very small pinhole (CD). Light from this pinhole had to pass through a second small pinhole (GH) placed in an opaque screen. Light having passed through both pinholes would then fall on a white screen (IK). If light propagation remained in straight lines after grazing an edge, light would be confined in area N to O. However, Grimaldi observed light in the areas beyond N and O, all the way out to IK. This proved that diffraction occurs. Light is bent slightly after grazing the edge of an obstacle—in this case, two pinholes.

In another experiment, Grimaldi admitted light into his darkened room through two neighboring pinholes and received this light on a white screen. Projected onto the screen were two circular pinhole images of the sun, each surrounded by a feebly illuminated ring. By placing the screen at a certain distance from the two pinholes, Grimaldi could overlap the edges of the outer rings, so that the outer edge of one ring was tangent to the outer edge of the image on the other ring. Curiously, light in this overlapping portion was *less* brilliant than in other areas around the rings! This phenomenon would be known later as *interference*.

Isaac Newton (1642–1727) in *Opticks* (part 1 of the third book) writes:

Grimaldo [sic] has inform'd us, that if a beam of the Sun's Light be let into a dark Room through a very small hole, the Shadows of things in this Light will be larger than they ought to be if the Rays went on by the Bodies in straight lines and that these Shadows have three parallel Fringes, Bands or Ranks of color'd Light adjacent to them. But if the Hole be enlarged the Fringes grow broad and run into one another, so that they cannot be distinguish'd. These broad shadows and Fringes have been reckon'd by some to proceed from the ordinary refraction of the Air but without due examination of the Matter. For the circumstances of the Phænomenon, so far as I have observed them, are as follows.

Observation: I made in a piece of Lead a small Hole with a Pin, whose breadth was the 42d part of an Inch. For 21 of those Pins laid together took up the breadth of half an Inch. Through this Hole I let into my darken'd Chamber a beam of the Sun's Light, and found that the Shadows of Hairs, Thred, Pins, Straws, and such like slender Substances placed in this beam of Light, were considerably broader than

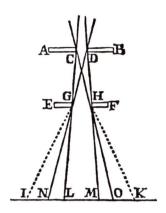

Figure 1.14 Francesco Grimaldi, Diffraction of Light by a Pinhole, from Physico-mathesis de lumine, coloribus, et iride, aliisque adnexis libri duo, 1665.

Figure 1.15 Isaac Newton, Circle X Represents the Middle of the Hair, Opticks, part 1, book 3, 1730.

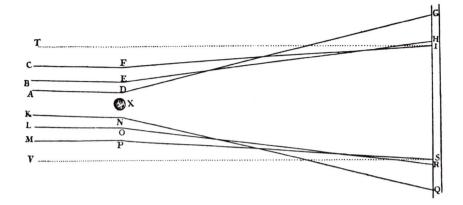

they ought to be, if the Rays of Light passed on by these Bodies in right Lines. And particularly a Hair of a Man's Head [Figure 1.15], whose breadth was but the 280th part of an Inch, being held in this Light, at the distance of about twelve Feet from the Hole, did cast a Shadow which at the distance of four Inches from the Hair was the sixtieth part of an Inch broad, that is, above four times broader than the Hair.⁹

Figure 1.16 Robert W. Wood, Sunlight projected through one pinhole onto 2 pinholes proving interference of light. From Physical Optics, 1934.

Interference

Over a century later, Thomas Young (1773–1839) modified Grimaldi's experiment and observed true interference of light. Young admitted sunlight through a pinhole, then received this diverging cone of sunlight onto two other pinholes placed in an opaque screen beyond the first pinhole (Figure 1.16). Each of these two pinholes also cast a diverging cone of light onto a screen. Where their cones of light overlapped on the screen, Young observed dark and light bands. In this experiment, the two pinholes lie on the wave front of the disturbances coming from the first pinhole, consequently they are in the same phase. ¹⁰

Thomas Young stated eloquently:

It was in May, 1801, that I discovered, by reflecting on the beautiful experiments of Newton, a law which appears to me to account for a greater variety of interesting phenomena than any other optical principle that has yet been made known. I shall endeavor to explain this law by a comparison.

Suppose a number of equal waves of water to move upon the surface of a stagnant lake, with a certain constant velosity [sic], and to enter a narrow channel leading out of the lake. Suppose then another similar cause to have excited another equal series of waves, which arrives at the same channel, with the same velosity, and at the same time with

the first. Neither series of waves will destroy the other, but their effects will be combined: if they enter the channel in such a manner that the elevations of one series coincide with those of the other, they must together produce a series of greater joint elevations; but if the elevations of one series are so situated as to correspond to the depressions of the other, they must exactly fill up those depressions, and the surface of the water must remain smooth; at least I can discover no alternative, either from theory or experiment.

Now I maintain that similar effects take place whenever two portions of light are thus mixed; and this I call the general law of the interference of light. 11

The final wave theory comes from Augustin Fresnel (1788–1827), who concludes the following in *Memoire sur de la defraction de la lumière*, 1819:

Let AG be the aperture through which the light passes [Figure 1.17]. I shall at first suppose that it is sufficiently narrow for the dark bands of the first order to fall inside the geometrical shadow of the screen, and at the same time be fairly distant from the edges B and D. Let P be the darkest point in one of these two bands; it is then easily seen that this must correspond to a difference of one whole wavelength between the two extreme rays AP and GP. Let us now imagine another ray, PI, drawn in such a way that its length shall be a mean between the other two. Then, on account of its marked inclination to the arc AIG, the point I will fall almost exactly in the middle. We now have the arc divided into two parts, whose corresponding elements are almost exactly equal, and send to the point P vibrations in exactly opposite phases, so that these must annul each other.

By the same reasoning it is easily seen that the darkest points in the other dark bands also correspond to differences of an even number of half wave-lengths between the two rays which come from the edges of the aperture; and, in like manner, the brightest points of the bright bands correspond to differences of an uneven number of half wavelengths—that is to say, their positions are exactly reversed as compared with those which are deduced from the interference of the limiting rays on the hypothesis that these alone are concerned in the production of fringes. This is true with the exception of the point at the middle, which, on either hypothesis, must be bright. The inference deduced from the theory that the fringes result from the superposition of all the disturbances from all parts of the arc AG are verified by experiments, which at the same time disprove the theory which looks upon these bands as produced only by rays inflected and reflected at the edges of the diaphragm. These are precisely the phenomena which first led me to recognize the insufficiency of this hypothesis, and suggested the fundamental principle of the theory which I have just explained—namely, the principle of Huygens combined with the principle of interference. 12

Figure 1.17 Augustin Fresnel, Aperture through which light passes, Memoire sur la defraction de la lumière, 1819.

In 1835, F. M. Swerd presented his monumental book on diffraction patterns created by light projected through thousands of pinholes in one plate. The pinholes in each individual plate were either triangular, square, or round. Swerd's book *Die Beugungsercheinungen*, published in Mannheim, is unfortunately little known; however, his meticulously crafted hand-colored drawings of diffraction patterns have been verified photographically by the contemporary scientist Richard Hoover.

THE PINHOLE IN PHOTOGRAPHY

By 1839, photography had been invented. A lens image from a small, portable *camera obscura* could now be chemically preserved. (There is some conjecture that the first photograph by Niépce—an eight-hour exposure made in 1826—might just be pinhole.¹³) However, in 1857, Joseph Petzval was apparently the first to attempt to find, by mathematical formula, the optimal pinhole diameter for the sharpest definition in a pinhole image.

The optimal formula was achieved about thirty years later by the Nobel prize winner Lord Rayleigh (John William Strutt, 1842–1919). For ten years, Rayleigh worked with pinhole formulas, hoping that pinhole apertures could be appropriately used in telescopes. His formula is still referred to today. Rayleigh spoke of his work in *Nature* (1891):

What, then, is the best size of the aperture? That is the important question in dealing with pin-hole photography. It was first considered by Professor Petzval of Vienna, and he arrived at the result indicated by the formula, $2r^2 = fl$, where 2r is the diameter of the aperture, l the wavelength of light, and f the focal length, or, rather simply the distance between the aperture and the screen upon which the image is formed.

His reasoning, however, though ingenious, is not sound, regarded as an attempt at an accurate solution of the question. In fact, it is only lately that the mathematical problem of the diffraction of light by a circular hole has been sufficiently worked out to enable the question to be solved. The mathematician to whom we owe this achievement is Professor Lommel. I have adapted his results to the problem of pinhole photography. The general conclusion is that the hole may advantageously be enlarged beyond that given by Petzval's rule. A suitable radius is $r = \sqrt{(f \, 1)}$.

I will not detain you further than just to show you one application of pin-hole photography on a different scale from the usual. The definition improves as the aperture increases; but in the absence of a lens the augmented aperture entails a greatly extended focal length. The limits of an ordinary portable camera are thus soon passed. The original of the transparency now to be thrown upon the screen was taken

in an ordinary room, carefully darkened. The aperture (in the shutter) was 0.07 inch, and the distance of the 12 x 10 plate from the aperture was 7 feet. The resulting picture of a group of cedars [Figure 1.18] shows nearly as much detail as could be seen direct from the place in question. 14

In 1889, Lord Rayleigh had shown that the optimal pinhole photographic image could "be at least as well defined as that received upon the retina." This means the *optimal* pinhole, designed for a specific focal length, projects an image that equals the sharpness produced by the lens in each of our eyes. Even though the bi-convex lens in each of our eyes accommodates (changes shape slightly for focusing at different distances), modern day camera lenses will actually focus to a point sharper than our eyes can see. The accompanying pinhole photograph in Figure 1.19, by the late mathematician Roy Hines (1929–1981), is probably as sharp a pinhole image as is possible with an optimal pinhole. This surprising sharpness seems similar to 20/20 vision, although all distances are in the same focus. The contrast in lighting helps to make this image appear so sharp.

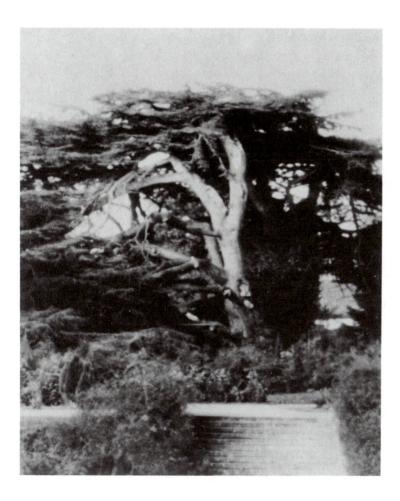

Figure 1.18 © Lord Rayleigh, A Group of Cedars. Pinhole photograph, circa 1890. Made by the author from a copy negative of the original print, courtesy of Hon. G. R. Strutt, John William Strutt archive.

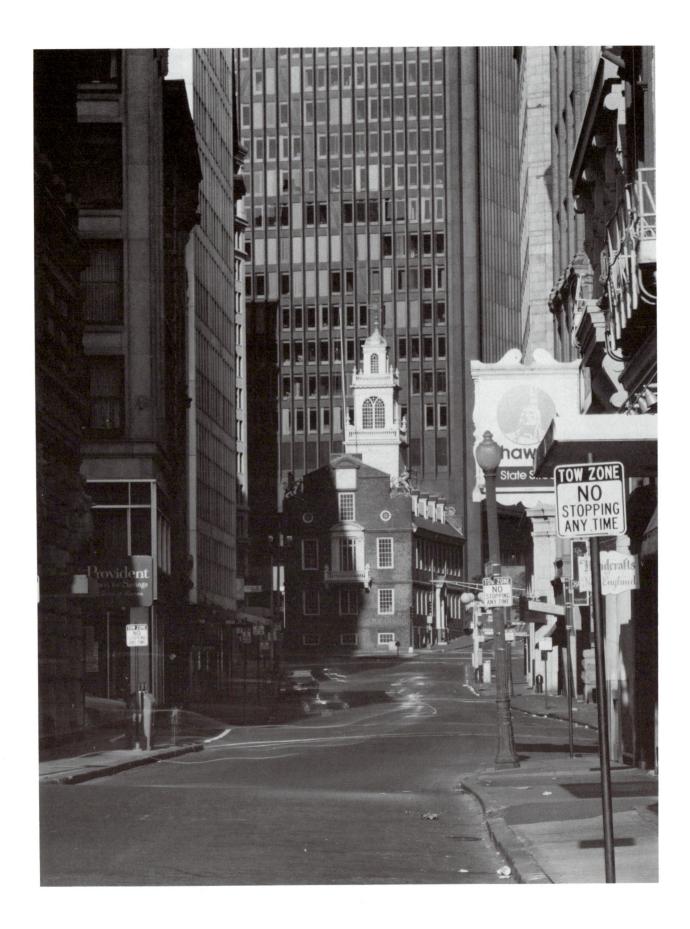

THE PINHOLE AND THE EYE

For decades, ophthalmologists have used an elegant, yet very simple, pinhole instrument, known as an *occluder* (Figure 1.20), to determine whether decreased visual acuity can be helped by prescribing eyeglasses for the correction of a refractive error. The occluder is held closely in front of one eye, while holding an opaque card over the other eye. If the patient can see clearly, while looking through a pinhole in the occluder, eyeglasses can be prescribed; if not, a medical or surgical correction is necessary.

While looking through a pinhole in the occluder, a person's cone of vision is narrowed, so that the image enters the viewer's eye only through the center of the lens. Projected onto the retina is a pinhole image! If a person's eyes can be corrected by glasses, then any distance, close or far, is in focus when an occluder is being used.

To try this, push a large shafted needle through an opaque card. If you wear glasses, take them off. Place your homemade occluder up to your eye, making sure to hold your free hand in front of your other eye. You should be able to see clearly through the pinhole. Since the image you are seeing is a pinhole image, you will be able to see objects at close range. In fact, the pinhole can act as a *magnifier!* To try this, use the occluder while holding this page very close to your eye. Even if you don't wear glasses, you can magnify the type held at close range while looking through the occluder. After you remove the occluder, you will see you have been viewing an area that is normally blurry.

Many centuries ago, Leonardo da Vinci (1452–1519) made use of this same principle. In Manuscript D, following 5r, he writes:

If you will make a hole as small as possible in a sheet of paper and then bring it as near as possible to the eye, and if then you look at a star through this hole, you are making use of only a small part of the pupil, which sees this star with a wide space of sky around it and sees it so small that hardly anything could be smaller. And if you make the hole near to the edge of the said paper, you will be able to see the same star with the other eye at the same time, and it will appear to you to be large, and thus in the same time with your two eyes you will see the one star twice, and once it will be very small and the other time very large. ¹⁶

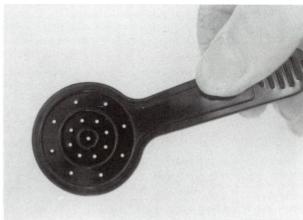

Figure 1.20 A Multiple Pinhole Disc Occluder, manufactured by Western Optical, reproduced by permission of Western Optical, Seattle.

Figure 1.19 © Roy Hines, Old State House, Boston, MA. An $8" \times 10"$ pinhole photograph made with an $8" \times 10"$ flat back camera, circa 1977. From the collection at Pinhole Resource.

Figure 1.21a Richard Blake et al., Pinhole Camera used to obtain the first soft X-ray pinhole photograph of the sun, 1960, from the collection at Pinhole Resource.

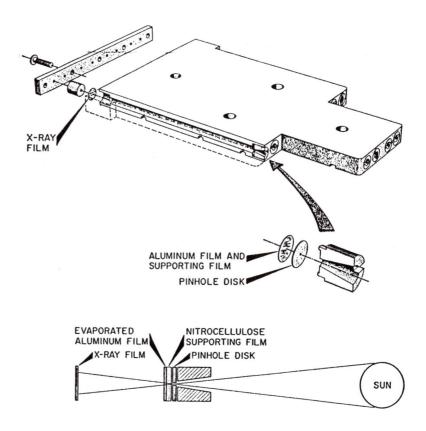

TWENTIETH-CENTURY PINHOLE IMAGING IN HIGH-ENERGY PHYSICS

With the advent of nuclear energy in the 1940s, pinhole cameras began to find their way into nuclear physics to image high-energy particles. It was found that a photographic lens absorbs rather than

projects high-energy X rays or gamma rays, whereas a pinhole will produce an image. The idea of imaging high-energy X rays and gamma rays from the sun, black holes, and exploding stars using pinhole cameras placed on space vehicles began in the late 1950s. The first soft X-ray pinhole photograph of the sun was achieved on 19 April 1960, when a set of pinhole cameras was flown on an Aerobee-Hi Rocket. Richard Blake, one of the designers of the pinhole cameras (Figure 1.21a), explains the flight, cameras, and resulting photographs (Figure 1.21b):

Duration of exposure was 286 seconds. Peak altitude was 220 KM. The camera was kept pointed at the sun within one minute of arc by biaxial pointing control. . . . There were actually eight cameras in the block, four of which survived the flight and impact (the recovery parachute

Figure 1.21b © Richard Blake et al., First Soft X-ray Photograph of the Sun, 1960, from the collection at Pinhole Resource.

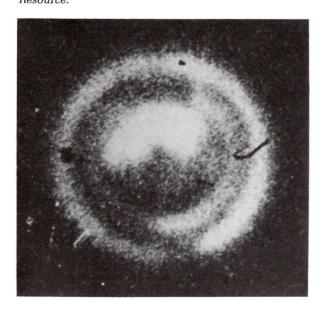

did not function properly). Two of the four were designed to produce photographs with a resolution of one-fifth solar diameter, the other two with one-tenth solar diameter. The camera producing the best picture utilized a pinhole which was 0.005 inch in diameter and was placed 6 inches from the film.

In order to adapt pinhole photography for use in the x-ray region, it is necessary to prevent visible and ultraviolet light from striking the film. The pinhole was covered with a thin film of Parlodion (a type of nitro-cellulose). The Parlodion, in turn, supported an evaporated film of aluminum.¹⁷

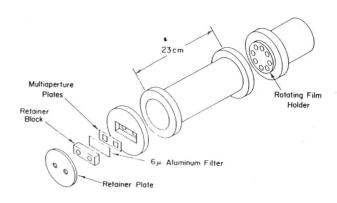

Figure 1.22a Richard Blake et al., Multi-aperture Pinhole Camera for 30 October 1972 flight.

At the suggestion of R. H. Dicke, scatter-hole X-ray pinhole cameras (Figure 1.22a) were designed in the 1970s. Many pinhole images were allowed to overlap. Blake continues:

Now the sun is a compact collection of complex sources which can be mapped by scanning collimators with about the same figure of merit as by the scatter-hole camera . . . two pictures are taken using complementary aperture plates. One picture has one half of the possible hole positions randomly selected and punched out [Figure 1.22b], the other plate has the other possible hole positions punched out. The two pictures can be subtracted to form a pseudopicture, which can then be correlated (digitally) with a pseudoaperture formed by subtracting the complementary aperture functions. . . . On 30 October 1972 we flew a camera incorporating two aperture plates to permit implementation of the subtractive postprocessing scheme. ¹⁸

After many years of theoretical groundwork in pinhole astronomy, today's pinhole cameras flown on space vehicles use multiple-pinhole optics, known as *coded-aperture imaging*, to photograph high-energy X rays and gamma rays (Color Plate 1.23, Figure 1.24) from extreme energy sources such as black holes and exploding stars. One astrophysicist working with pinhole optics, Thomas A. Prince, describes the first gamma-ray image of a supernova (exploding star):

The Caltech imaging gamma-ray telescope was launched from Alice Springs, Northern Territory in Australia on November 18 [1987]. It observed the supernova for approximately two and one-half hours starting at 14 hrs. 30 min. U.T. The telescope used a technique called coded-aperture imaging to produce images in a wavelength where mirrors and lenses are not feasible. A coded-aperture imager functions like a multiple-pinhole camera. In such a camera, multiple holes cast overlapping images on a position sensitive electronic detector. The individual, overlapping images are unscrambled using a computer and superimposed to yield the final image of a gamma-ray source [Figure 1.25a]. . . .

Figure 1.22b Richard Blake et al., One of Two Complementary Multiaperture Plates for 30 October 1972 flight camera.

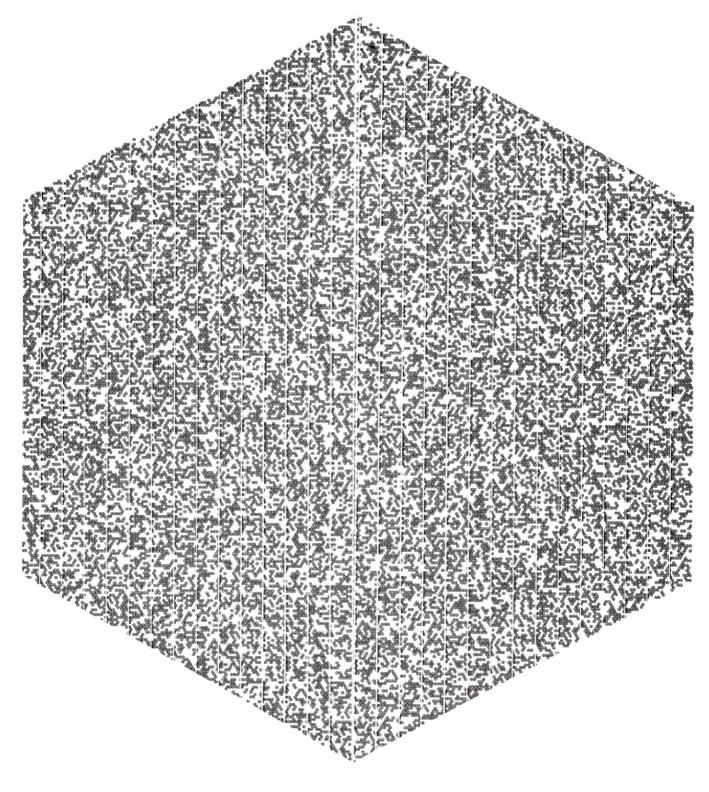

Figure 1.24 E. E. Fenimore, A 26,232-pinhole Uniformly Redundant Array Aperture Study Plate, 12" w. x 13" h., 1985, courtesy of the Los Alamos National Laboratories.

Using the coded-aperture technique, the Caltech telescope produced an accompanying slide image of Supernova 1987A [Color Plate 1.25b]. This is the first such image of the supernova at gamma-ray energies. Indeed, it is one of the first few images at gamma-ray energies (100 keV to 10 MeV) of any astronomical object. The hard x-rays and gamma-rays which make up this image are thought to be direct and scattered photons from the decay of radioactive cobalt 56, newly produced in the explosion of the supernova. The field of view shown in the slide is 12 degrees across and the supernova itself is unresolved. The background in the supernova field is produced by statistical fluctuations in the diffuse hard X-ray and gamma-ray background and does not necessarily represent real structure. 19

Over the last twenty years, the pinhole has also been used widely by nuclear physicists to image high energy in laser plasma. An object is heated by laser beams inside a vacuum chamber to extreme high energies (Figure 1.26a), equal to the sun's nuclear energy reaction heat

An HURA of order 139

An HURA of order 151

An HURA of order 619

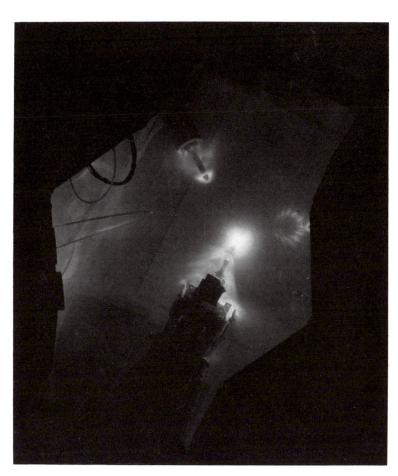

Figure 1.26a © *Allan Hauer,* Inside the Antares Laser Chamber *during* an actual laser shot, 1985. Pinhole camera is coming down from upper left. Lens photograph provided by Los Alamos National Laboratories.

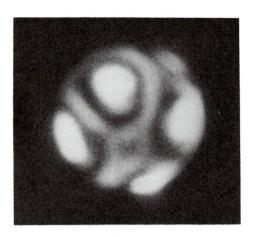

Figure 1.26b © Allan Hauer, X-ray Pinhole Photograph of laser irradiated glass micro shell, 1985. Laser Plasma Experiments Group, Los Alamos National Laboratory. Laser beams are tightly focused on the surface of the sphere. Four of the focused beams appear as the oval-shaped areas. Tightly focused beams cause very large magnetic fields to be generated, which in turn channel some of the blow-off back to the target surface in the "canals" or "channels" between the laser spots. Lens photograph provided by Los Alamos National Laboratories.

at 10 million degrees F; upon implosion, the object is photographed (Figure 1.26b) with a pinhole camera. This laboratory simulation of the sun's energy allows the scientist to study nuclear reactions under somewhat ideal conditions.

NOTES

- 1. Angus C. Graham, *Later Mohist Logic, Ethics, Science* (London: School of Oriental and African Studies, University of Hong Kong with University of London Press, 1978), 375–79.
- 2. W. S. Hett, trans., *Aristotle*, Book XV, Chapter 911bl (Cambridge, MA: Loeb Classical Library, Harvard University Press, 1936), 333–35.
- 3. G. L. Huxley, Anthemius of Tralles (Cambridge, MA, 1959), 6-8, 44-46.
- 4. Ibn al-Haitham, *Opticae Thesaurus* [1572], ed. F. Risnero, Basel, in A. C. Crombie, "The Mechanistic Hypothesis and the Scientific Study of Vision: Some Optical Ideas as a Background to the Invention of the Microscope," in *Historical Aspects of Microscopy*, edited by S. Bradbury and G. L' E. Turner (Cambridge, MA: Heffer and Son, 1967), 108–12.
- 5. William Livingston, "Solar Time Standards and the Medieval Church," *Pinhole Journal* 2(2):2–3.
- Ronald Giovanelli, Secrets of the Sun (New York: Cambridge University Press, 1984), 18.
- Michael Dorris, A Yellow Raft in Blue Water (New York: Warner Books, 1987), 202.
- 8. Francesco Grimaldi, *Physico-mathesis de lumine, coloribus, et iride, aliisque adnexis libri duo*, Bononiae, 1665, in M. H. Pirenne, *Optics, Painting and Photography*, (New York: Cambridge University Press, 1970), 190.
- 9. Isaac Newton, *Opticks*, Third Book of Optics, Part 1, (London: S. Smith and B. Walford, 1730), 317–18.
- 10. Robert W. Wood, Physical Optics (New York: Macmillan, 1934), 186-87.
- 11. Henry Crew, *The Rise of Modern Physics* (Baltimore: Williams and Wilkins, 1928), 163–65.
- Augustin Fresnel, "Memoir on the Diffraction of Light," in *The Wave Theory of Light*, trans. by Henry Crew (New York: American Book Company, 1900), 81, 144.
- 13. Roy Flukinger, Curator, Harry Ransom Humanities Research Center, Austin, TX, personal communication with author, February 6, 1987.
- John William Strutt (Lord Rayleigh), "On Photography," Nature 44(16 July 1891):249–54.
- 15. Lord Rayleigh, The Photographic News 33 (20 September 1889):611.
- 16. Leonardo da Vinci, Manuscript D following 5r, Institut de France
- 17. R. L. Blake, T. Z. Chubb, H. Friedman, and A. E. Unzicker, "Interpretation of X-ray Photograph of the Sun," *The Astrophysical Journal* 137(1):3–16.
- 18. R. L. Blake, A. J. Burek, E. E. Fenimore, and R. Puetter, "Solar X-ray Photograph with Multiplex Pin-hole Camera," *Review of Scientific Instruments* 45(4):513–16.
- 19. Thomas A. Prince, "Pinhole Telescope: First Gamma-Ray Image of Supernova 1987A," *Pinhole Journal* 4(2):26–27.

I used to tell my friends that the inventor of painting, according to the poets, was Narcissus, who was turned into a flower; for as painting is the flower of all the arts, so the tale of Narcissus fits our purposes perfectly. What is painting but the act of embracing by means of art the surface of the pool?

LEON BATTISTA ALBERTI On Painting and on Sculpture, 1435

2

Perspective is a Latin word meaning Seeing-Through.

Albrecht Dürer Book of Measurements, 1525

Pinhole's History in Art

BRUNELLESCHI'S PINHOLE PERSPECTIVE DEVICE

Lippo de ser Brunelleschi of Florence founded the procedure of working out this method [of perspective] in which there was truly something ingenious, subtle, and beautiful; by rational procedures he constructed what you see when you look in a mirror. ¹

The western world's concept of space would radically begin to change at the end of the first quarter of the fifteenth century because of one singular device that used a small aperture (Figure 2.1). Certainly this is not something we were taught in school. We are fortunate to be able to read about it firsthand because Filippo Brunelleschi's small-apertured perspective device was explained to us by his "Anonymous Biographer"—someone who apparently worked with Brunelleschi, yet never has been fully identified (although thought to be Antonio Manetti).

From a paper by the "Anonymous Biographer," written in approximately 1482, we discover the following:

About this matter of perspective, the first thing in which he displayed it was a small panel about half a braccio square on which he made a picture showing the exterior of the church of S. Giovanni in Florence. And he depicted in it all that could be seen in a single view; to paint it he took up a position about three braccia inside the middle door of S. Maria del Fiore. The work was done with such care and accuracy and the colours of the black and white marble were so faithfully reproduced that no miniaturist ever excelled him. In the picture he included everything that the eye could take in, from the Misericordia as far as the corner and the Canto de'Pecori on one side to the column

Figure 2.1 Filippo Brunelleschi's Small-apertured Perspective Device. In the drawing, Brunelleschi's extended arm holds the mirror facing the painting. His eye looks through a hole drilled through the back of the painting. Drawing by Jack Neff, 1988.

commemorating the miracles of St. Zepotius as far as the Canto alla Paglia and all that could be seen beyond it on the other. And for what he had to show of the sky, that is where the walls in the painting stand out against the open air, he used burnished silver so that the actual air and sky would be reflected in it and the clouds also, which were thus seen moving on the silver when the wind blew. Now, the painter had to select a single point from which his picture was to be viewed, a point precisely determined as regards height and depth, sideways extension and distance, in order to obviate any distortion in looking at it (because a change in the observer's position would change what his eye saw). Brunelleschi therefore made a hole in the panel on which the picture was painted; and this hole was in fact exactly at the spot on the painting where the eve would strike on the church of S. Giovanni if one stood inside the middle door of S. Maria del Fiore, in the place where Brunelleschi had stood in order to paint the picture. On the picture side

of the panel the hole was as small as a bean, but on the back it was enlarged in a conical shape, like a woman's straw hat, to the diameter of a ducat or slightly more. Now Brunelleschi's intention was that the viewer, holding the panel close to his eye in one hand, should look from the back, where the hole was wider. In the other hand he should hold a flat mirror directly opposite the painting in such a manner as to see the painting reflected in it. The distance between the mirror and the other hand was such that, counting small braccia for real braccia, it was exactly equivalent to the distance between the church of S. Giovanni and the place where Brunelleschi was assumed to be standing when he painted it. Looking at it with all the circumstances exactly as described above—the burnished silver, the representation of the piazza, the precise point of observation—it seemed as though one were seeing the real building. And I have had it in my hand and looked at it many times in my days and can testify to it.²

Filippo Brunelleschi (1377?—1446), the brilliant Renaissance architect and engineer, invented the small-apertured perspective device in 1425 when he was about forty-seven years old. The "Anonymous Biographer" tells us the diameter of the hole was "as small as a bean" (lentil-sized, which is about 3/16 inch in diameter).* The hole enlarged in the back of the painting "to the diameter of a ducat or slightly more," would have been approximately one inch in diameter. Fred Leeman in his book *Hidden Images* simplifies this description:

This picture had to be observed in a particular way: One had to stand exactly where the artist had stood when he painted his subject—that is, almost six feet inside the entrance of the church. A peephole had

^{*}Interesting to note: The word "lentil" in Latin is *lens*. A lentil is biconvex, like the lens in our eyes.

been cut in the center of the picture, and the viewer had to look through it from the back of the picture. Gazing through the hole, he would see the cathedral square and the Baptistery just as Brunelleschi had painted them. Then, holding up a mirror, he could look through the peephole and this time see the front of the painting, which coincided exactly with the actual view of the square. In order to enhance the effect, the sky was not painted in on the panel; instead, a layer of silver reflected the real sky. "And so," as Manetti writes, "the clouds that one saw in the silver moved with the wind when it blew."

Brunelleschi used two very basic optical devices: the small aperture and the mirror. He wanted to create a theory for perspective pertaining to the eye, which sees objects in three dimensions and then places those objects into two dimensions, as in drawings and paintings. In Brunelleschi's experiment, he was able to demonstrate that there was a vanishing point in three dimensional space where specific lines of perspective converged on a point farthest from the eve (like looking down two railroad tracks, which converge to a point). Similarly, there was a vanishing point at one eye where specific lines of light converged on the eye. Brunelleschi was able to perfectly represent the reality of three dimensions by looking through the lentilsized aperture drilled into the two dimensional painting. The painting was reflected back toward him in the mirror. When he removed the mirror, he had a duplicate of the painting in three dimensions. To accomplish this, he had to be standing exactly at the correct distance in front of the real building and his eye behind the hole had to remain stationary. This seemingly simple experiment profoundly changed humanity's concept of space. Brunelleschi's theory became known as the "theory of one point perspective." It was the first theory to scientifically prove how three dimensions could precisely become two dimensions.

Many art historians have written about Brunelleschi's small-apertured perspective device. Because of this, his device is well known in the history of art. The historians have failed to realize one crucial element: Brunelleschi's device was operating on the geometric principles of the enlarged pinhole. By failing to recognize this, they fail to realize that Brunelleschi was also theoretically demonstrating the workings of a small-apertured *camera obscura*. Historians never mention pinhole optics, and some have even gone so far as to duplicate the experiment by using a lens camera!

ALBERTI'S FIRST DIFFRACTION CAMERA

Brunelleschi's mirror and small aperture had captured threedimensional space and scientifically placed it into two dimensions. Why couldn't someone capture three-dimensional space and scientifically replace it into *three dimensions*? This could be accomplished by transferring the fixed point, where Brunelleschi's eye had been behind the hole in the painting, and placing it as a small aperture in the wall of the darkened room. By doing this, we have a *camera obscura*. The projected image can be viewed in two dimensions on a screen, or it can be viewed in three dimensions on the walls, floor, and ceiling.

The early artist/scientist "Renaissance man" certainly knew of the "hole in the shutter" optical principle, since researchers in light used it from Alhazen (1020 A.D.) onward. With an aperture of the correct diameter, the projected image would be well defined on the walls, floor, and ceiling. The only theoretically correct way to re-view the projected image was by looking through the aperture! Since one's head would naturally block the light coming into the darkened room, the projected image had to be painted. This, of course, preserved the image. When you put your eye at the fixed-point aperture, you could actually see the painted image, precisely as it looked outside. (Of course, the image was painted upside down and light had to be added inside.)

How profound! Theoretically, everything was geometrically correct! The first *diffraction camera* was brilliantly created and made by Leon Battista Alberti (1404–1472), a friend of Filippo Brunelleschi.

In an anonymous biography on Alberti published in Muratori's *Rerum Italicarum Scriptores* (xxv296), quoted by Vasari, it states:

Alberti painted wonderful pictures, which were exhibited in some sort of small closed box, viewed through a very small aperture. The pictures showed marvelous verisimilitude; one picture was nocturnal, showing the moon and stars, the other diurnal, showing a day scene.⁴

Undoubtedly, this was a *camera obscura*, because it is stated the paintings were "viewed through a very small aperture." Unfortunately these boxes are lost. A present-day room-sized *camera obscura* is shown in Figures 2.2a through 2.2d.

Probably Alberti would have made his day scene of a well-known landmark, so that the scene could have been viewed outside the box in its well-known three-dimensional reality or from the aperture in the box in its newly created three-dimensional reality.

How would Alberti have painted this scene? To be theoretically consistent with Brunelleschi, he would have probably made a rectangular or square box with the top removed and a small aperture in one side aimed toward the well-known landmark. Alberti could have draped a thick black cloth over himself and the box—thereby excluding all extraneous light from entering the box, except for the image through the small aperture.

The image of the landmark would have been upside down on the inside of the box. Alberti could have duplicated the image with paint or in pencil on the entire inside of the box. It would not have been easy to bend over and paint or draw the upside-down image, but if my understanding is right about the milieu of those early Renaissance times, this kind of craziness would have been just perfect.

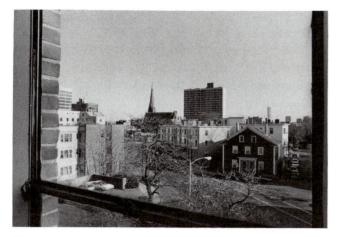

2.2c

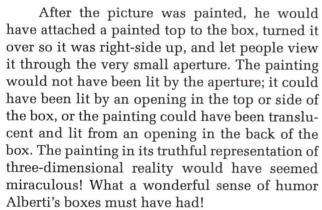

Are there any other cameras where you view the image through the aperture? There are. Boxes like Alberti's, with a painting in three dimensions inside, viewed through a peephole, became known as "peep-show boxes" or "perspective cabinets." Unfortunately art historians never

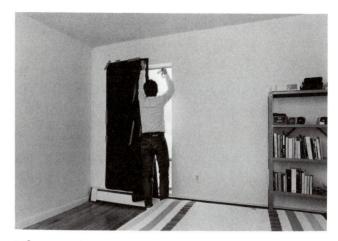

2.2b

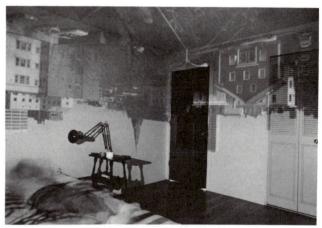

2.2d

Figure 2.2a To convert an ordinary room into a camera obscura, select a room with a window overlooking a spacious view. To avoid direct sunlight, choose a window facing north, if possible. (From How to Convert an Ordinary Room into a Camera Obscura, © Bob Rosinsky, 1984).

Figure 2.2b Block out the selected window and all other windows with an opaque material. Black plastic, available at most hardware stores, is quite effective. Plastic is rather inexpensive and attaches easily with gaffer's tape or pushpins. (© Bob Rosinsky, 1984.)

Figure 2.2c Make a hole about the size of a penny in the center of the selected window. A larger hole will render a brighter but fuzzier image and a smaller hole, a fainter but sharper image. (© Bob Rosinsky, 1984.)

Figure 2.2d Once the preceding steps have been completed, close any door allowing light into the room and/or turn off all artificial lights. An inverted and reversed image of the outside view will appear on the walls and ceiling. (© Bob Rosinsky, 1984.)

refer to them as any type of *camera obscura*. Less than a dozen have survived. The best preserved peep-show box (Figure 2.3a and detail in Figure 2.3b), by Samuel Van Hoogstraten (1627-1678), resides in the National Gallery in London. For light, one of its sides is glass covered. There are two apertures. Each is placed in the side near the glass, halfway up the side. Van Hoogstraten was a contemporary of Jan Vermeer and Carel Fabricius. Although partially destroyed, a sixsided peep-show box by Van Hoogstraten is on display at the Detroit Institute of Art. The side containing the small aperture has been removed! Because you don't look at the scene through the aperture, the idea is lost, and the scene simply looks distorted. Several other peepshow boxes are in The Netherlands and Denmark. The peep-show box, a painting in three dimensions, remained only a curiosity—one that was seldom realized by artists over the centuries to follow. A contemporary use of the peep-show box concept is shown in Gillian Brown's installation (see Color Plates 6.4a, 6.4b).

Figure 2.3a Samuel Van Hoogstraten, Peep-show Box. Size of interior: 21½" high, 31½" wide, 21" deep. Circa 1660, courtesy of the National Gallery, London. The box consists of three sides, a top, and a bottom. The fourth side is clear, covered with glass. About half way up each side adjoining the glass, a peephole is situated. These two peepholes are approximately ¾" in diameter and are near to the glass. Viewed in person, the painted interior has a beautiful light and looks absolutely real.

ALBERTI'S INTERSECTOR

Filippo Brunelleschi's small-apertured perspective device was transformed by Alberti in another way. He used it as a device for two-dimensional drawing and painting, known as the *intersector* or the *veil*. This was of great assistance to the artist, particularly in foreshortening, and was widely used over many centuries. In *De Pictura*, Alberti says:

I believe nothing more convenient can be found than the veil, which among my friends I call the intersection, and whose usage I was the first to discover. It is like this: a veil loosely woven of fine thread, dved whatever color you please, divided up by thicker threads into as many parallel square sections as you like, and stretched on a frame. I set this up between the eye and the object to be represented, so that the visual pyramid passes through the loose weave of the veil. This intersection of the veil has many advantages, first of all because it always presents the same surfaces unchanged, for once you have the fixed positions of the outlines, you can immediately find the apex of the pyramid you started with, which is extremely difficult to do without the intersection. . . . A further advantage is that the position of the outlines and the boundaries of the surfaces can easily be established accurately on the painting panel; for

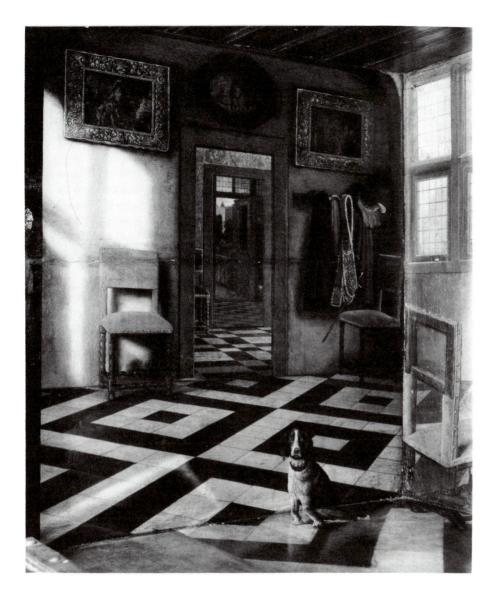

Figure 2.3b Samuel Van Hoogstraten, Detail of Peep-show Box courtesy of National Gallery, London. The line going across the dog designates where the bottom of the box meets the side of the box. When viewed through the peephole, it can be seen that the painted image does not rely on the edges of the box. Deep space is created by the illusion of the anamorph.

just as you see the forehead in one parallel, the nose in the next, the cheeks in another, the chin in one below, and everything else in its particular place, so you can situate all the features on the panel or wall which you have similarly divided into appropriate parallels. Lastly, this veil affords the greatest assistance in executing your picture, since you can see any object that is round and in relief, represented on the flat surface of the veil.⁵

While using the "intersector," the artist's eye had to remain stationary at the fixed point; consequently, some of the early devices had a small aperture placed at eye level. Many preliminary drawings from the Italian Renaissance show horizontal and vertical grid lines associated with the intersector. Some finished paintings even retain sparse patches of these lines.

Figure 2.4a Masaccio, The Trinity in S. Maria Novella, Florence. The painting was intended to be viewed at a distance of exactly twenty feet and one inch.

Figure 2.4b Prerestoration drawing of Masaccio's The Trinity. There are grid lines on the figure standing on the left and finer grid lines across the face. The areas to be restored are dark. Drawing by the Instituto del Restauro, Florence.

Brunelleschi's gifted friend Masaccio (1401–1428) used the intersector for *The Trinity* (Figure 2.4a)—apparently the first painting in one-point perspective. The woman standing on the left has grid lines across her figure and finer grid lines across her face as shown in Figure 2.4b. It must have been extraordinary to view the superb realism of this painting in 1428! Many consider *The Trinity* to be as powerful a painting in two dimensions as Brunelleschi's dome in the Cathedral of Florence is in three dimensions!

Another friend of Brunelleschi, Donatello (1386–1466), apparently was the first to use one-point perspective in sculpture.

The Flemish painter, Jan van Eyck (1390–1441), contemporaneously achieved one-point perspective in his masterpiece *The Marriage of Giovanni Arnolfini and Giovanni Cenami*, although his

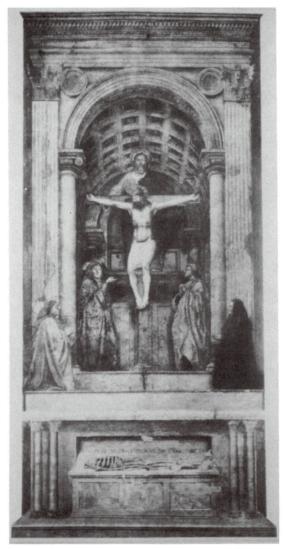

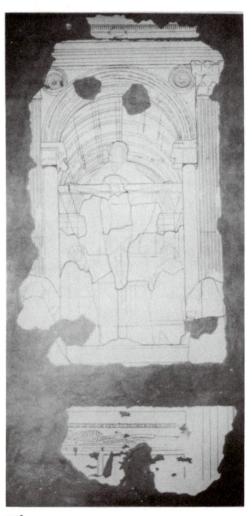

2.4b

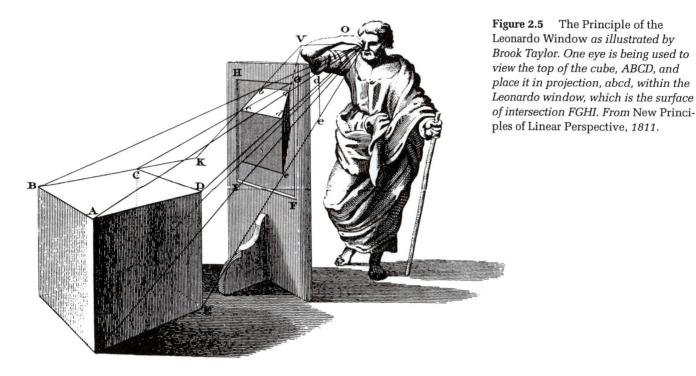

theories and experiments in one-point perspective have not been historically documented. It is known that Flemish painters were in artistic contact with the Italian Renaissance and that van Eyck had even been urged by King Alfonso to emigrate to Naples to decorate his new palace. Flemish artists were known to have painted directly onto the reflection in a mirror to depict interiors, another way of achieving one-point perspective, as long as the painter's eye remained stationary.

LEONARDO DA VINCI

One-point perspective, using the intersector as a painting aid, was refined to its highest point by Piero della Francesca (1420–1492) in *De prospectiva pingendi*, published in 1480. Later, Leonardo da Vinci (1452–1519) explained his use of the fixed point (Figure 2.5):

You should have a pane of glass as large as a royal half folio, and fix it firmly before your eyes, that is, between your eye and the thing you wish to depict, and then you take up a position with the eye at 2/3 braccio from the glass, fix your head with some device so you cannot move it, shut or cover one eye, and with the brush or pencil or chalk draw on the glass what you see beyond it, and then polish it down with sandpaper and dust it over good paper and paint it as you wish.⁶

Figure 2.6 Leonardo da Vinci, The Last Supper, circa 1496. In Santa Maria delle Grazie, Milan. The vanishing point goes to Christ's right eye.

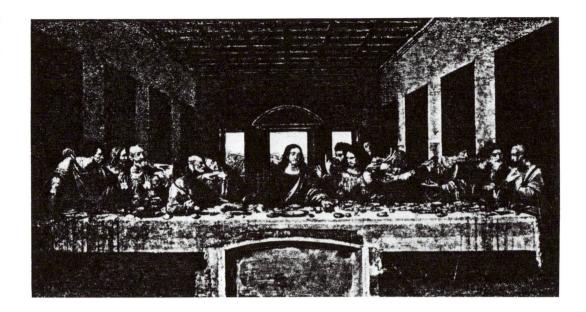

Undoubtedly the best-known painting in one-point perspective is da Vinci's *Last Supper* (Figure 2.6)—the vanishing point goes to Christ's right eye! An example of Leonardo's use of one-point perspective grid lines can be seen in Figure 2.7.

Leonardo mentions the use of a small aperture in at least twenty places in his manuscripts. Some of his more notable quotes on the subject are as follows:

If you transmit the rays of the sun through a hole in the shape of a star you will see a beautiful effect of perspective in the spot where the sun's rays pass.

LEONARDO [C.7a (9b)]

Only one line of the image, of all those that reach the visual power, has no intersection; and this has no sensible dimensions because it is a mathematical line which originates from a mathematical point, which has no dimensions. According to my adversary, necessity requires that the central line of every image that enters by small and narrow openings into a dark chamber shall be turned upside down, together with the images of the bodies that surround it.

LEONARDO [W. 19152a]

That I must first show the distance of the sun from the earth; and, by means of a ray passing through a small hole into a dark chamber, detect its real size; and besides this, by means of the aqueous sphere calculate the size of the globe.

Leonardo [Leic. Ia]

A method of seeing the sun eclipsed without pain to the eye. Take a piece of paper and pierce holes in it with a needle, and look at the sun through these holes.

LEONARDO [Trib. 6b]

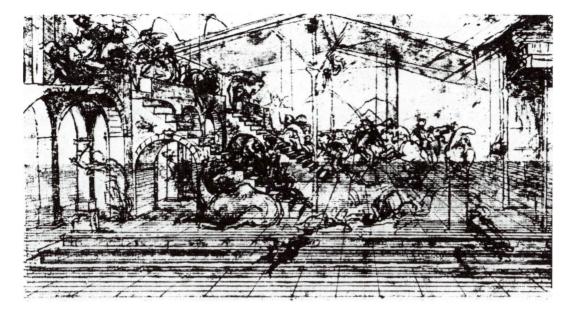

Figure 2.7 Leonardo da Vinci, Adoration of the Magi, circa 1500. In the Uffizi Gallery, Florence. Study of figures and architecture in one-point perspective.

The edges of a color transmitted through a small hole are more conspicuous than the central portions.

LEONARDO [C.A. 190a]

An experiment, showing how objects transmit their images or picture, intersecting within the eye in the crystalline humour. This is shown when the images of illuminated objects penetrate into a very dark chamber by some small round hole. Then, you will receive these images on a white paper placed within this dark room and rather near to the hole, and you will see all the objects on this paper in their proper forms and colors, but much smaller. . . . And let the little perforation be made in a very thin plate of iron.

LEONARDO [D. 80]

What difference is there in the way in which images pass through narrow openings and through large openings, or in those which pass by the sides of shaded bodies? By moving the edges of the opening through which the images are admitted, the images of immovable objects are made to move.

LEONARDO [W. 19149a]

Leonardo's well-known, and frequently published, statement on the pinhole *camera obscura* reads as follows:

I say that the front of a building—or any open piazza or field—which is illuminated by the sun has a dwelling opposite to it, and if, in the front which does not face the sun, you make a small round hole, all the illuminated objects will project their images through that hole and be visible inside the dwelling on the opposite wall which should be made white; and there, in fact, they will be upside down, and if you make similar openings in several places in the same wall you will have the same result from each. Hence the images of the illuminated of the same result from each.

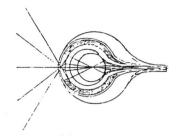

Figure 2.8 Leonardo da Vinci, Light rays entering the eye and light rays entering the glass globe placed inside a small camera obscura. Codex Atlanticus fol. 337 r., circa 1500.

nated objects are all everywhere on this wall and all in each minutest part of it. The reason, as we clearly know, is that this hole must admit some light to the said dwelling, and the light admitted by it is derived from one or many luminous bodies. If these bodies are of various colors and shapes the rays forming the images are of various colors and shapes, and so will the representations be on the wall.

LEONARDO [C.A. 135b]

Two drawings by Leonardo (Figure 2.8), without written explanation, show light rays entering a human eye and light rays entering a glass globe placed behind the aperture of a small camera obscura. These drawings would award Leonardo priority for the first refractive camera (containing a lens); however, historians of science overlook these drawings, choosing instead to credit Daniele Barbaro (1513–1570).* Leon Battista Alberti's diffraction camera is not even in the running! Science historians must think a camera has to have a standard lens.

Albrecht Dürer (1471–1528) was responsible for transporting concepts of the Italian Renaissance to Germany. He learned the use of one-point perspective, the intersector, the small aperture, and the fixed point while traveling in Italy. Dürer, the great draftsman, had gone there specifically "to learn the secrets of the art of perspective from a man who is willing to teach me."

It is thought Dürer learned perspective by personal instruction from Leonardo or from Luca Pacioli (1450?–1520?), the author of *The Divine Proportion*. It is known that Dürer read Piero della Francesca's

Figure 2.9a Albrecht Dürer, Perspective Instrument, from Book of Measurements. Artist views scene through small aperture in upright, sighting past top of pointed column, circa 1525.

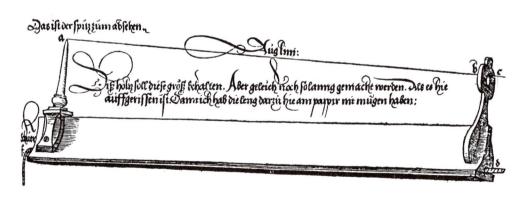

^{*}Obviously, as soon as a lens was placed in a *camera obscura*, artists no longer needed to use the pinhole *camera obscura*. When the lens *camera obscura* became portable, by about the late seventeenth century, it made Alberti's intersector somewhat obsolete. This would have happened around the time of Vermeer (1632–1675). For a scholarly discussion on the lens *camera obscura*, see M. S. Hammond, "The Camera Obscura: A Chapter in the Pre-History of Photography." *Dissertation Abs. Int.* 47(10): (Ph.D. diss., Ohio State University, 1987).

De prospectiva pingendi, published in 1480, because in 1525, Dürer wrote della Francesca's five rules of perspective in his own Book of Measurements:

Perspective is a Latin word meaning "Seeing-Through" [seeing through the small aperture]. To this same "seeing through" belongs five things.

- 1. The first is the eye that sees.
- 2. The second is the object seen.
- 3. The third is the distance between (eye and object).
- 4. The fourth; one sees everything by means of straight lines, that is to say the shortest lines.
- 5. The fifth is the dividing from one another of the things seen.⁹

Included in Dürer's *Book of Measurements* were drawings (Figures 2.9a through 2.9d) of many tools for the artist to use in creating one-point perspective by using the fixed point.

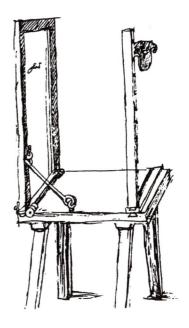

Figure 2.9b Albrecht Dürer, Perspective Apparatus, from Book of Measurements, circa 1525.

Figure 2.9c Albrecht Dürer, Perspective Instrument, from Book of Measurements. Artist is viewing through a tube, which is attached to the back wall, circa 1525.

Figure 2.9d Albrecht Dürer, The Intersector, from Book of Measurements. The artist's eye remains stationary behind the pointed upright, circa 1525.

ANAMORPHOSIS—THE DECEPTION OF THE EYE

By the sixteenth and seventeenth centuries, many artists became aware of a kind of super realism that could be obtained by using the fixed point for casting a picture. To achieve this heightened realism, the finished picture had to be viewed from that same fixed point. A new school of art, known as trompe l'oeil, which translates "to deceive the eye," evolved around this concept. Possibly trompe l'oeil's highest achievement is to be found in the curved vault at St. Ignazio in Rome in the painting Entrance of Saint Ignatius into Paradise by Fra Andrea Pozzo (1642–1709). To show the viewer the position of the fixed point, Pozzo placed a marble disc on the floor below the curved vault. When viewers stand on that disc and look upward, their eyes match the fixed point and the entire painting snaps into place. The multitude of painted figures on the vault look as if they are truly floating in space above the viewer.

To create this painting, Pozzo placed grid lines across the surface of his flat preliminary drawing. Next a giant net, enlarged in scale from the same grid, was placed horizontally across the bottom of the vault. Pozzo then ran a set of strings from the fixed point, which was at eye level above the marble disc, through each intersection in the net. He then marked where each string, when held taut, touched the vaulted ceiling. This showed him how to place the original grid onto the curved ceiling, thereby enabling the flat painting to be reproduced onto the curved surface.

Pozzo's painting is an anamorphosis, directly descended from Brunelleschi's small aperture perspective device, Alberti's intersector, and Leonardo's anamorphic pinhole projections. In an anamorphosis, an image is projected and then drawn onto a surface that is angled away from the fixed point; for instance, Pozzo's painted curved vault or the side walls, ceiling, and floor of Van Hoogstraten's peep show box (Figure 2.3b).

Leonardo wrote the following about creating anamorphic projection:

If you want to represent a figure on a wall, the wall being fore-shortened, while the figure is to appear in its proper form, and as standing free from the wall, you must proceed thus: have a thin plate of iron and make a small hole in the center; this hole must be round. Set a light close to it in such a position that it shines through the central hole, then place any object or figure you please so close to the wall that it touches it and draw the outline of the shadow on the wall; then fill in the shade and add the lights; place the person who is to see it so that he looks through that same hole where at first the light was; and you will never be able to persuade yourself that the image is not detached from the wall.

LEONARDO [A. 42b]

Figure 2.10 Leonardo da Vinci, Child's Face and an Eye. Anamorphic drawing in Codex Atlanticus, fol. 35, verso a, circa 1485.

Leonardo's drawing of a child's face is the first known anamorphic drawing (Figure 2.10). Viewed frontally, the child's face is very wide and almost unrecognizable; viewed on edge, the face becomes recognizable. It is best to view Leonardo's drawing by holding one hand over one eye and viewing the drawing from the right edge. In the same drawing is another anamorph—an eye, also to be viewed from the right edge.

The anamorphic pinhole, which da Vinci is credited with discovering, results in two views:

- 1. a distorted view of reality (what a person sees when viewing the anamorph from the normal frontal position);
- 2. an undistorted view of reality (the true picture). This view can be found *only* if you know where the pinhole or small aperture had been situated to make the painting or drawing. Usually, the pinhole was on one side. A number of historic anamorphs are shown in *Perspective*, by Pierre Descargues (Harry N. Abrams, 1977) and *Hidden Images*, by Fred Leeman (Harry N. Abrams, 1976).

Even more deceptive is a painting that looks real from the front but may contain an area within it that is an anamorph. The bestknown example of an anamorph within a realistic painting is *The* Ambassadors by Holbein the Younger (1497?–1543). The anamorph is located in the center foreground. When viewed frontally, the anamorph looks like a diagonal blur; when viewed from the above right it is seen as a skull.

THE FIRST PINHOLE PHOTOGRAPHS

Except for a few peep-show boxes and a limited number of anamorphs, the pinhole technique lay relatively dormant in art from about 1653 to 1850. This was changed by the invention of photography.

Sir David Brewster, the well-known English scientist, was one of the first to make pinhole photographs. In Brewster's 1856 book, *The Stereoscope*, he coined the word *pin-hole*, and it stuck. Other names have been suggested or even urged as a replacement. Some examples follow:

- natural camera, by Joseph Petzval in 1859
- stenopaic photography, by Dehors and Deslandres, in the late 1880s
- again, natural camera, by George Davison in 1889
- lensless, by Alfred Maskell in 1890
- rectographic, by J. B. Thomson in 1901
- needle-hole, by Gray in 1907¹⁰

Yet, as inappropriate as it might seem, since the pinhole is almost always made with a needle or drill, the term *pinhole* has its own particular charm and historical appropriateness.

Here is Brewster's observation as he coined pin-hole:

Pictures thus taken are accurate representations of the object, whether it be lineal, superficial, or solid, as seen from or through the hole; and if we throw sufficient light upon the object, or make the material which receives the image very sensitive, we should require no other camera for giving us photographs of all sizes. The only source of error which we can conceive, is that which may arise from the inflexion of light, but we believe that it would exercise a small influence, if any, and it is only by experiment that its effect can be ascertained.

The Rev. Mr. Egerton and I have obtained photographs of a bust, in the course of ten minutes, with a very faint sun, and through an aperture less than a hundredth of an inch; and I have no doubt that when chemistry has furnished us with a material more sensitive to light, a camera without lenses, and with only a pin-hole, will be the favorite instrument of the photographer. At present, no sitter could preserve his composure and expression during the number of minutes which are required to complete the picture.¹¹

Sir William Crookes (1832–1919), John Spiller, and William de Wiveleslie Abney, all from England, were also some of the first

Figure 2.11a © Flinders Petrie, Khafre Pyramid, pinhole photograph made from a 3-by-4-inch original glass negative, 1881. Courtesy of the Petrie Museum, University College, London.

photographers to try pinhole. Probably the earliest extant group of pinhole photographs were made by the "father of archaeology," the English Flinders Petrie (1853–1942), during his excavations in Egypt (Figures 2.11a, 2.11b). His first pinhole photographs were taken in 1881 at Gizeh during his second expedition to Egypt. Petrie's biscuit tin camera is described by Margaret Drower in her 1985 biography, titled *Flinders Petrie*. She says:

... never having owned or used a camera in his life, he set to work to design one. It was essentially a box of japanned tin about the size and shape of a biscuit tin; the lens had two apertures, drilled in a sheet of tin, and the drop-shutter was also of tin, strengthened by a slip of wood; there was a sleeve of opaque material into which he could insert his hand to remove and replace successive plates, exposed and unexposed plates being separated by a slip of cardboard.¹²

Petrie's pinhole camera is lost. However, from Drower's description and from Petrie's suggestions in *Methods and Aims in Archaeology* (1904), it is possible to reconstruct his camera. It had some sort of simple lens, stopped down with two pinholes, one at f/100 and the other at f/200. If one of these pinholes had been of optimum diameter, then Petrie's camera would have produced true pinhole images while that pinhole was in use.* Petrie was not afraid to take a nonconformist

^{*}Maurice Pirenne, in *Optics, Painting, and Photography* (p. 23), states: "Indeed for a pinhole of the optimum size it is not possible to improve the accuracy of the image by placing a lens in front of the pinhole."

Figure 2.11b © Flinders
Petrie, Waiting
to Begin Work,
pinhole photograph made
from a 3-by-4inch original
glass negative,
circa 1883–84.
Courtesy of the
Egypt Exploration Society,
London.

position in camera technologies; he achieved exactly what he wanted in the most basic, direct way. Petrie wrote:

Small stops can be made out of a strip of tin plate or blackened card; and the hand camera [placed on a tripod] can be stopped down with a pinhole stop stuck in front of the lens so as to work at almost any nearness and scale with exposures of 1/2 or 1 minute in full sunshine.

The instantaneous shutter is a useless article for all fixed objects. It is far better to work with a small stop which gives plenty of depth of focus, and exposed 2 to 20 seconds, which is long enough for f/100 on slow plates in Egypt. For direct enlargement of objects a stop of f/200 is excellent, and only needs 30 seconds exposure. If a shutter is wanted a simple drop can easily be extemporised. 13

In Petrie's *Diary*, dated 20 September 1881, he noted: "finished off camera and trying plates of newspapers as tests of definition. Got a line of 1/1600 inch wide on the plate."

Another pleasantly insightful observation on Petrie's camera and methods comes from M. V. Seton-Williams in *The Road to El-Aguezin*:

He took all his photographs on the site. The objects and pottery were arranged on shelves draped with a black backcloth against the sides

of the hut. Then the stand camera would be set up . . . the exposures could take anything up to half an hour, but the film was, speed 40 H & D, made specially for him by Kodak, that it did not matter if the whole expedition passed between the camera and the objects, as they sometimes did because the camera was set up in the only passageway into the mess room. 14

PINHOLE'S POPULARITY IN EARLY "PICTORIALISM"

By the late 1880s, the Impressionist movement in painting influenced a few of the more daring "art" photographers. For the first time, a sharply focused image was not deemed paramount by some; it was opportune to experiment with pinhole technique. This aroused intellectual antagonism: on one side were those from the "old school," who believed in the sharpest focus and achieved it with highest-quality lenses; on the other side were those from the "new school" who admired atmospheric qualities, otherwise derided as "fuzziness." Later "fuzziness" became known as "pictorialism." And then, there were factions within each group, reflecting differences in opinion as to the extent of sharpness or just how much "fuzziness" was desirable. In England, the most outspoken proponent for "fuzziness" was George Davison. At that time photography was not considered art. In 1889, in the new magazine *Photography*, Davison wrote:

It need hardly be said that nearly all beginners and many old stagers simply go straight for the smallest stop they dare use in order to make sure of getting all sharp. If the object is what we may call scientific, well and good, but if there be anything worthy of artistic representation in the picture selected, such a procedure will certainly tend to lose, suppress, or distract attention from it. Some of those who are fond of chewing the word "fuzziness" say that they quite see all this, and they express approval of many pictures shown them with soft out of focus backgrounds, and also of pinhole landscapes, but still they persist, apparently out of personal partisanship, in taking up a hostile position towards those who venture to call this artistic focus. and who point to the necessity for such treatment in every pictorial subject. Now, in regard to ninety-nine hundredths of the photographs turned out, it does not matter in the main how they are treated in this respect; they would be almost equally feeble however focused, but given a subject with really strong and poetic possibilities in it, sharpness and detail will go a long way to render it commonplace. 15

A month earlier, Davison described his technique:

Our own apparatus is a thin flat piece of brass with a succession of holes of sizes 1/20 in. to 1/80 in., about 1/2 in. apart, countersunk in it. This bar of brass slides across a hole in a special front to the camera, through slots made in a simple telescopic lens tube, which tube serves as a sky shade. . . . It will certainly do most photographers

Figure 2.12 © George Davison, The Onion Field, 1890. Courtesy of John and Elizabeth Fergus-Jean.

good to produce a few pinhole pictures. If they are not warped by prejudice, or blinded by ignorance, they cannot fail to feel the advantage that frequently is gained by such diffusion of focus. ¹⁶

A year later Davison's pinhole photograph *An Old Farmstead* (Figure 2.12) won the highest award at the Annual Exhibition of the Photographic Society of London. (Davison later changed the title to *The Onion Field.*) Davison received praise; the pinhole received criticism:

It is certainly a satire on the labours of the optician that after the resources of science have been exhausted to produce a perfect lens, the best work can be produced with no more elaborate optical instrument than a bit of sheet metal with a hole pierced in it.¹⁷

This award and criticism was the beginning of the schism in the Royal Photographic Society that resulted in the formation of the "Linked Ring"—a group of "art" photographers dedicated to their ideal of pictorialism. George Davison was one of the original twelve founders. International exhibitions of art photography were presented by the group. Later the words "pictorial photography" were substituted for "art photography."

By 1892, photographic enthusiasts in Europe, Japan, and the United States were purchasing a variety of commercial pinhole equipment. In London that year, 4,000 pinhole cameras, known as "Photomnibuses," were sold! (Oddly enough, not one of these cameras can be found in any historic collection.) Several years earlier, an American company invented the "Ready Fotographer" (Figure 2.13)—a camera a century ahead of its time, for it was the first disposable camera—and it was a pinhole camera. It contained one dry, glass plate, a pinhole in tinfoil, and a folding bellows (in fact the entire camera folded flat). The first commercial pinhole camera came from France, designed by

Dehors and Deslandres in 1887 (Figure 2.14). It, too, was unusual, having a rotating pinhole disc with six pinholes (three pairs of similar sizes), used singly or in stereoscopic pairs. Another American company sold the "Glen Pinhole Camera," which included six dry plates (each $2^{1}/_{2}$ inches square), chemicals,

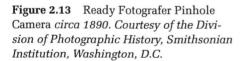

Figure 2.14 Messrs. Dehors and Deslandres' Pinhole Camera and Pinhole Disc from "Photography without a Lens," Anthony's Photographic Bulletin 18(19) (8 October 1887):599–601.

2.13

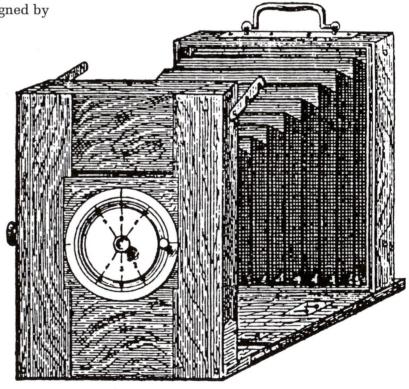

2.14

Figure 2.15 Glen Pinhole Camera from "One Dollar Photographic Outfit," Scientific American 65(4 July 1891):5.

trays, print frame, and ruby paper for a safelight (Figure 2.15). As if this were not enough, several companies sold rotating pinhole discs (Figure 2.16), which could be placed directly into a lens board (after the lens had been removed). All of these pinhole cameras and attachments are extremely rare today. These cameras are remarkably inventive, and it is unfortunate they are no longer available.

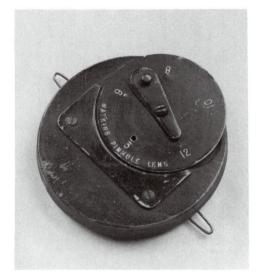

Figure 2.16 Watkins Universal Pinhole Lens circa 1905. Courtesy of Allen Sipprell.

AUGUST STRINDBERG

In 1892, the renowned Swedish dramatist August Strindberg (1849–1912) began experimenting with pinhole cameras. In his study of science and art, Strindberg became the creator of his own exotic branch of metaphysics. He distrusted lenses. Unfortunately, his pinhole psychological portraits from this period are lost. Strindberg's search within the photographic form had many nonconventional approaches, one of which was to create images without a camera. For instance, Strindberg's "Celestiographs" were made by holding photographic paper in his hand pointed toward the galaxy or planet he was photographing. His manuscripts at the Royal Library in Stockholm give evidence that he often completed fifteen pages of mathematical calculations to arrive at how and when to aim the photographic paper.

Photo historians are still at a loss as to how to place Strindberg in the history of photography. Although his work spanned forty years, only around 100 images exist today. Of these images, just three might be pinhole; two are in his *Occult Diary*, and the other is his photographic verification of Fraunhoefer diffraction. An additional two images were published in Frieda Uhl's book on Strindberg and are listed as being "made with a camera without a lens." Yet, in spite of the dearth of surviving images, we are fortunate indeed, for preserved in some of his writings are explanations and investigations, although written with his cryptic, searching humor. Translated by Jan-Erik Lundström, a contemporary European photo critic, is this excerpt from Strindberg's "On the Action of Light in Photography—Reflection on the Occasion of the X-Rays":

But: First speculate, then experiment! And I speculated as follows: Coming from the next room, the sound from an instrument touches my ear more forcefully if the door is open, than if it is closed. Analogy: The light ought to work more directly in the camera, if it doesn't have to pass through a solid medium, such as glass.

This was true and false at the same time; because sound is more easily transmitted in solid bodies than in the air. And yet, when I open the door, I can hear better!

And I do see clearer through glass lenses than through air!—Here I stopped, amazed at the changeability of the unchangeable laws of nature, their capriciousness, their self-contradictions, and their looseness. But I then continued. Took away the lens from the camera, and inserted a diaphragm, drilled through with a sewing needle. I photographed a person, and received a result which in all aspects was more successful than in photographing with a good lens.

Against all rules, I had placed the man against a window—behind which was a landscape with fir trees in the foreground, and lakes and forests in the background.

The man appeared in clear detail; and so did the trees, in perspective all the way out to the distance.

Test with a lens and the same pose. The man now appeared flat, no detail, and of the trees not a trace—the whole landscape only a bright white background.

But my diaphragm gave me yet another advantage. The man's coat was white with blue stripes. These blue stripes should normally turn out white, but here they remained greyish, outlining themselves against the white coat. And this fact, that blue retained its value, became for me the starting point for further experiments with colour photo-graphy.

My speculation was correct when I took away the glass-lens, and allowed the light to work directly without passing through a medium. 19

Elaborating on Strindberg's ideas about pinhole photography, Jan-Erik Lundström writes:

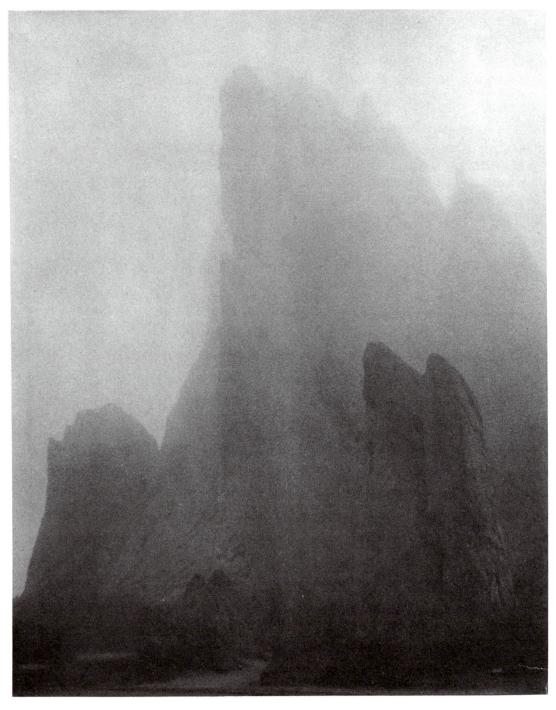

Figure 2.17 Laura Gilpin, Ghost Rock, Garden of the Gods, 1919, $8" \times 10"$ platinum print, P1979.95.66, © Amon Carter Museum, Laura Gilpin Collection, Fort Worth, Texas. Used by permission.

Human vision is an artifact. Just like our understanding of nature is nothing but models that we construct, which are more or less feasible in our dealings with the world. And as a consequence the realism of the camera or photography cannot be easily trusted.

These are of course ideas that have many reverberations in contemporary cultural discourse—that realism is relative, that language constructs a world rather than reflecting one—in the heydays of deconstructivism, and a post-modernism that has given up the possibility of a sensory world, a world of direct physical experience. Strindberg's turn to pinhole photography might then be viewed as a counterpoint—a search for an *unmediated* world, an absolute realism.

Such was also his mode of photography—seldom expressionist or window-on-the-world realism, but rather conceptual, analytical, symbolic, metaphysical. The camera was an instrument with many ends. Photography a medium with endless applications.²⁰

PINHOLE'S DEMISE IN THE EARLY TWENTIETH CENTURY

By the twentieth century, pinhole technique was pigeonholed and labeled "impressionistic." The technique could find only limited usage by "pictorialists"—those photographers who put a great deal of atmospheric effect into their art (Figure 2.17). "New realism," mass-produced photographic equipment, and the cataclysmic need for speed left pinhole technique far, far behind. By the 1930s, the technique was barely remembered. At best, in the photographic art world, it became merely a teaching tool. Frederick Brehm, in the late 1930s, was possibly the first college professor to stress the educational side of pinhole technique at the college that would later become Rochester Institute of Technology. Brehm also designed Kodak's only commercial pinhole camera—the Kodak Pinhole Camera (circa 1940s). This kit offered the first build-it-yourself commercial pinhole camera (Figure 2.18).

During the decades between 1940 and 1960, the pinhole was rarely used. Pinhole technique was practically forgotten in art. The few articles published about it trivialized the medium. A new awareness was needed.

Figure 2.18 Two details from Frederick Brehm's Instructions for Building Kodak's Pinhole Camera circa 1940. Gift of Richard Zakia, from the collection at Pinhole Resource.

NOTES

- Filarete (1400–1469), in Eugenio Battista, Brunelleschi (New York: Rizzoli International, 1981), 110.
- 2. Ibid., 102-13.
- 3. Fred Leeman, Hidden Images (New York: Harry N. Abrams, 1976), 21-22.
- James Waterhouse, "Camera Obscura," in Encyclopædia Brittanica (1910), 102.
- 5. Leon Battista Alberti, On Painting and on Sculpture (1435; reprint, edited by Cecil Grayson, London: Phaidon Press, 1972), 69.
- 6. Eugenio Battista, Brunelleschi, 110.
- 7. Leonardo da Vinci, The Notebooks of Leonardo da Vinci, ed. Jean Paul Richter (New York: Dover Publications, 1970). Leonardo's contributions to pinhole optics are in the following: D. 8a; A. 64b; Br. M. 174b; W. 19152a and b; D. 5r; A. 9b; C. A. 190a; A. 9b; W. 19150b; A. 42b; C. A. 135b; W. 19149a; B. N. 2038. 20b; Triv. 6b; F. 5a; C. 6a; Leic. 1a; C. 7a (9b); W. 19148b; C. A. 204b.
- 8. William Martin Conway, *The Writings of Albrecht Dürer* (New York: Philosophical Library, 1958), 208.
- 9. Ibid., 208.
- Stanley R. Page, "The Golden Age of Pinhole Photography 1885–1919," Pinhole Journal 2(2):29. A complete description of pinhole photography in the 1890s.
- 11. Sir David Brewster, *The Stereoscope: Its History, Theory, and Construction* (London: J. Murray, 1856), 136–37.
- 12. Margaret Drower, Flinders Petrie (London: Victor Gollanca Ltd., 1985), 48.
- Flinders Petrie, Methods and Aims in Archeology (New York: Macmillan, 1904), 74–75.
- M. V. Seton-Williams, The Road to El-Aguezin (London: Kegan Paul Int., 1988), 3.
- George Davison, "Softness in Photographs and Means of Obtaining It," Photography 1(12 December 1889):684

 –86.
- George Davison, "Softness in Photographs," Photography 1(14 November 1889):634–35.
- 17. "Exhibition of the Photographic Society," *Times* (London), 29 September 1890, p. 4.
- 18. Stanley R. Page, "The Golden Age of Pinhole Photography 1885–1919," *Pinhole Journal* 2(2):21–25.
- August Strindberg, "On the Action of Light in Photography—Reflection on the Occasion of the X-rays," trans. Jan-Erik Lundström, *Pinhole Journal* 4(1):19. The entire article was written circa 1894 and appeared in Strindberg's *Collected Works*, Vol. 26, ed. John Landquist (Stockholm: Bonniers, 1912–1920).
- 20. Jan-Erik Lundström, "Notes on 'On the Action of Light in Photography . . . '," *Pinhole Journal* 4(1):21.

Pinhole's Revival in Art: The 1960s and 1970s

REBIRTH

In the mid- to late-1960s, a number of artists whose training was not necessarily photographic chose to explore pinhole photography. None of them were aware others were working in the pinhole technique. Chronologically, who was first does not seem important. What sets all these people apart is that they chose to experiment in pinhole photography without instruction from others: Paolo Gioli in Italy; Gottfried Jäger in West Germany; and David Lebe, Franco Salmoiraghi, Wiley Sanderson, and the author of this book in the United States.

Why were these artists working in pinhole, if pinhole photography had practically died a decade or two before? Because there was a changing reality in the air in the late 1960s, prompting the investigation of alternatives. Something as accepted universally as the sharpness produced by a lens camera needed to be reexamined. The obvious alternative camera was pinhole.

Some of the concerns, fascinations, and needs of the artists just mentioned are clarified in the following statements, both personal and theoretical.

Paolo Gioli wrote:

There is in the history of writing, of graphics, a mark that continues to fascinate me: the dot. It's always amazing to see a dot made by a pencil and then the dot immediately become a pinhole. The eye of a needle is probably the most provocative design in the history of art.

Figure 3.1 © Paolo Gioli, La Mia Finestra. A $3^{1}/_{2}$ " x 5" pinhole photograph, 1969. From the collection of the photographer.

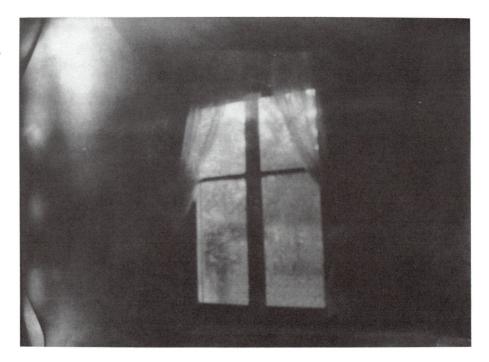

Most of my work goes through the eye of a needle, basically with a great variety of *camera obscuras*, not a 35mm camera. I have taken the stenopeic slit as an ideological as well as a plastic "point of view." The photostenopeic image came to me because I didn't have a camera. I am fascinated by the purity of the action of shooting "poor" and the equally pure image that one gets back [Figure 3.1]. Mine is not a brief scholastic experiment, but a definite way of understanding space specifically through a point in space which, as we know, penetrated into caves with alarming rays, or, reflected on the walls perturbing the first Arab thinkers . . . and my sensitized papers. ¹

Gottfried Jäger, in the beginning of his article "Pinhole Structures" (1988), proclaims what the late 1960s meant:

Toward the end of the 60s there was a pervading sense of change in the Federal Republic of Germany. The years of recovery after the Second World War had seen a general settling of the economy; however, important social reforms, for example in the field of education, had not materialized. The student movement at West German universities around 1968 and the subsequent change in the political climate at the beginning of the 70s are an expression of this turbulent period. In addition, there were the first signs of a new technological era, ushered in by the new media and the computerization of society, a development that became very apparent not only in the field of technology, but also in intellectual areas such as schools and universities, in art and in culture. Many of my age group regarded this, despite the problems connected with this development, as an indication of a better world, because of an improved flow of information. They expected a more communicative and therefore better world.

Jäger continues, giving insight on his idea of democracy in art:

In 1968 I organized the exhibition "Generative Photography" in Bielefeld. It was a direct response to the prevalent trends in West German photography at that time. On the one hand it was a reaction to "Subjective Photography," dating back to the 50s and 60s and now on its last legs. The latter had been increasingly reduced to a formal level and had shown lack of innovation. It was also a reaction to the ideas championed by Karl Pawek, the German philosopher, and propagating "Total Photography," a metaphysically legitimated photo-realism on a journalistic basis which disclaimed any semblance of art in photographs right from the start. Both tendencies aimed in their own particular way at expression and effect and at a magically captivating picture. In contrast, generative photography [Figures 3.2a, 3.2b] aimed at clarity and transparence. It did not want to convey anything magical or mysterious in its pictures. On the contrary, it aimed at enlightenment and rationality. Using a methodical, step-by-step procedure and being completely open about its method, it endeavored to avoid the enigmatic in art; instead, it attempted to make inherent ideas and forms understandable to everybody at all times. The sequenced composition, based on a programme previously defined, was here one of its essential means.

It aimed in its own way for objectivity and lucidity. It wanted to reveal the basic elements of photography accountable to an increasingly critical public that wanted to be involved in the composition of a work of art, and should be, too. Nothing was to remain obscure. An elementary abstract, systematic, constructive, indeed "democratic" picture language was the result. Form had no "top" or "bottom"; there was no hierarchy amongst the pictures. They were all taken together, of the same significance, and importance as the others.

"Generative photography" thus presented itself as the continuation of the trend begun in the 20s, i. e. Constructivism and Elementarism, as defined by Theo van Doesburg, Moholy-Nagy and others. "Elementarism is an intellectual rebel, a trouble-maker, deliberately disrupting the tranquility of bourgeois life with its regularity and repetition at the cost of its own peace and quiet."

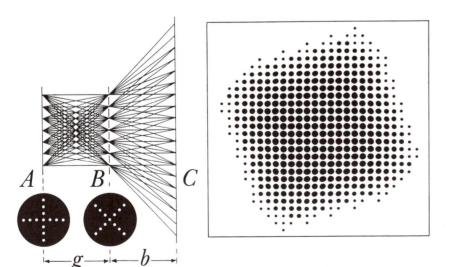

Figure 3.2a © Gottfried Jäger, Apparatus system of Pinhole Structures. Multiple pinhole camera combined with light pattern subject. A: Light pattern subject, variable. B: Multiple pinhole, variable. g: Distance A-B, variable. b: Distance B-C, variable. C: Pinhole Structure, result. Collection of the photographer.

Figure 3.2b © Gottfried Jäger with Pinhole Structure. Light graphic work, 3.8.14, modification F2.6, gelatin silver print on canvas, 118 x 110cm, 1967. Photo: Ursel Jäger, circa 1968. Collection of the photographer.

David Lebe, Franco Salmoiraghi, and Wiley Sanderson speak of "time" and "reality" in changing the photographic medium.

David Lebe:

Reality moves so fast that everything is either an expectation or a memory. . . . We experience many fragmented and concurrent images and perceptions which flow together instantly, creating a picture [Color Plate 3.3] and a feeling of a scene. It is this flow of images and this sense of time that I want in my work.³

Franco Salmoiraghi:

Photography has long been associated with the recording of fact and the representation to the viewer of something which he feels is real. Many photographers today are making an attempt [Color Plate 3.4] to break with this traditional concept.⁴

Wiley Sanderson:

The incisive photograph [Figure 3.5] can assemble visual fragments of time, independent of the memory/sight combine. History can be now and the Universe can be here, photographically. By appreciating the limitations of visual logic and exploiting the camera to reveal facets of non-human vision, a multitude of recordable accuracies will be demonstrated. The egocentricity of constructing a camera to coincide with the limitations of human vision needs questioning. Moreover, the vast range of visual relationships between parts within a photograph far exceed man's notation by sight.⁵

Sanderson, professor of photography at the University of Georgia, taught pinhole photography from 1953–1988. During that time, his students built 4,356 pinhole cameras.

Figure 3.5 © Wiley Sanderson, Prow Menace in Venice. A 3" \times 9 $\frac{1}{2}$ " pinhole photograph, 1972. Collection of the photographer.

For myself, much is a paradox and a puzzle. Just how did I end up with pinhole photography as my life's work? The following comes from an interview made in 1987:

In 1960, when I was in design school, I had to make a pinhole camera which was a standard kind of design school project. The professor didn't know anything about pinhole; he didn't know anything about photography—but he did have inspiring projects! We had to buy a piece of film from him for a quarter. We got only that one piece and he told everybody to load it in their cameras and to take them outside to expose for a designated length of time. I was the only person who didn't take my camera outside; I exposed through a window. Everybody else's was over-exposed and black-mine was the only one that worked! I didn't think anything more about pinhole photography for eight years. After graduate school, I realized I was no longer interested in design. Curiously enough, just before getting out of graduate school, I applied for a Fulbright to do camera design with Hasselblad in Sweden. Of course I didn't get it—it was kind of idiotic I applied for that kind of grant. Two days after graduating, I started to teach for the State University of New York. John Wood, who became a good friend of mine, was teaching photography there. That may have had some influence on my beginning photography. One day in 1968, I was walking down the street, and I said to myself, or something said to me: "Why don't you make a camera that takes a whole environment into view?" I was sort of disgusted with what I had seen in photography—a single image that didn't say enough to me somehow. I remembered I knew something about pinhole photography. After about two months, I made a camera [Figure 3.6a] that used six pinholes to make a 360 degree image [Figure 3.6b, 3.6c]. . . .

After about 6 years the people at *Afterimage* published an article about my work. After that, I didn't have to knock on doors. . . . I loved pinhole photography—it was like I had found a way to get

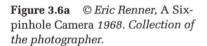

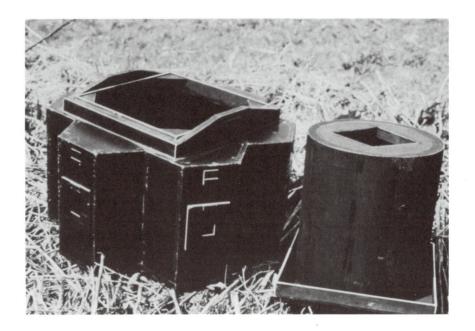

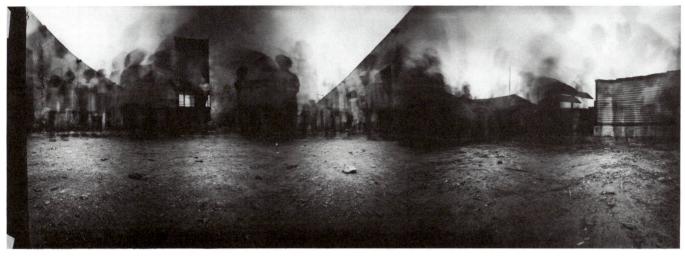

3.6b

3.6c

inside myself—express what was inside of me. I've always depended upon artwork in lots of ways and had real feelings about people and this planet—the things that are on it—the sun, the moon, the clouds, the love. I've always wanted some way to sense these things; the way that seemed appropriate was pinhole photography.⁶

All of the artists mentioned in this section were working in a nonconventional manner within the photographic medium; none of us cared to preserve the status quo. Coincidentally, most of us were working with multiple pinhole images, with obvious physical and structural similarities.

Two scientists were also working with pinhole photography, for the dual purpose of art and science: Kenneth A. Connors in the United States, and the late Maurice Pirenne in England. Connors researched pinhole definition and resolution; his findings were printed in his

Figure 3.6b © Eric Renner, Ticul
Schoolyard 9" x 25"; a five-pinhole
photograph, 1969. (This, my favorite
pinhole photograph from the Ticul,
Yucatan series, actually is only five
overlapping pinhole images because
the negative was accidentally chopped
short in the darkroom prior to developing.) Collection of the photographer.

Figure 3.6c © Eric Renner, Fishing, Lake Erie 9" x 29"; a six-pinhole photograph, 1974. Collection of the photographer.

Figure 3.7a Maurice Pirenne, Luminous Points of Light Sending Divergent Rays. From Optics, Painting, and Photography. Courtesy of Cambridge University Press, London, 1970.

Figure 3.7b Maurice Pirenne, Pinhole Camera Selecting Certain Cones of Rays. From Optics, Painting, and Photography. Courtesy of Cambridge University Press, London, 1970.

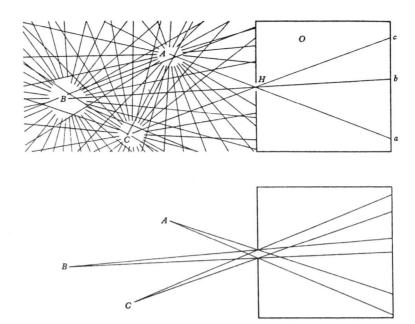

self-published periodical *Interest*. Pirenne used pinhole optics to study perspective in his remarkable book *Optics, Painting and Photography* (Cambridge University Press, 1970).

Pirenne was a physiologist and optical scientist who wrote widely. He had spent a lifetime studying the history of art, particularly the use of perspective. For decades he explored the complexities of viewing two-dimensional paintings using both eyes (as in ordinary binocular vision), and with one eye (as in the fixed point required for Renaissance one-point perspective). He wanted an overview—one that explained how people have viewed two-dimensional paintings over past centuries. *Optics, Painting, and Photography* is Pirenne's synthesis. Within it are twenty-two pinhole photographs; most are couplets, each with a slightly shifted perspective. Pirenne prefaces his work by stating:

In a sense, the present work constitutes a commentary on Leonardo. Instead of merely relying on texts, however, it deals on an experimental basis with problems which confronted Leonardo. Some of the experiments were specifically made for the present purpose. The book also deals with relevant aspects of the history of optics, from Euclid to Einstein.⁷

Pirenne also explains the pinhole camera:

Whereas each luminous point sends divergent rays into its surroundings [Figure 3.7a], the pinhole camera does select certain cones of rays [Figure 3.7b] from among all the rays which fill the whole of space, so that the main rays of these cones do now converge toward

the centre of the pinhole. These main rays are shown in [Figure 3.7a] as the lines AH, BH and CH.

The fact that image-forming systems so select certain cones of rays in each of which the rays diverge from its object point, while the cones themselves all converge towards the image-forming system, is the crux of the matter with regard to the formation of "real" optical images.

The situation is essentially the same for the eye—except that inside the eye, as well as inside the lens camera, the rays of each cone are made to converge, whereas inside the pinhole camera they remain divergent. Outside the eye, the narrow divergent cones of rays coming from the different object points all converge towards the pupil. The main rays of all these individual cones thus form a visual pyramid or a pyramid of sight which geometrically diverges from the eye, even though physically the light goes towards the eye.⁸

Pirenne's "visual pyramid" in this quote refers to the pinhole perspective devices of Brunelleschi and Alberti, placed into a twentieth-century context. Pirenne's book, a must for anyone whose mind can intermingle perspective, optics, photography, and painting, covers an extremely complicated subject. In his own unpretentious way, Pirenne has resolved some of the intricate visual conceptualizations da Vinci questioned.

Like Pirenne, Kenneth A. Connors, professor of pharmacy at the University of Wisconsin, confronted the Brunelleschi/Alberti "visual pyramid" (a section of which is a photograph) and also adjusted it for a twentieth-century optics context. Connors stated:

The pinhole is a "phase-selector," a recombination element that selects only waves that are (very nearly) in phase. In order to do so, of course, it must reject most of the light, so that image intensity is very low. The process of optimizing pinhole diameter for a given focal length consists of applying a criterion that specifies the range of phase differences that is acceptable in the admitted wave-front.⁹

Toward the end of the 1960s, Nathan Lyons, Curator of Contemporary Photography at the George Eastman House, confronted traditionalists in photography by espousing the idea that photography in a larger sense could encompass nonconventional imagery and processes. He believed the entire field would gain a greater depth if the boundaries were broken and promoted his views internationally through publication of books showing a wide variety of images and ideas, including pinhole photography. In 1971 Time-Life Books published *The Art of Photography* in its widely distributed Life Library of Photography series and included one of my panoramic pinhole images, which was far from conventional.

In 1975 Phil Simkin created a project with the Philadelphia Museum of Art in which fifteen thousand hand-assembled preloaded pinhole cameras were stacked in the entry way and an adjacent room

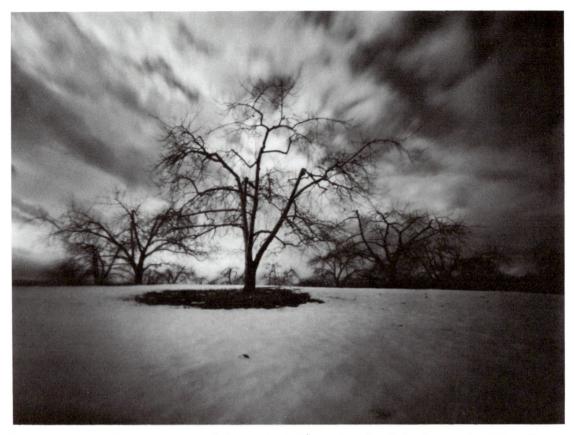

Figure 3.8 © Jim Haberman, Trees and Clouds. A 4" \times 5 $^{1}/_{2}$ " Polaroid pinhole photograph, 1975. Collection of the photographer.

in the art museum. Simkin organized this as a "Displacement Project"—people would come into the museum and take (displace) a camera out of the huge stack of cameras, then make an exposure. A public darkroom was built in the museum, where, with the help of museum assistants, photographers would develop and print their images. During the month-long duration of this project, images were continuously exhibited. Each camera was made from die-cut paper and a taped-in brass shim with a pinhole; $3" \times 10"$ Ilford photo paper was used as a negative. The entire project received much publicity when *Popular Photography* published the article "Pinholes for the People" in June 1975.

In the 1970s, pinhole photography became increasingly popular, although multiple pinhole cameras, often designed by pinhole photographers in the late 1960s, were seldom explored. Generally, in the 1970s, pinhole photographers chose to work with alternative printing processes, standard light-sensitive materials, and single-pinhole cameras. Their combined efforts produced pinhole imagery in almost every old or new process, such as cyanotype, gum bichromate, serigraph (Color Plate 3.9), platinum, dye transfer, Polaroid, Xerox, video,

and 8mm film (Figure 3.10). Pinhole was an ideal starting point for any photographic printing process requiring a large negative. A camera accommodating a large negative could be made from any type of box, can, or suitcase. Photographers needed only to coat their light-sensitive paper with platinum, gum, or cyanotype and contact-print their negative. Pinhole photography was gaining momentum, offering proof that this was the height of the back-to-basics era.

By the mid-1970s, Jim Shull's *The Hole Thing: A Manual of Pinhole Photography* (Morgan and Morgan, 1975) was published, as were many widely read articles, such as "The Alternative Optic" by Wiley Sanderson in *Photographic Journal* (June 1975), wherein he proposed that the pinhole camera be the primary type of camera used in a college photography curriculum; "I Really Should Be Interviewing You" by Charles Hagen and Charles Kelly in *Afterimage* (December 1974), describing my pinhole photography; and "Are Pinholes a Threat to the Glass-Based Camera-Lens Industry?" by Bob Schwalberg, senior editor, in *Popular Photography* (October 1976). Stan Page of Utah became pinhole's primary historian, collecting 450 articles on pinhole photography published after 1850, a monumental project that took over five years to complete.

Even though a number of artists were seriously involved in making pinhole imagery, photographic critics in the United States did not know of this contribution toward a broader photographic awareness, and at best pinhole photography was still trivialized as a primitive approach. However, in Europe, Paolo Gioli and Dominique Stroobant received much wider attention and consideration.

Valuable statements were written by the artists about their work. Jim Haberman of Massachusetts said:

My approach to photography is to explore new territory, to show people photographs they have never seen. I do this by listening to my curiosity and trying to follow the clues it suggests. I became interested in pinhole cameras because they seemed magical, and I knew nothing about them. The first model I made was crude, but I was stimulated by the process. After some experimenting I built the wide-angle 4-by-5-inch pinhole camera I used for this work [Figure 3.8]. My pinhole photographs are basically of people in solitude. There is a quality to the images that is suggestive of a dream. I have tried to create in them a spirit of timelessness. ¹⁰

Martha Madigan, of Philadelphia, said of her work:

Through each photograph the pinhole camera provides the magic of a small surprise. My interest in working with this "primitive" photographic system is sustained because the long exposures not only transcend the obvious limitations of a fraction of a second, but they also playfully celebrate the PRESENT. Time is at once defined and defied. Not only is each photograph a record of fact, it is also an expression of pure energy. Photographing people with a pinhole camera is a great

Figure 3.10 © Paolo Gioli, Composite of Super 8 Pinhole Portraits, 1975. From the collection of the photographer.

privilege and honor. The several-minute exposure [Figure 3.11] represents an energy exchange, which is often a deeper revelation or portrait than the quick glimpse might be.¹¹

Dominique Stroobant, of Belgian descent, who lives in the marble-quarrying and sculpture-producing center of Miseglia de Carrara in Italy, also spoke philosophically:

I got trapped by pinhole photography, once I discovered how obvious and pleasant it was to realize everything from the start. My tools could not be ready-made. Why try to conceive of anything more sophisticated than the cameras presently in use: there is more enjoyment to go the other way. Since Niépce in photography nothing else has been done but reduce space and time to smaller fragments at each step. . . . Once I showed people what I could realize with these clumsy, heavy, but still hand-some devices of mine, they thought it was sorcery. However, I believe, all they are accustomed to use is real sorcery! Just try to dismantle any camera of today. We live in an age where many peasants do not even know how to grow a salad, or anything else, with-

out very specific chemicals. There is no trick to what is shown here. I see it as my duty, however, (or rather my pleasure) to dissolve the boundaries of consciousness [Figures 3.12a, 3.12b], wherever people think they should be fixed. The first photographers did what real painters did and are still doing: they tried to fix not just what they saw, but in order that they could see it. Since one sees only what one thinks one sees, there is no way of seeing things the way they are. Not only do we see 99% with our memory but even whatever we use to visualize what we see or feel, is almost entirely programmed by some preconceived idea of what we should see. One can also build devices to visualize things one cannot see, which one can only imagine in an indirect way. It took me time to see-not just understand as an abstraction—how the sun affects us. Most people understand things by rationalization, through spatial geometry for example, but they still do not "see." . . . Many things are not obvious. Most ready-made images give us a fragmented view of things. This fits easily into the field our eyes can embrace at once. Perhaps part of Alberti's perspective system, and many existing prejudices about what is a deformed or non-deformed image in photography, are due to accepting as a norm the limitations encountered in human optical perception.¹²

Figure 3.11 © Martha Madigan, Student Portraits Series. A 20" x 16" pinhole photograph, 1978. From the collection of the photographer.

Figure 3.12a © Dominique Stroobant, January 8, 1978. One-day exposure, 7" x 9" pinhole photograph from camera H2-R. From the collection of the photographer.

Ruth Thorne-Thomsen, of Chicago, wrote:

The photographs in "Expeditions" are what I call "environmental collages," consisting of small props and photographic cut-outs . . . assembled in the environment, and photographed with a pinhole camera and paper negatives [Figure 3.13]. I attempt to create photographically convincing realms. 13

Nobuo Yamanaka from Japan, who died in 1982 when he was 34, started making pinhole *camera obscuras* in the early 1970s (Figure 3.14). Of his work Janet Koplos, art critic for the *Asahi Evening News*, wrote:

His next "movie" *Pinhole Camera* (1972) was a decisive change that introduced the approach he pursued for the remainder of his life: Yamanaka made his first *camera obscura*. He is best known for using entire rooms as *camera obscuras*—photographing scenes outside his

home and catching his presence inside the camera at the same time. He recorded the view from a ninth-floor apartment as the image fell on the back and side walls, and on the floor and ceiling. He held two-part exhibitions in which the exposure process went on for several days, and the results were shown precisely where they had been made. Not surprisingly, Yamanaka also worked with a pinhole camera (a 35mm camera with a copper plate over the lens opening), thus taking his *camera obscura* on the road. He made a series of color prints taking the sun as his theme—a new expression of his fascina-

His last several works made his photographs into objects: the image was fractured into fragmentary planes and wrapped around the interior of one or more black-painted wooden boxes. Though the box was supposedly just a more convenient way to send his work to the Paris Biennial, he was actually recapitulating both the camera-room and the camera-device in a literal and symbolic black box. 14

tion with light.

Figure 3.12b © Dominique Stroobant, June 28, 1978. One-day exposure, 7" x 9" pinhole photograph from camera H2-R. From the collection of the photographer.

Some pinhole photographers felt no need to explain their work. This was best stated by Clarissa Carnell of Pennsylvania in her cryptic, yet wonder-filled, statement:

There is a song that gets stuck in my mind that goes, "You think we're diving for gold; we know we're diving for pearls. . . ." No matter what you are up to, someone will always think you are up to something else. So, all I'll tell you is I'm having fun. What is the point of using a pinhole camera if it's not fun. Otherwise, it is too confusing. 15

The following statement by Dale Quarterman of Virginia epitomizes the reason most people become involved in pinhole photography:

The pinhole camera is so simple and direct in its creation of a photograph that it allows the artist to shed the technical trappings of modern photographic equipment and concentrate on the development of very personal imagery. . . . Pinhole cameras are all about freedom.

Figure 3.13 © Ruth Thorne-Thomsen, Head and Plane, Chicago. A $4^{1}/_{2}$ " x $5^{3}/_{4}$ " pinhole photograph from Expeditions, 1979. From the collection at Pinhole Resource.

Figure 3.14 © Nobuo Yamanaka, Pinhole Room, 1973. From the collection of the estate of the photographer.

The freedom to create a unique vision of the world, by going back to the basics of photography in order to have the total control of this magical and enjoyable act of painting with light.¹⁶

Even though pinhole photography and the making of pinhole cameras as an art form gained popularity during the 1970s, very few pinhole photographers knew of the others' photographs. This lack of communication resulting from geographic isolation provided a diversity of approaches to pinhole imagery and cameras.

NOTES

- Paolo Gioli, "Photographs/Cameras," Pinhole Journal 2(2):16–17. Two books are available on Paolo Gioli's pinhole photographs. They are Paolo Gioli Obscura, la natura riflessa (Milano: Electa, 1991) and Paolo Gioli Gran Positivo nel crudele spazio stenopeico (Firenze: Alinari, 1991).
- 2. Gottfried Jäger, "Pinhole Structures," Pinhole Journal 5(2):22-23.
- 3. David Lebe, "Artist's Statements," in *The Visionary Pinhole*, ed. Lauren Smith (Layton, Utah: Peregrine Smith Books, 1985), 76.
- 4. Franco Salmoiraghi, "An Exploration of the Inherent Qualities of the Pinhole Camera," (graduate M.F.A. thesis, Ohio University, 1968), 49.

- 5. Wiley Sanderson, "Artist's Statement," in *The Pinhole Image—Eleven Photographers*, catalogue (Richmond, Va.: Institute of Contemporary Art of the Virginia Museum, 1982), 14. Organized by Willie Anne Wright, this was the first group exhibit of pinhole photographers working throughout the United States.
- 6. Eric Renner, "Interview," Pinhole Journal 3(3):25-26.
- 7. Maurice Pirenne, *Optics, Painting, and Photography* (London: Cambridge University Press, 1970), xxi.
- 8. Ibid., 17.
- 9. Kenneth A. Connors, "Resolution and Definition in Pinhole Photography," *Pinhole Journal* 2(1):10.
- 10. Jim Haberman, "Artist's Statement," in *The Pinhole Image—Eleven Photographers*, 6.
- 11. Ibid., 9.
- 12. Dominique Stroobant, "Solar Recorders," Pinhole Journal 4(2): 18–19.
- 13. Ruth Thorne-Thomsen, "Artist's Statement," in *The Pinhole Image—Eleven Photographers*, 15. For a complete discussion of Ruth Thorne-Thomsen's pinhole photographs, see *Within This Garden* (New York: Aperture, 1993).
- 14. Janet Koplos, "Made in Japan," Afterimage 16(2):20.
- 15. Clarissa Carnell, "Artists' Statements," in The Visionary Pinhole, 40.
- 16. Dale Quarterman, "Artist's Statement," in *The Pinhole Image—Eleven Photographers*, 12.

I have been photographing out here [the American West] for eleven years and I have found that I could go back to all the same places I had worked before with a pinhole. It was as if I was photographing in a completely different world. It seems almost as if the pinhole camera takes you beneath the surface of reality as we know it into another dimension, another place. . . . The whole convergence of light to the center was a fascinating concept to me and the whole idea of a passageway going to a different place, a different reality—it all seems to have mystical overtones for me. I'm not really sure where I'm going with it. It was really good for me to leave the whole idea of the control that I was exerting over my photography through the 8" x 10." I felt in some cases I got tired of that control, I wanted to let go of some of it. I found that pinhole photography has freed me to a great degree. Whether I stay with pinhole or go back to lenses some day, pinhole has forever altered the way I see the world.

Douglas Frank interview Pinhole Journal, 1991

I wondered if I could do pinhole images, but I was always afraid of doing them because I was such a control oriented person. But then I did my first shot of my friend who was going through a very difficult divorce, who was trying to be more of a person than her husband. In my very first shot, I had her wrists tied. She came off looking like half man, half woman—I couldn't even read the negative. I thought I really couldn't understand this at all. And I made the print and I thought oh my God, pinhole photography captured so much more than I was able to see with my naked eye.

DAVID PLAKKE INTERVIEW Pinhole Journal, 1990

Pinhole's Revival in Art: The 1980s

THE PETER PAN PRINCIPLE, OR "I CAN FLY"

Pinhole photography can be the art of surprise, like looking at the world through a child's eyes. It is a continual wonder, and surely magical, that time after time pinhole cameras can make an intriguing image. This curious attribute is the pinhole camera's greatest gift to its user. I truly appreciate that something as easy to make as a pinhole camera performs such a seemingly complex task as producing an image. Here, within mere minutes is a camera and in a few more minutes an image! Some people have tried to make pinhole photography complicated, but it is not, and it should not be. Knowing f/stops and exact pinhole diameters, making view finders and using light meters are not necessary considerations. A pinhole camera's inherent simplicity is the basis of its character. The excitement of making and using something so simple appeals to a childlike innocence within all of us.

Those who have retained this innocence are in accord with pinhole photography (Color Plate 4.1). It has taken me twenty-six years of thinking about what a pinhole camera really is to arrive at this explanation. This very "innocence" has often been overlooked by photo historians, photo critics, and other writers who have attempted to define the "why" of pinhole photography.

Lauren Smith's *The Visionary Pinhole*, published in 1985 by Peregrine Smith Books, documented for the first time that there were many serious artists making pinhole photographs.

PINHOLE PHOTOGRAPHERS, THEIR CAMERAS, AND IMAGES

A pinhole camera consists of four parts (more or less): the aperture, the camera body, the light-sensitive material placed inside the camera, and the shutter. The artist can vary each part enormously according to artistic need. The completed pinhole camera and image undoubtedly reflect their maker's thought processes.

For example, in a darkroom, Thomas Bachler of West Germany placed short, cut pieces of 35mm film in his mouth. He then left the darkroom and stood in the light in front of a mirror. Opening his lips to resemble a pinhole for an instant, he formed a self-image on the film. In this process, his lips acted not only as the aperture, but also as the shutter. Returning to the darkroom, he took the film out of his mouth, which had been the camera body, and reloaded. The entire process was recreated at least sixty-three times and the images later contact-printed onto one sheet of black-and-white paper (Figure 4.2). The completed piece was physiologically entitled *The third eye, pinhole photographs made with the mouth, using lips as an aperture, film in mouth, standing in front of a mirror, all self portraits*.

In a shifted new reality, Bachler physically became the "camera" when he placed unexposed film inside himself! Exposing the film, he imaged his "camera-self" in the mirror, thus becoming the "photograph" too, in much the same manner of Narcissus who saw his mirrored image reflected on the surface of the pool, as mentioned by Alberti in the quotation at the beginning of Chapter 2. Through this purposeful redefinition of photography, Bachler makes the camera, image, and himself "one." The "third eye" in his title makes reference to this oneness. The nonconventionality of this type of artistic endeavor is typical of pinhole photography.

A similar idea of "oneness" exists in my plaster face cameras. My first plaster face camera was made in 1985 by the usual process of having someone pour plaster over my face which had been covered with Vaseline. After removal of the dried plaster, this casting became a mold for the face camera. In this first plaster face camera, the pinhole was in my right eye only, making reference to visual things I have seen from within, occurring in that eye. For many years, I have seen what

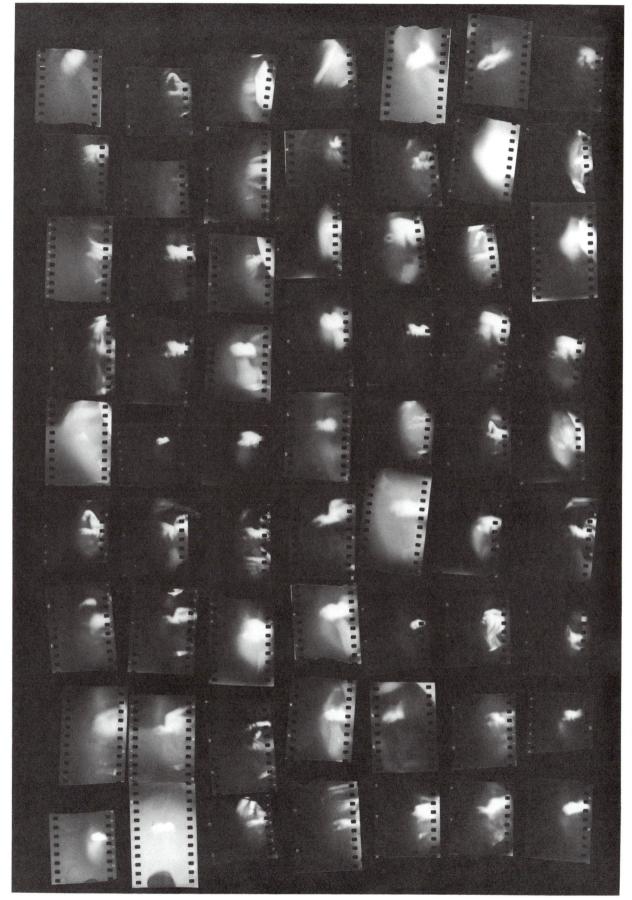

Figure 4.2 © Thomas Bachler, The Third Eye, pinhole photograph made with the mouth, using lips as an aperture, film in mouth, standing in front of a mirror, all self-portraits. A 15" x 20" contact print of mouth photographs, 1980s. From the collection at Pinhole Resource.

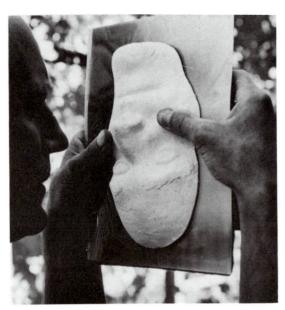

Figure 4.3a © Eric Renner, Plaster Face Camera, Pinhole in One Eye, 1985. A lens photograph from the collection of the photographer.

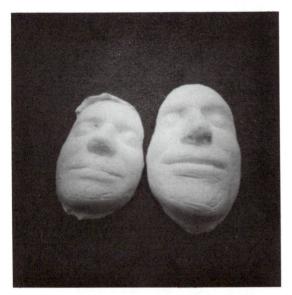

Figure 4.4a © Nancy Spencer and Eric Renner, Plaster Face Cameras, 1988. A pinhole photograph from the collection of the photographers.

I refer to as "little movies" in my right eye when the lid is closed. An example of these "little movies" (which Jung probably would have called a "lucid dream") happened late one night in 1983 after putting my two-year-old son Zephy back to bed for the eighth time (no exaggeration; I counted). When I got back in bed, in my right eye I saw a pyramid with a door in it, which opened. Out of the door came a small figure (Zephy?) who walked along a long, low wall extending from the pyramid. At the end of the wall, the figure stopped and turned, looked around, and said to me, "Everything is going to be alright." The figure then retraced its steps back into the pyramid.

The first plaster face camera was an attempt to make tangible the "little movie" experience. This pinhole camera was used for self-portraits—the camera was "me." In later versions of the plaster face cameras, there were pinholes in both eyes and photographs were not always "self" oriented. It took me almost twenty years of working in pinhole photography to come to the realization that I should make my face and mind into a camera—for that is what I really am! I did not want the camera to have a back, as if, metaphorically, my mind were free. When making a photograph, I held the camera upside down (Figure 4.3a), so that the image would be right side up on the Ilfochrome Classic color paper held against the flattened back (Color Plate 4.3b). The pinhole image area was quite sharp and clear, even though I held the camera in my hand for five- to seven-second exposures. Sunlight always worked its way under edges of the plaster face, in photogram fashion, making a variety of planned accidents. If used in low sunlight, the inner dark area remained black and unexposed; used in bright sunlight, it exposed purple-blue. Later, in 1988, after Nancy and I were married, I made plaster face cameras of both of us (Figure 4.4a) and used these for double self-portraits (Color Plate 4.4b), with the obvious idea that we were "one."

A very primal and uniquely symbolic manner of portraying "self" was invented by Jeff Fletcher of Austin, Texas. In his photographic series *Bromide Eggs* (Figures 4.5a and 4.5b), we are invited to enter a dozen aspects of his private world, which have been imaged onto the cave-like inner surfaces of opened egg shells. Fletcher's light-sensitive material is the emulsion Liquid Light, which has been brushed into the inner shell and when exposed is the negative. His pinhole camera is a pepper shaker; the pinhole is in the bottom with the egg placed inside.

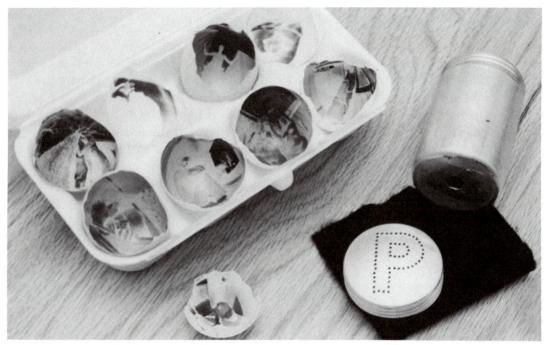

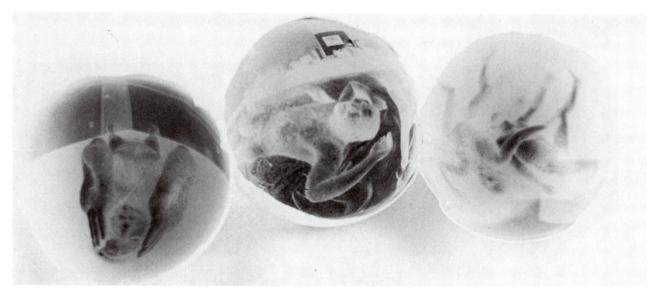

 $\begin{tabular}{ll} \textbf{Figure 4.5b} & @ \textit{Jeff Fletcher}, \ \texttt{Bromide Eggs}, \ \texttt{Self Portraits}, \ \textit{1990. Pinhole photographs from the collection of the photographer}. \end{tabular}$

4.6a

4.6b

One of the first photographers to intertwine camera and photograph into a singular art object is Julie Schachter of Washington. Her "Boraxo" camera (Figure 4.6a) was placed in the sands of Death Valley (harking back to the old television commercial for Borax soap, which featured a twenty-mule team that trudged across the desert) to portray biographically the violent mentality of "Death Valley Days" television actor and "Star Wars" United States President Ronald Reagan (Figure 4.6b). It was vital that Schachter's pinhole camera be constructed out of the soap can made by the company that sponsored Reagan's television program and be placed in an appropriate landscape for a revealing portrait of the man and his gun.

Other Schachter cameras sculpturally combined tripod, pinhole camera, and photograph into one: Tinkertoy pieces supported a Tinkertoy box (Figure 4.6c) to photograph her son Marlon (Figure 4.6d), pink newspaper television sections covered a pod supporting a television (Figure 4.6e) to

Figure 4.6a © *Julie Schachter*, Boraxo Pinhole Camera, 1980s. A lens photo from the collection of the photographer.

Figure 4.6b © Julie Schachter, Ronald Reagan. A $3^{1}/_{4}$ " x $4^{1}/_{4}$ " pinhole photograph from Boraxo pinhole camera, 1980s. From the collection of the photographer.

Figure 4.6c © Julie Schachter, Tinkertoy Camera with wood cardboard and string pod, 1980s. A lens photo from the collection of the photographer.

Figure 4.6d © Julie Schachter, Self-portrait with Marlon. A $5^{1}/2$ " x 7" pinhole photograph made with a Tinkertoy camera, 1986. From the collection of the photographer.

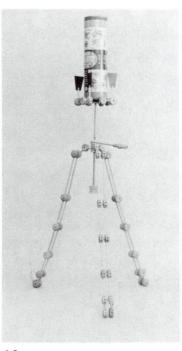

4.6c

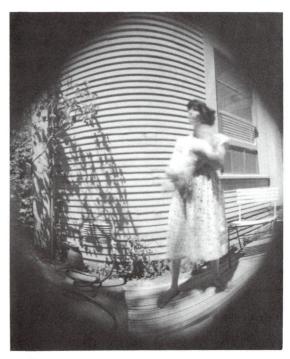

4.6d

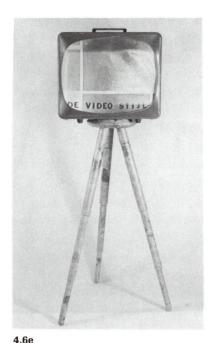

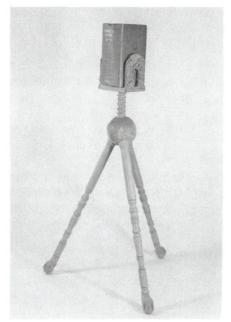

4.6f

2.00

photograph someone watching soaps while ironing, and a solid, carved-oak pod supported a hollowed-out 1939 *Who's Who* (Figure 4.6f with detail) to photograph 100 of her friends. Below the surface of humor and whimsy lies Schachter's serious attempt to broaden the photographic art form.

Peggy Ann Jones of California may have been the first artist to make pinhole cameras as sculptural objects *only*—some were never meant to capture images. In 1977 she placed a group of seven of her cast lead non-functioning cameras into a photographer's carrying case. The case weighed 44 pounds and was titled "One Thing Lead to Another"! Obviously Jones was playing on the idea that most photographers think they need an overabundance of equipment. By the time their carrying case is full, it's too much and none really gets used.

Delving into tongue-in-cheek humor, Larry Bullis of Washington took the biblical statement "It is easier for a camel to go through the eye of a needle, than for a rich man to enter into the kingdom of God" (Matthew 19:24) and deliberately transformed his conventional Polaroid camera into a soul-saving Polaroid needle-hole camera—to instantly redeem those who eternally suffer from monetary greed. How? Bullis explains:

Thinking about the nature of life and the need for magic, it occurred to me I could for once and for all answer an age old question and revive hope for countless otherwise helpless individuals, who, because

Figure 4.6e © Julie Schachter, TV Pinhole Camera with wood covered with pink newspaper TV sections. 4 pods, 1980s. A lens photo from the collection of the photographer.

Figure 4.6f © Julie Schachter, Who's Who Pinhole Camera with solid carved oak pod, including detail of camera, 1980s. A lens photo from the collection of the photographer.

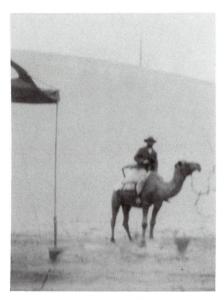

Figure 4.7a © Larry Bullis, Camel Photographed with Needle Eye Camera. A $2^3/4$ " x $3^3/4$ " pinhole photograph, 1987. From the collection of the photographer.

of their unfortunate wealth had resigned themselves to eternal suffering. I know that I will be able to photograph using the eye of a needle [Figures 4.7a, 4.7b] as imaging device. The only proper subject for this device would be a camel.

There were some difficulties here, which were not expected. When you need a camel you go to the zoo, right? Wrong. Neither Woodland Park, nor the Portland Zoos have camels anymore. Too boring. Fortunately, there is a camel ride concession at the dunes in Florence (Lawrence of Florence? [Oregon]). Originally, I greeted this with some measure of despair, because Florence is such a long way for such a dumb idea. But the more I thought about it, the better it got. Think of it. This guy rents out his camels for folks to climb atop to have their pictures taken, so I can get on top of the camel, thus getting a free trip through the eye of the needle myself.

I'm working on the camel project. It is more difficult than one might expect. The first subject photographed with the needle eye camera was the Trojan Nuclear Power Plant. Perhaps this is our contemporary equivalent of a camel; another kind, another quality of transformation \dots ¹

After making the images, Bullis continued:

A quick note to let you know history has been made. I drove 850 miles with my younger daughter for that image last weekend. Of course, the camel had decided to take that day off—the first in three summers. So we drove to Coos Bay and sat on the rocks at Cape Arago. Came back for the camel on Tuesday.

Figure 4.7b © Larry Bullis, Needle Eye Camera, 1987. A lens photo from the collection of the photographer.

I had built a needle eye camera out of a Polaroid Color Pack II; just pulled the lens off and replaced it with a piece of brass shim stock with a needle glued into a gash in it with black Duro rubber. So I had an automatic exposure, too. It was great! 3000 speed Polaroid is wonderful material for pinhole work.²

As with all superb ideas, someone was working on the same concept simultaneously. In 1990 I received photographs from Paolo Gioli of Italy. In 1986 he also had made a needlehole camera (Figures 4.8a, 4.8b) to photograph camels, with the same biblical statement in mind! Soul saving is worldwide.

Figure 4.8b © *Paolo Gioli*, Il Cammello della Cruna Stenopeica. A $3^{1}/2^{n}$ x 4" needle-hole photograph, 1986. From the collection of the photographer.

Figure 4.8a © *Paolo Gioli*, Camera Agostenopeica, 1986. A lens photo from the collection of the photographer.

Figure 4.9a © Paolo Gioli, Conchiglia Stenopeica, 1986. A lens photograph from the collection of the photographer.

Figure 4.9b © *Paolo Gioli*, Le Mani di una Conchiglia. *A 4" x 6" pinhole photograph, 1986. From the collection of the photographer.*

During the 1980s, Paolo Gioli created other unique pinhole cameras. Some were Duchampian "ready-mades," where Gioli used objects, such as shells, with holes in them that would act as pinholes (Figures 4.9a, 4.9b).

Much in art is intuitive. Without view-finders, light meters, and other technical tools, we can arrive at the barest essentials necessary for a pinhole camera. Inherent in this simplicity is the photographer's sense of intuition. Some pinhole photographers have gone so far as to let their pinhole cameras operate as basic light receptors—with insights gained from each camera's specific light-gathering qualities and each film's specific latent imaging sensitivities. A pinhole

camera does produce an image of what its opened aperture projects onto light sensitive material placed inside, rather than what the photographer sees and expects to be recorded. One such instance would be the pinhole suitcases Thomas Bachler shipped from one city in Germany to his home city of Kassel, Germany. The pinhole was open during the entire shipping process. Whatever amount of light projected onto the photographic paper inside became Bachler's final image.

Denis Bernard, of Paris, builds pinhole cameras in a hemispherical, global fashion, with the film inside surrounded by pinholes. Of this idea, he says:

The instantaneous photography worked too fast in my opinion; I began using the pinhole. With its one-point-of-view lens, the camera was one eyed: I multiplied the points of view [Figures 4.10a, 4.10b] and used long exposures. The very first model of mine was the vision of insects; other forms of visual perceptions (particularly the fish; the Anableps you have heard about, of course! . . . One thinks they've got 4 eyes, in fact they've got only two of them: they simultaneously see sky and water; they live over water) constituted the origin of my questioning of photographic space and its reading. It is mere catching of the light that interests me . . . its identification is not my concern. What is given to be seen remains to be defined when the camera works without me.³

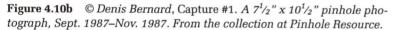

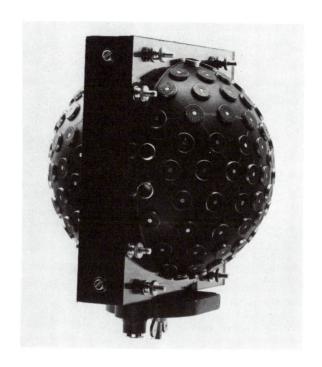

Figure 4.11a © Terrence Dinnan and Dominique Stroobant, Pinhole Earth Camera while Digging. Terrence Dinnan in front, May 1980, Miseglia de Carrara, Italy. A lens photo from the collection of the photographers.

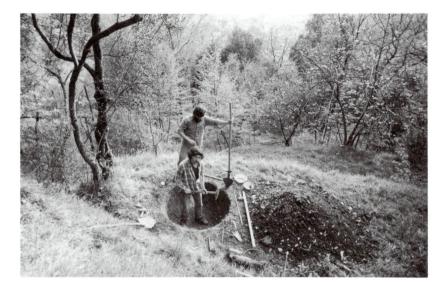

Figure 4.11b © Terrence Dinnan and Dominique Stroobant, Setting of Black Plastic on Pinhole Earth Camera, 1980. From the collection of the photographers.

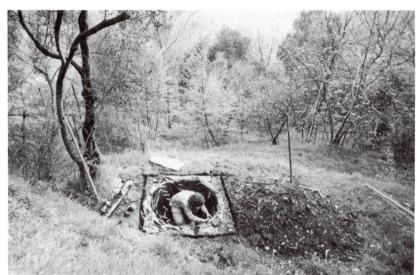

Figure 4.11c © Terrence Dinnan and Dominique Stroobant, Pinhole Earth Camera on Exposure, 1980. From the collection of the photographers.

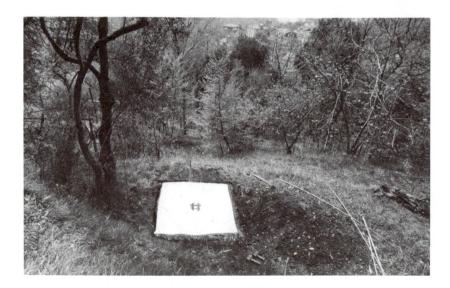

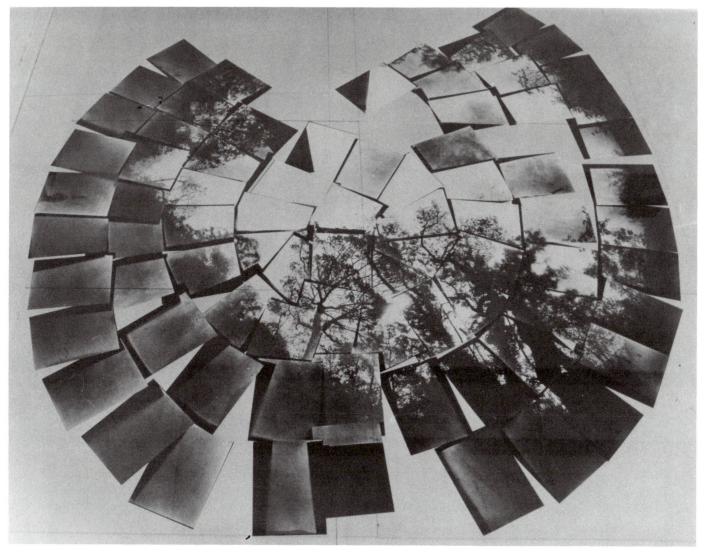

In Miseglia de Carrara, Italy, in the clearing of a hillside wood, Terrence Dinnan of Vermont and Dominique Stroobant collaboratively dug a four-foot-diameter rounded hole, shaped like half of a globe (Figure 4.11a), and covered it with black plastic and an entry bag (Figure 4.11b) for loading and unloading the photographic paper. In the middle of the cover was a pinhole (Figure 4.11c). The hole became an "Earth Camera," and Dinnan crawled through the hole to place eighty sheets of unexposed photographic paper around the entire surface of the hole. After Dinnan crawled out, an exposure was made (Figure 4.11d). Reminiscent of the astronauts leaving their space capsule to make a photograph, the entire process had been inverted to take place on Mother Earth—yet the final image has the look of a stellar composite.

Figure 4.11d © Terrence Dinnan and Dominique Stroobant, Earth Camera Photographs, ICC, Antwerp, June 1980, from their collection of photographs.

Figure 4.12 © Dominique Stroobant, 6 Months Photographs—December 22, 1981, to June 22, 1982. Four 7" $\times 9^{1}/2$ " pinhole cameras were set at different angles. Pinhole photograph made with litho film. From the collection of the photographer. (See following pages.)

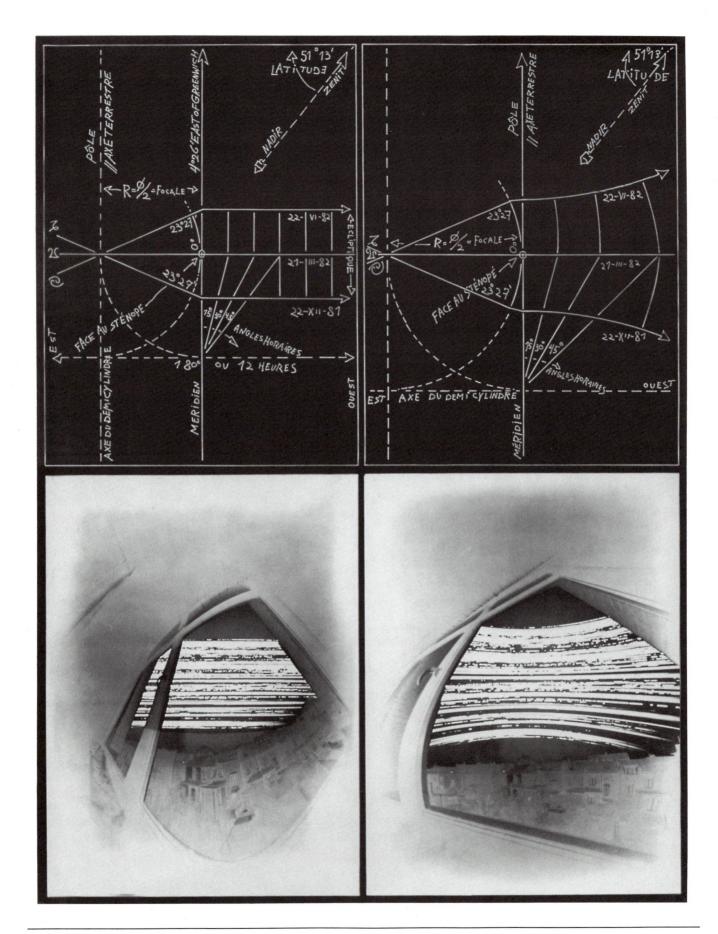

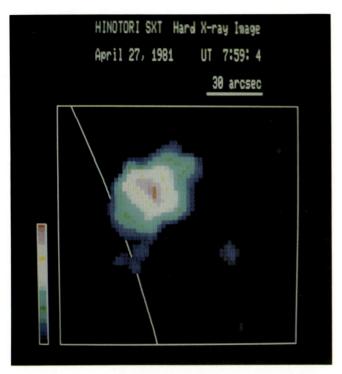

Color Plate 1.23 © T. Takakura. Hard X-ray pinhole image of a solar flare made aboard the Japanese satellite Hinotori, 1981. The image shows a bright region in the solar corona above the limb of the sun which is indicated by a curved line. From the collection of the photographer.

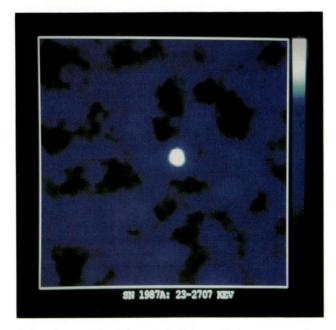

Color Plate 1.25b Thomas A. Prince. First gamma-ray image of Supernova 1987A. Coded-aperture pinhole image, 18 November 1987. Courtesy of the California Institute of Technology, George W. Downs Laboratory of Physics, Pasadena.

Color Plate 3.3 © David Lebe, Susan. A $2^{1}/_{2}$ " x 12" hand-colored pinhole photograph, 1973. From the collection of the photographer.

 $\begin{tabular}{ll} \textbf{Color Plate 3.4} & @ \textit{Franco Salmoiraghi}, \textbf{Untitled}. \textit{Color pinhole photograph}, \textbf{1969}. \\ \textit{From the collection of the photographer}. \\ \end{tabular}$

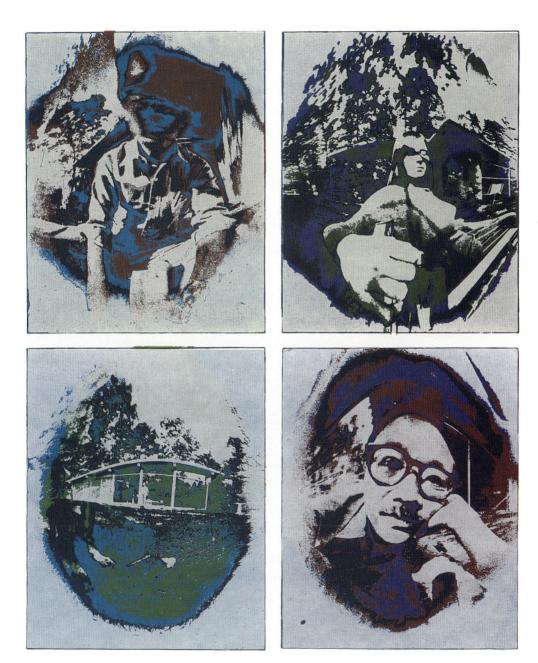

Color Plate 3.10 © Sam Wang, Untitled. A 10" \times 13" pinhole photoserigraph, 1972. From the collection at Pinhole Resource.

Color Plate 4.1 © Margaret L. Harrigan, The Marble Picture. A 12" \times 18" Type C print pinhole photograph, 1988. From the collection at Pinhole Resource.

Color Plate 4.3b © Eric Renner, Self. An 8" x 10" unfiltered Ilfochrome Classic pinhole photograph, 1985. From the collection of the photographer.

Color Plate 4.4b © *Eric Renner and Nancy Spencer*, Self-Portraits. *An 8" x 10"* unfiltered Ilfochrome Classic pinhole photograph made from a seven-second exposure, 1989. From the collection of the photographers.

Color Plate 4.14 © Willie Anne Wright, Anne S. in Front of Jack B.'s Pool. From the Pools Series. A 9" x 13" Ilfochrome Classic pinhole photograph, 1984. From the collection at Pinhole Resource.

Color Plate 4.15 © Lauren Smith, Untitled. From the Spring Passion Series. An 8" x 10" unfiltered Ilfochrome Classic pinhole photograph, made from a Charlie Chip Potato Chips can pinhole camera, 1982. From the collection of the photographer.

Color Plate 4.17 © Barbra Esher, Kimono Heart/Mind Series. A 30" x 40" Type C pinhole photograph, 1980s. From the collection of the photographer.

Color Plate 4.19b © Pierre Charrier, Untitled. A 20" \times 30" Type C pinhole photograph, 1986. From the collection at Pinhole Resource.

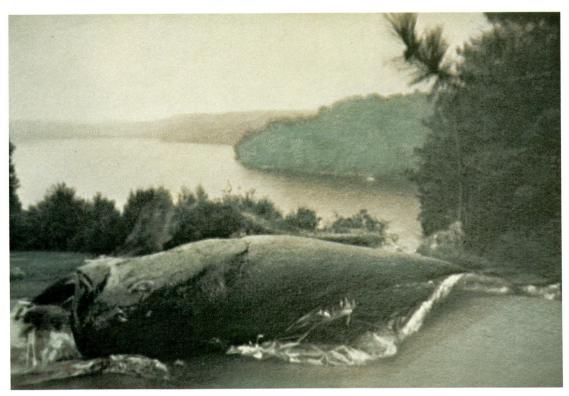

Color Plate 4.23a © Sarah Van Keuren, Fish by Lake. An $8" \times 10"$ cyanotype and gum pinhole photograph, 1986. From the collection of the photographer.

Color Plate 4.23b © Sarah Van Keuren, Figure by Pool. An $8" \times 10"$ cyanotype and gum pinhole photograph, 1986. From the collection of the photographer.

4.25b

4.25d

4.25f

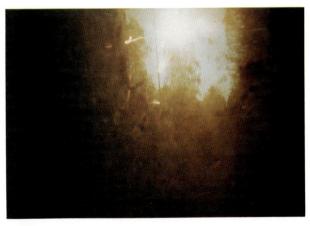

4.25c

4.25e

Color Plate 4.25b © Sandy Moss, Water. An 11" x 14" unfiltered Ilfochrome Classic pinhole photograph, twenty-minute exposure, 1987. From the collection of the photographer.

Color Plate 4.25c © Sandy Moss, Earth. An 11" x 14" unfiltered Ilfochrome Classic pinhole photograph, one-hour exposure, 1987. From the collection of the photographer.

Color Plate 4.25d © Sandy Moss, Air. An 11" x 14" unfiltered Ilfochrome Classic pinhole photograph, twenty-minute exposure, 1987. From the collection of the photographer.

Color Plate 4.25e © Sandy Moss, Fire. A 14" x 17" unfiltered Ilfochrome Classic pinhole photograph, ten-minute exposure, 1987. From the collection of the photographer.

Color Plate 4.25f © Sandy Moss, TV. A 14" x 17" unfiltered Ilfochrome Classic pinhole photograph, ten-minute exposure, 1987. From the collection of the photographer.

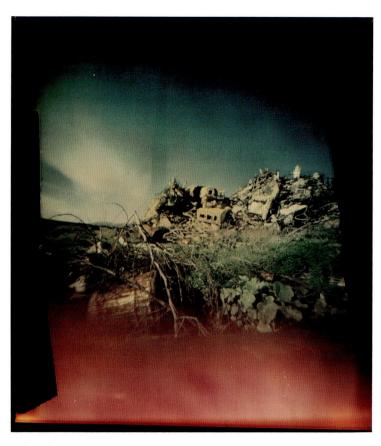

Color Plate 4.26 © Jo Babcock, Alcatraz. A 40" x 54" Type C pinhole photograph, 1988. From the collection of the photographer.

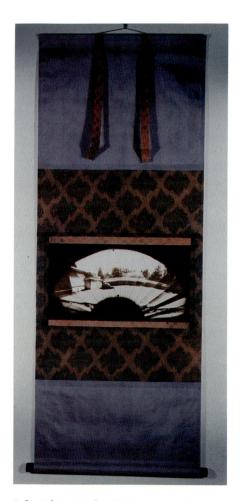

Color Plate 4.28b © *Peggy Ann Jones*, Kakemono Series. *A 47" x 20" fabric with pinhole photograph, 1988. From the collection of the photographer.*

Color Plate 5.13 © Nancy Spencer and Rebecca Wackler, Flight Series. An 8" x 10" handcolored pinhole photograph, 1986. Note: the oatmeal-box camera has been angled slightly downward (not perpendicular to the ground), which creates an exaggerated curved-earth effect. From the collection of the photographers.

Color Plate 5.16 © Linda Hackett, Untitled. A 4" x 5" Type C pinhole photograph from Santa Barbara Camera. The camera was held by hand while the photographer was cross-country skiing, 1988. From the collection at Pinhole Resource.

Color Plate 5.24 © Thomas Kellner, Untitled, 1992. A 3½" x 4½" Type C pinhole photograph, made with a Kodak "Quick-Snap Camera" with pinhole added. The pinhole is 10 times the size it should be for optimal sharpness. From the collection of the photographer.

Color Plate 5.29 © Denis Farley, Tonopah, Nevada. A $2" \times 7^{1}/_{2}"$ Type C pinhole photograph, 1990. From the collection at Pinhole Resource.

 $\textbf{Color Plate 5.33a} \quad \textcircled{o} \textit{Paolo Gioli}, \textbf{Tondo di pupilla riaperta}. \textit{A 3" x 4" stereo Polaroid Polachrome,} \\ \textit{Microstenopeica Stampata su Ilfochrome Classic, 1986}. \textit{From the collection at Pinhole Resource.}$

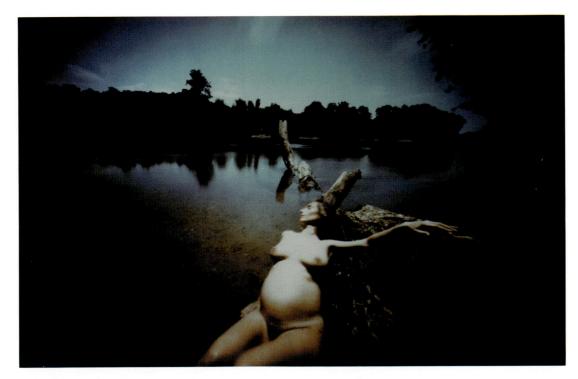

Color Plate 5.34 © Willie Anne Wright, Pregnant Woman, James River Pregnant Women Series. A $16" \times 20"$ filtered Ilfochrome Classic pinhole photograph, 1987. From the collection of the photographer.

Color Plate 5.36 © Rita DeWitt, Elvis Visits Lake Michigan, 1989. A 20" x 30" Type C pinhole photograph, from a plastic camera with a pinhole. From the collection of the photographer.

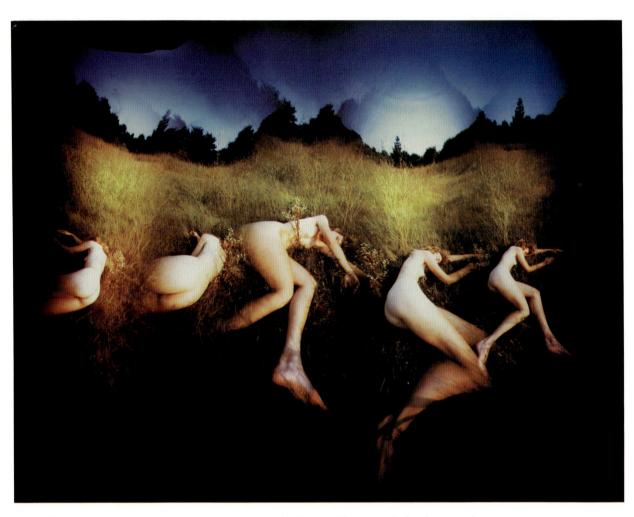

Color Plate 5.43 © Jim Cherry, Katie. An $8" \times 10"$ Ilfochrome Classic pinhole photograph, 1987. A five-pinhole panorama. From the collection at Pinhole Resource.

Color Plate 5.49a © Claire
Messimer, Untitled Still Life,
1991. From a 4" x 5" pinhole
transparency. Film is 64 Tungsten with a Tiffen enhancement filter. Photographed with
Lowell lights, five-minute exposure. Note netting has turned
magenta because of filtering.
From the collection of the
photographer.

Color Plate 5.49b © Claire Messimer, Untitled Still Life, 1991. From a 4" x 5" zone plate transparency. The zone plate is 150mm; the film is 64 Tungsten, unfiltered. Photographed with Lowell lights; five-second exposure. From the collection of the photographer.

Color Plate 5.50 © Howard E. Williams, Untitled, 1987. A 20" x 24" Ilfochrome Classic pinhole photograph, filtered with Lee Filter #102 light amber. Two-hour exposure on a cloudy day, from a $6^{1}/_{2}$ -inch-focal-length camera. From the collection of the photographer.

Color Plate 6.2 © Bruce Habegger, Clothespin. An $8^{1}/_{2}$ " x 13" pinhole Polachrome, 1987. From the collection at Pinhole Resource.

Color Plate 6.3 © Sam Wang, Untitled Still Life. A 4³/4" x 7" nail-hole color-separated computer print, 1989. (Macintosh ported to Atari ST.) Printed on Star. From the collection at Pinhole Resource.

Color Plate 6.4a © *Gillian Brown*, Painted image seen from hole. *A lens photo, 1989.* From the collection of the photographer.

Color Plate 6.4b © *Gillian Brown*, Painted image seen from angled view. *A lens photo, 1989. From the collection of the photographer.*

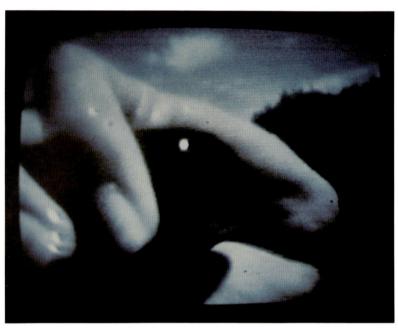

Color Plate 6.5 © *Jay Bender*, Dance of the Hondo Rock. *A pinhole video* (single frame), 1985. From the collection of the photographer.

Color Plate 6.6 © Reid Wood, State of Being. Photocopied transfer of pinhole photographs, mail art, 1990. From the collection at Pinhole Resource.

Color Plate 6.7 © Eric Renner, John Wood, 1985. An 11" x 14" unfiltered Ilfochrome Classic slit photograph; twenty-second exposure. If you view it long enough, you can see a face in the upper right-hand corner and an enlarged hand below. From the collection of the photographer.

Color Plate 6.8 © Harry Littell, Slit camera obscura images, $12' \times 100'$. These images are being viewed from front of rear-projecting screen. Omaha, Nebraska, 1989. A lens photo from the collection of the photographer.

Color Plate 6.13b © Russ Young, Waterlily, 1991. A 4" x 5" zone plate Type C photograph. From the collection at Pinhole Resource.

Color Plate 7.7 © Elaine McKay and Warren Padula, Untitled, 1993. A 4" x 6" Type C pinhole photograph. The color in this image was produced by using Ektachrome Professional 100 slide film. Rather than processing it normally, the photographers processed it in a C-41 standard print developer. The negatives were printed in standard print chemistry without color corrections. From the collection at Pinhole Resource.

Color Plate 7.8a © Joseph Jakusz, Motion Blur . . . Tunnel 10 (west of Caliente, NV), 1991. A pinhole photograph made with Fujichrome 50 film. The pinhole was mounted in a C3 Argus camera and shot from a Union Pacific cab. From the collection of the photographer.

Color Plate 7.8b © Joseph Jakusz, Motion Blur . . . Tunnel 7 (approach to Stine, NV), 1991. A pinhole photograph made with Fujichrome 50 film. The pinhole was mounted in a C3 Argus camera and shot from a Union Pacific cab. From the collection of the photographer.

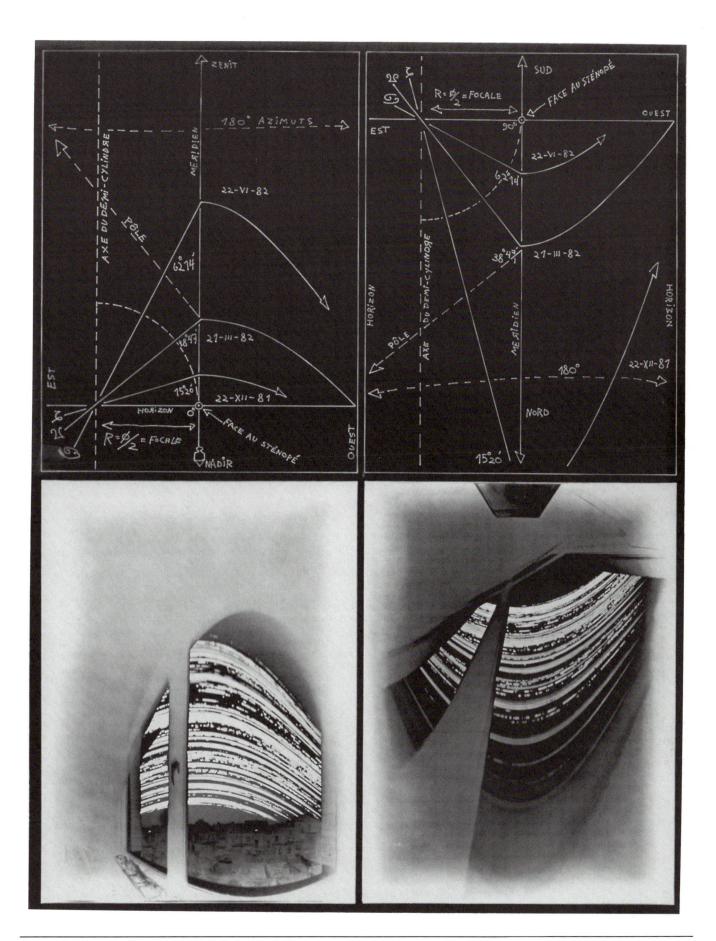

4.13a

4.13b

Figure 4.13a © Catherine Rogers, Portable Darkroom. A lens photo, 1986. From the collection at Pinhole Resource.

Figure 4.13b © Catherine Rogers, Negatives Drying in The Wind. A lens photo, 1986. From the collection at Pinhole Resource.

Figure 4.13c © Catherine Rogers, Untitled. A 5-inch diameter Van Dyke pinhole photograph, 1986. From the collection at Pinhole Resource. During the 1980s, Dominique Stroobant continued his work photographing the sun, making many cameras that could remain outside for extended periods of time, even as long as six months. Many of his projects used multiple cameras, each of which was aimed at different angles from the horizon to zenith in the sky. One such set is shown in Figure 4.12, where the camera was left to photograph for six months. What is amazing is that Stroobant can still achieve a correctly exposed view of the landscape while photographing the sun for as long as six months. Stroobant used very slow Litho film to make these images.

Catherine Rogers of Australia built a portable darkroom (Figure 4.13a) to be used while in the field with a group of friends and students who were hiking in the outback. Since they were hiking about sixty miles, their heavier supplies were hauled by car and dropped at certain points along the route. The group made pinhole cameras out of existing materials. For instance, one camera was made of bark, mud, straw, and glue. Negatives were loaded and processed in the portable darkroom, which was set on the ground in the shade. The negatives were then hung to air dry (Figure 4.13b). Alternative process emulsions, like Van

4.13c

Dyke, were painted on watercolor papers by starlight, the print was contact-printed the next day by sunlight, and then washed in the river upside down in the maker's shadow (Figure 4.13c) so that the least amount of light would fog the image while processing.

In the early 1980s, Willie Anne Wright of Virginia and Lauren Smith of Ohio began using large sheets of Ilfochrome Classic paper in their cameras. Ilfochrome Classic is a direct positive color paper (used without a negative) and is intended to be used with tungsten light under an enlarger for printing color slides. Smith used the paper unfiltered (Color Plate 4.15), while Wright filtered her Ilfochrome Classic, balancing it to daylight color (Color Plate 4.14).

Wright organized the first national pinhole exhibition, entitled *The Pinhole Image: Eleven Photographers*, at The Institute of Contemporary Art of the Virginia Museum in 1982. Of her imagery, Wright says:

Plato's image of a world of shadows inhabited by prisoners has, for me, layers of meaning concerning the nature of reality and has a direct relation to the concept of the *camera obscura*. Plato says:

And now, I said let me show in a figure how far our nature is enlightened or unenlightened: Behold! Human beings living in an underground den, which has a mouth open toward the light and reaching all along the den; here they have been from their childhood, and have their legs and necks chained so that they cannot move, and can only see before them, being prevented by the chains from turning round their heads. Above and behind them a fire is blazing at a distance, and between the fire and the prisoners there is a raised way; and you will see, if you look, a low wall built along the way, like the screen which marionette players have in front of them, over which they show the puppets.

I see.

And do you see, I said, men passing along the wall carrying all sorts of vessels, and statues and figures of animals made of wood and stone and various materials, which appear over the wall? Some of them are talking, others silent.

You have shown me a strange image, and they are strange prisoners.

Like ourselves, I replied; and they see only their shadows, or the shadows of one another, which the fire throws on the opposite side of the cave.

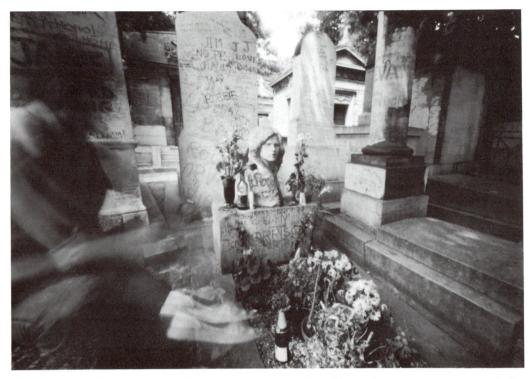

Figure 4.16 © Clarissa Carnell, Waiting for Jim. A 5" x 7" gold-toned printing out paper pinhole photograph, 1984. From the collection at Pinhole Resource.

Wright completes her explanation:

To me if you vaguely compared the den to a *camera obscura*—the sun would be the fire and the people would sit (inside) facing the back of the camera (making room for the pinhole, of course) and would watch the figures thrown on the back (inside) of the camera. Now going a step further this could be considered a metaphor for life in this world—where appearances are not always true and we see as through "a mirror darkly" truth to be revealed in its entirety perhaps in another world. It's probably better not to try literally to interpret the simile, but to grasp it intuitively.⁴

Clarissa Carnell of Philadelphia, Pennsylvania, used gold-toned printing out paper to express subtle or mysterious qualities that often appear as part of the image when lengthy time exposures are deliberately used in pinhole photography. Carnell's photograph at Jim Morrison's Paris grave intentionally made use of the blurred unknown sitter who awaits the moment of resurrection (Figure 4.16).

Barbra Esher, presently living in Maryland, has chosen to show layers of color to speak for the layers of intrigue she found while living in Japan. Of her *Kimono Heart/Mind* series (Color Plate 4.17) she states:

The Japanese word *kokoro* means both heart and mind, not separated but seen together as a whole. This series, in which I've chosen the kimono to explore the Japanese *kokoro*, was conceived and begun during a year's stay in Japan and nine months in America. When I first arrived in the countryside near Mt. Fuji, ideas of what I thought Japan would be like jumbled with my surroundings. I was staying with Japanese people who didn't speak English and everything I did seemed to be wrong. As I frantically searched my dictionary for explanations, they patiently corrected me. Their kindness and consideration was amazing, embarrassing and confusing. Learning Japanese was a step toward understanding what was going on but only because it changed the way I thought and felt.

Permeating the language is an unselfish sensitivity to the "other," whether another person or nature. Deference is expressed through a complicated system of honorific speech, which means you could address a person when you first meet them on a choice of about 13 different levels. These forms of speech have to gradually be changed according to age, social position and the amount of familiarity developed.

As a buffer to this "other," directness is considered rude. Japan's is a culture of wrappers, postcards and books or concealed jealousies and desires. Layers upon layers to peel through only to get to more wrappers. As well as privacy this creates a curious mystery. Nothing is spelled out; it must be discovered. There's an unseen drama in the shadows which hides as well as describes. It's important in Japanese to talk around the subject; something is lost in being direct. If the area around the subject is described and defined, then what you have left is the thing intact; not broken down but as it actually exists—as a beautiful perfect whole.⁵

One cold morning in December of 1982, I placed a glass pickle jar—made into a pinhole camera by painting it black on the inside, wrapping it with three layers of duct tape, and placing the pinhole inside the glass—under the icy water in a pool near my house in New Mexico. Naively, I was trying to photograph the landscape above the water. The camera was sitting upright, the pinhole about one half of an inch under the water. To my complete surprise, the camera photographed underwater what is known in physical optics as "total internal reflection." Reflections underwater!

For the next two years, I worked on a series of images where I placed the camera underwater with a heavy rock on top to counteract its buoyancy. The camera simply photographed what was in front of it—the image was a combination of the pool's bottom over to the edge and a reflection of the pool's bottom on the underside of the upper surface (Figures 4.18a, 4.18b, 4.18c). The exposures were twenty minutes long. I used photographic paper as a negative. The pool had to remain still for the reflection to be clearly mirrored, otherwise it blurred. I became so intrigued with the blended bilateral symmetry in the images that I began to look in old optics books hoping to find information on "underwater reflection," as I called it. I found the early optical scientists, from Alhazen onward, had used pinholes in their window shutters for intimate studies of isolated light rays. This knowledge was my first introduction to the idea that pinholes were a primary tool. I never did find anyone credited with the discovery of underwater reflections, but I did trace the discovery of "total internal reflection" (in glass) back to Theodoric of Freiberg (1290) and the discovery of "the critical angle of total internal reflection" to Johannes Kepler (1600).

It was profound for me to realize a reflection existed underwater, very similar to the reflection on the surface above the water. It was even more profound for me to consider how these two reflections are physically placed against one another, and that their interface must be of microscopic thickness!

Figure 4.18a Eric Renner, Drawing Illustrating Underwater Reflection, 1984. From the collection at Pinhole Resource.

Figure 4.18b Eric Renner, Drawing Illustrating Underwater Reflection, 1984. From the collection at Pinhole Resource.

Figure 4.18c © Eric Renner, Under the Sod Bank, underwater reflection. An $8" \times 8"$ pinhole photograph, 1984. From the collection at Pinhole Resource.

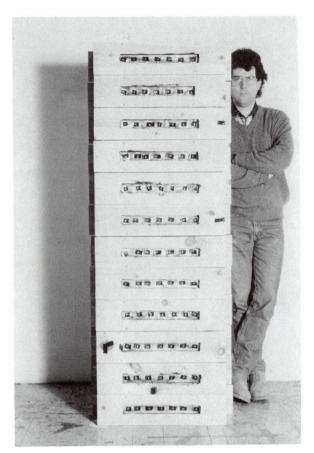

Figure 4.19a. © Pierre Charrier, Selfportrait with Pinhole Camera, 1986. A lens photo from the collection at Pinhole Resource.

Pierre Charrier, of Montreal, uses layers of cameras stacked one on top of another to the height of the person he photographs (Figure 4.19a). Each of the cameras uses an entire roll of color film stretched horizontally with seven pinholes in the front. All together, the entire camera has approximately ninety pinholes. His model is posed about a foot from the camera; he opens one pinhole at a time over a period of six to twelve hours (each exposure is about twelve seconds). Each strip of film is processed; all of the strips are then contact-printed together as they were in the original layer of cameras (Color Plate 4.19b).

Charrier speaks of his work:

The way I work is to pile them [the cameras] up one over the other. They go to about 6'4". Sometimes I use 12, sometimes 13—all depending upon the height of the person I'm photographing because I'm interested in head to toe recording. If you add all these pinholes, it's 84 or 91 pinholes. In my first photographs I exposed all the pinholes. The type of image I was obtaining was very dense. I call them, I don't know if the English term is very good—very charged. I was looking for an image I could look at for a very long time and not just glance at the image and turn away from it. I could find detailed parts that I could look at longer to find out more about what was happening. It was sort of a vision I would use when looking at a paint-

ing. But I would never look at a photograph as long. So I wanted to solve this problem—to look at my photos longer. In my photographs now, I don't expose all the pinholes, I may expose 50 or 30 or 70 depending on how I compose the picture.⁶

Also from Canada, Paul Cimon uses single-frame pieces of cut 35mm film placed in thirty-six match boxes (Figures 4.20a, 4.20b). After processing, each black-and-white image is enlarged and hand-colored, then placed panoramically in three dimensions (Figure 4.20c).

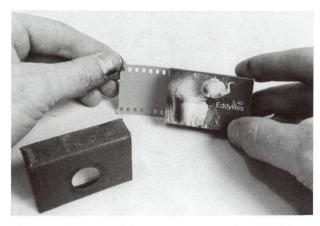

Figure 4.20a © *Paul Cimon*, New Generation Matchbox Pinhole Camera, 1986. A lens photo from the collection of the photographer.

Figure 4.20b © Paul Cimon, New Generation Matchbox Pinhole Camera, 12 to a box, 36 in all. In each box there is a viewfinder. A 1986 lens photo from the collection of the photographer.

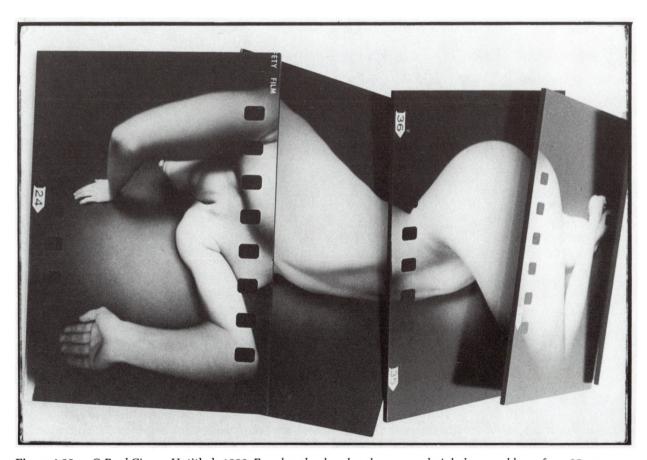

Figure 4.20c © Paul Cimon, Untitled, 1989. Four hand-colored and sequenced pinhole assemblages from 35mm film placed in a new-generation matchbox pinhole camera. Each singular image is 11" \times 14". From the collection of the photographer.

Figure 4.21 © Guillermo Gonzalez, Land Crab Pinhole Camera, from the class of Professor Sanchez Gaetan, Universidad del Sagrado Corazon, San Juan, Puerto Rico, 1980s. A lens photo. The pinhole is placed at the crab's mouth. From the collection of the photographer.

Some of the most interesting cameras are made from very unusual existing objects and come from Professor Sanchez Gaetan's college class at the University of the Sacred Heart in San Juan, Puerto Rico. The land crab camera by Guillermo Gonzalez is shown in Figure 4.21. All of the cameras in Gaetan's class are able to produce an image.

Not everyone who does pinhole photography makes a specialized type of pinhole camera. Many people use very simple, reliable cameras like an oatmeal box, or a large format camera with lens removed and pinhole attached, or one of the readily available commercial pinhole cameras (like the "Santa Barbara"), sold through Pinhole Resource (see list of suppliers at back of book). At least six different commercially produced pinhole cameras were manufactured during the 1980s. The first to appear was the 4" x 5" "Pinhole Camera Kit" designed collaboratively by Jerry Stratton and Bob Witanowski of Ohio. Containing an acid-etched pinhole, the camera could be assembled in about two minutes; 5000 have been sold. Next was the "Pinzip," designed by David Pugh of Delaware, using 126 Instamatic cartridges. Pugh's use of the "Pinzip" is shown in Figure 4.22. Almost

10,000 were sold through an outdoor catalogue. By 1986, the 4" \times 5" film holder "World Famous Lenseless Camera of Santa Barbara," made of refined plywood and hand-crafted by Walter Boye, was available. In 1988, the "Make Your Own Working Camera" kit manufactured in book form arrived. From Switzerland a pinhole stereo camera shaped to resemble a block of Swiss cheese was available. And from England, John Adams Toys produced a 3" \times 3" kit, called "Pinhole Camera," which included photo paper and photochemistry.

Sarah Van Keuren of Pennsylvania uses $8" \times 10"$ film holders that attach to the end of a wooden box. Of her introduction to pinhole photography and her evolving philosophy (Color Plates 4.23a, 4.23b), she observes:

I got more and more involved with it partly because I needed a large format negative for my non-silver processes. I had been enlarging 35mm negatives on copy film, commercial film, or duplicating film. That seemed kind of phony to me. Pinhole was so beautifully simple and so inexpensive. I've had kind of a reaction against the high priced equipment; I'm not an equipment jock. I liked the fact I could make a pinhole camera for almost no money at all and get a large negative. It was only after I'd been doing it for awhile that I began doing portraits. I had always done portraits as a lithographer—for years and years. I began to realize that a pinhole photograph provided a composite image of a person—like what you get when you're drawing a model over a period of time. It's a collection of expressions. The body of the model slumps into a characteristic pose, if I'm doing a full figure during the 6 or 7 minute duration of my indoor exposures. You don't get a fleeting expression of someone's face; it's very different in feeling, kind of like the early photos where the people had to pose for a long time. To me it seems to get at a certain inner truth like a psychological x-ray.⁷

Figure 4.22 © David Pugh, Pig on a Manhole Cover. A $6^1/_4$ " x $8^4/_2$ " pinhole photograph, 1982. This image was made from a "PinZip" camera f110, 4-second exposure of a 3" high brass piggy bank standing on a manhole cover. The raised letters (part of the word "Salisbury") are about $^1/_8$ " high and the square bumps are about $^1/_4$ " high. From the collection at Pinhole Resource.

In the late 1980s, photographer Nancy Spencer worked in collaboration with playwright and actress Rebecca Wackler. One of their series, Gospel of Mary, concerns the disrespect and lack of appreciation that Christ's disciple Mary Magdalene receives in the Bible compared to her honored place in the Gnostic Gospels (a set of thirteen books written nearly 2000 years ago, but only discovered in 1945, unearthed from inside a buried vase in Egypt).

One of their pinhole photographs, made to accompany a stage production, shows a woman crucified

Figure 4.24a © Nancy Spencer and Rebecca Wackler, Untitled, Gospel of Mary Series. An 11" x 14" pinhole photograph, 1989. From the collection of the photographers.

(Figure 4.24a), symbolizing Mary Magdalene on the cross. Spencer explains this controversial image:

It possibly may be offensive to many people, but what we were trying to say in *Gospel of Mary* was that Christianity crucified women, but the Gnostic Gospels don't.⁸

Of other noncollaborative imagery by Spencer, specifically her *Earth Goddess Series*, Spencer says:

Obviously the title is somewhat tongue-in-cheek—they're selfportraits [Figure 4.24b]. I started the photographs two years ago, partially as a way of making a statement about the goddess image

Figure 4.24b © Nancy Spencer, Untitled, Earth Goddess Series. An 11" \times 14" pinhole photograph, 1988. From the collection of the photographer.

which I feel was very strong before Christianity. She represents fertility, the cycles of creation, our connection to the planet, and feminine spirituality. As evidenced by the artifacts left by those people, there was simultaneous worship of both the god and goddess. Many pre-Christian people lived in ways in which it did not seem necessary to protect themselves from other people: they did not leave behind images of war, and their weapons were perhaps used only for hunting animals. They chose to build their homes in unprotected areas, unlike the later hillside fortifications found throughout Europe. They seemed interested in placing their homes in beautiful places and in making art, not in making war. Sometime around three or four thousand years ago, the old Europeans were invaded by people from the north, and the goddess cults began to wane, replaced by warlike male gods. With the advent of Christianity, the cults were obliterated. In fact, the Christians knocked down most of the stone circles, monoliths and other remnants of pagan civilizations, often breaking up the large stones to build their houses. It was heretical to worship the goddess after Christianity came into being, and in fact, many of those people were burned at the stake or murdered in other ways if they continued to engage in goddess worship or in worship of a two-sided god that was both male and female. As a result, women were associated with loathsome qualities—there was a great deal of fear and hatred towards women because if anyone engaged in any kind of goddess worship, his or her life was endangered. Many believe that women were at that time forced to learn to become reserved and unassertive in order to survive. In fact, it has been estimated that millions of women may have been destroyed after being branded as witches. The origins of sexism and misogyny in our culture can be traced back to the loss of the goddess/god worship.9

In 1988, the first international exhibition of pinhole photography, "Through a Pinhole Darkly," was organized by the Fine Arts Museum of Long Island, the idea being suggested to them by the pinhole photographer Bernice Halpern Cutler. In the exhibition, cameras and photographs from forty-five individuals were shown.

A second international exhibition soon followed in Spain. In May 1988, the Museum of Contemporary Art of Seville showed the work of nine pinhole photographers. Four months later, a third exhibition, the International Pinhole Exhibition, was organized by the Center for Contemporary Arts of Santa Fe (New Mexico) and showed the work of twenty pinhole photographers. Undoubtedly, the most thorough analysis of 1980s pinhole photography, from the standpoint of photo criticism, came from James Hugunin's essay "Notes Toward a Stenopaesthetic," in the catalogue of this show. Many of Hugunin's insights are of great value in understanding specific artists' sensibilities, thoughts, and directions. Small pieces of Hugunin's essay follow (reproduced by permission of James Hugunin).

On Sandra Moss:

Sandra Moss, who lives in Sweden, has been exploring the four elements—earth, air, fire and water—in order to "de-construct them [Color Plates 4.25b through 4.25e] and to observe how they contrast

with each other."¹⁰ Due to the all pervasiveness of electronic media, she decided to add a "fifth element"—television [Color Plate 4.25f], an element of the "bad life"—which she sees as inexorably diminishing our relationship to the original four. As Guy Debord put it in *Society of the Spectacle*, the media promoted "a counterfeit life requir[ing] pseudo-justification."¹¹ Moss explains her modus operandi "I don't want to photograph at earth, or at TV . . . I want to photograph through it."¹² For her study of water, a container of it was put right up against the pinhole of a home-made camera [Figure 4.25a] for twenty minutes, an hour exposure through dirt placed over the pinhole and Moss had obtained *Earth* (1987).

In this show, Moss only displays work exploring that "fifth element," television. *TV Landscape*, #1–6 (1987) is part of a larger series she calls "Van-

ishing Senses" and was photographed at various distances from the color TV screen. When the pinhole was right against the screen, as in TV Landscape #5, the stenope worked as a magnifying lens enlarging a minuscule area, resolving only the raster's "phonemes": the red, blue and green constituents of the full color image. TV Landscape #1 was made further back from the set.

A Swedish TV test pattern in blue and white takes up much of frame left; to the right, a window opens onto a gaggle of blurry leaves outside. By this juxtaposition, Moss contrasts the traditional window-onto-nature scene with television's "ob-scenity," where (as Jean Baudrillard reminds us): "the body, landscape, time all progressively disappear as scenes." ¹³ If the window-onto-nature is our Western model for representation, then the obscenity of the visible that television participates in puts an end to such representation. It is this Baudrillardian dystopia Moss symbolically attacks. ¹⁴

On Jo Babcock:

In a large 30 x 40 inch type C color print titled *Alcatraz* [Color Plate 4.26], Babcock aims his pinhole at the remains of the once infamous, impregnable penitentiary where "The Birdman" perched for many years. The middle third of the image depicts chunks of crumbling white concrete whose twisted, tortured rebars suggest the agonies of the many inmates who suffered behind those walls. The disorder Babcock sees in this subject—a "clash of uncoordinated orders," as Rudolph Arnheim reminds us, and "not the absence of all order"—is echoed in the composition. 15 Unified pictorial space is cut into three quasi-autonomous zones—the blue sky in the top third of the print, the concrete remnants, an area of magenta colored fogging at the bottom. This, and the irregularly shaped edges of the image, suggest yet a deeper reading of this image. May not Babcock be pointing to the inexorable entropic "running down" of all matter, even that of such formidable institutions as Alcatraz and, by implication, the decline of authority and power garnered by these institutions? Herein lies the essence of Babcock's political commentary. 16

Figure 4.25a © Sandy Moss, Pinhole Camera for 11" x 14". A 1987 lens photo. From the collection of the photographer.

Figure 4.27a © Martha Casanave, Untitled. A 16" x 20" pinhole photograph, 1986. From the collection of the photographer.

On Martha Casanave:

Martha Casanave did her first pinhole photographs in 1984, affixing a pinhole on the front standard of her 4 x 5 inch camera. Her reason for using the device? "I've often heard myself say that if I could made a photograph with just my eyes and brain," she has commented, "and not this clumsy and noisy mechanical device, I would be very happy. Using a pinhole camera comes closer to this ideal [Figures 4.27a, 4.27b]."

Casanave's portrait-narratives deal with what the photographer confesses are "uncomfortable and ever traumatic memories." Yet, as Casanave found upon exhibiting this work and getting responses to it, her imagery also "spoke" of similar memories by women other than herself. Not merely interested in form, Casanave tries to implicate her personal expression with a universal feminism. 19

Figure 4.27b © Martha Casanave, Untitled. A 16" x 20" pinhole photograph, 1986. From the collection of the photographer.

On Peggy Ann Jones:

In her "Kakemono" series, Southern California artist Peggy Ann Jones combines her interests in printmaking, fiber arts, sculpture, and pinhole photography with her delight in Japanese artifacts. . . . What Jones wanted to build was a device capable of holding a piece of lightsensitive paper folded out like a Japanese fan, so that marked distortions would occur during image projection. At first, in her series "Preconceptions of Japan" [Figure 4.28a], Jones did not attach the fanphoto to a scroll. Soon, however, the flattened out fan-image was to become the starting point for the construction of the long vertical kakemono scrolls [Color Plate 4.28b]. . . . The composition of the print itself blends so well with the fan-fold shape that the subject photographed and the object upon which it is rendered fuse into a single visual entity. Pictorial space becomes ambiguous: at times it advances to the picture plane, then it recedes back into the illusory third dimension. Empty space is permitted to have great impact, conforming to the Japanese conception of mu (which anticipated Gestalt psychology), the intuition that negative space is not merely empty, but active, as worthy of esthetic attention as the figure. This kakemono invites the kind of quiet contemplation urged upon us by Zen brush paintings and rock gardens.20

Figure 4.28a © Peggy Ann Jones, Taos Pueblo Church, from Preconceptions of Japan #1. An 8" x 16" pinhole photograph, 1988. From the collection at Pinhole Resource.

By the end of the 1980s, many photographers, who might have otherwise known only lens photography, chose to try pinhole. Many were accomplished photographers, bringing with them a strong sense and knowledge of the medium. Douglas Frank of Oregon had used lens cameras to make large-format platinum prints for years. In the late 1980s, he turned to pinhole; his sophisticated wide-angle pinhole landscapes employ a series of masks to either accentuate or de-accentuate the edges of the image (Figure 4.29). Similarly, David Plakke of New Jersey brought a prior sense of the medium to pinhole photography. His emotionally intense pinhole images (Figure 4.30) deal with AIDS and contemporary issues of sexuality.

Figure 4.29 © Douglas Frank, Untitled. An 11" x 14" platinum pinhole photograph, 1990. From the collection of the photographer.

Figure 4.30 © David Plakke, Untitled. A 40" x 50" pinhole photograph and nails, 1988. Courtesy of the Witkin Gallery, New York City.

Politically, the 1980s ended abruptly—communism leapt toward democracy. In one brilliant statement West German Marcus Kaiser used holes that had been torn through the Berlin Wall as pinhole cameras (Figure 4.31a). On one side of the wall's hole, he taped a pinhole; on the other side of the wall's hole, he taped a film holder (Figure 4.31b). For the first time in decades, an individual could photograph through this cherished light toward the East (Figure 4.31c)—or move his pinhole and film holder around and photograph toward the West (Figure 4.31d). Long-dreamt-of freedom had arrived!

Figure 4.31a © *Marcus Kaiser*, Pinhole Camera Made in a Hole in the Berlin Wall, Mauerblicke Series, 1990. A lens photo from the collection at Pinhole Resource.

Figure 4.31b © Marcus Kaiser, Placing film holder (back of pinhole camera) over a hole in the Berlin wall, 1990. A lens photo from the collection at Pinhole Resource.

Figure 4.31c © *Marcus Kaiser*, Mauerblicke Looking East. *A 5" x 7" pinhole photograph, 1990. From the collection at Pinhole Resource.*

Figure 4.31d © Marcus Kaiser, Mauerblicke Looking West. A 5" x 7" pinhole photograph, 1990. From the collection at Pinhole Resource.

4.31b

4.31a

4.31c 4.31d

NOTES

- 1. Larry Bullis, "Letters to the Editor," Pinhole Journal 3(3): inside front cover.
- 2. Ibid., inside front cover.
- 3. Denis Bernard, "Light Captures," Pinhole Journal 4(2):23.
- 4. Willie Anne Wright, "Photographs: Pools," Pinhole Journal 2(1):25.
- 5. Barbra Esher, "Artist's Statement," Pinhole Journal 5(2):20.
- 6. Pierre Charrier, "Interview," Pinhole Journal 3(3):10-11.
- 7. Sarah Van Keuren, "Interview," Pinhole Journal 3(3):18.
- 8. Nancy Spencer, "Interview," Pinhole Journal 6(1):9.
- 9. Ibid., 8.
- 10. James Hugunin, "Notes Toward a Stenopaesthetic," *The International Pinhole Photography Exhibition Catalogue* (Santa Fe, NM: Center for Contemporary Arts of Santa Fe, 1989), 16.
- Guy Debord, Society of the Spectacle (Detroit: Black and Red, 1983), section 48.
- 12. Sandra Moss, "Light Paths/Planetary Elements: Sandra Moss Interview," *Pinhole Journal* 4(2):30.
- 13. Jean Baudrillard, "The Ecstasy of Communication," in *The Anti-Aesthetic:* Essays on Postmodern Culture (Port Townsend: Bay Press, 1983), 129.
- 14. Hugunin, 16.
- Rudolph Arnheim, "Order and Complexity in Landscape Design," in Toward a Psychology of Art (Berkeley and Los Angeles: University of California Press, 1966), 125.
- 16. Hugunin, 13.
- 17. Martha Casanave, "Interview," Pinhole Journal 3(3):2.
- 18. Artist's statement, unpaginated, 1988.
- 19. Ibid., 12.
- 20. Ibid., 19-20.

5

One of my teachers recalled a memory of a discarded refrigerator box. Climbing inside the box and closing up the flaps, he and his brother found images of an upside-down world. Soon they had all the kids on the block assembled to view the spectacle, for a penny, and then jump up and down outside for the benefit of the other viewers.

HARRY LITTELL personal letter to the author, 1990

The How-To of Pinhole Photography

MAKING A SIMPLE PINHOLE CAMERA

A pinhole is basically a very sophisticated light leak. An image is produced because it is a *small* hole (Figure 5.1), one of the two "natural" systems that will form an image—the other system is a lens, as in our eyes. There is one animal that uses pinhole eyes for sight: the mollusk Nautilus (Figures 5.2a, 5.2b), which has been a species on this planet since the dinosaurs. The open aperture in each eye can enlarge or shrink. This ability is called *accommodating* by scientists.

A simple pinhole camera can be made in about ten minutes. The simplicity of pinhole cameras was demonstrated by John Wood of New York, who painted the inside of a paper grocery bag black, put photographic paper inside, and poked a hole in the bag with a pin (Figure 5.3).

The easiest ready-made box that can be transformed into a pinhole camera is a small cylindrical grits or cornmeal box (Figures 5.4a, 5.4b); the Quaker Oats oatmeal box cannot be used because it has a plastic lid, which is translucent and lets in too much light. First empty out the contents—only in pinhole photography does a camera come packed with food—then take a cloth and dust out the insides. I am suggesting this camera as a starting point since the box is so easy to transform into a pinhole camera; after using it, other pinhole cameras more personally adapted to each individual can be invented if desired.

Figure 5.1 © Larry Bullis, Drawing of image entering a pinhole and being projected onto the film plane, 1988. From the collection at Pinhole Resource.

Figure 5.2a Nautilus Drawing (eye is oval in upper right). From Arthur Willey, Zoological results based on material from New Britain, New Guinea, Loyalty Islands and elsewhere collected during the years 1895, 1896, and 1897. London: Cambridge University Press, 1900).

Figure 5.2b Macroscopic view of the eye in vertical section. From Arthur Willey, Zoological results based on material from New Britain, New Guinea, Loyalty Islands and elsewhere collected during the years 1895, 1896, and 1897. London: Cambridge University Press, 1900).

Materials Needed:

- a grits, cornmeal, or oatmeal box; the small size preferred (3½" diameter). *Don't* use an oatmeal box with a plastic lid because the lid is translucent and leaks light.
- .002-gauge metal
- a small sewing needle
- · a sheet of #600 emery sanding paper
- one roll of black vinyl electrical tape
- · one roll of masking tape
- · a pair of scissors
- a single-edged razor or mat knife
- a ten-sheet package of RC multigrade mat-surfaced photographic paper
- a normal photographic darkroom with black-and-white chemistry
- ultra flat black spray paint (optional)

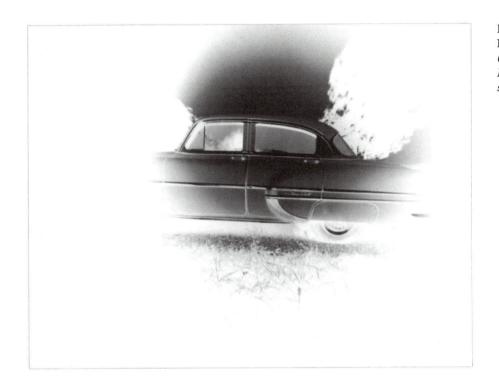

Figure 5.3 © John Wood, Paper Bag Pinhole Photograph of the Chevy. A $6" \times 7^{1}/_{2}"$ pinhole photograph, 1975. From the collection at Pinhole Resource

Adding the Pinhole

The most readily available material for pinholes is semi-disposable baking sheets or pie pans that come in a variety of sizes and shapes in most local food markets. The aluminum is approximately .002 gauge, and one pan will supply many pinholes. Those wanting "higher class" pinholes can buy .002-gauge brass shim stock at an automotive store, but this is more expensive and not always readily

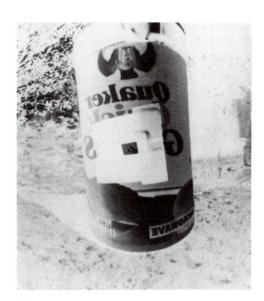

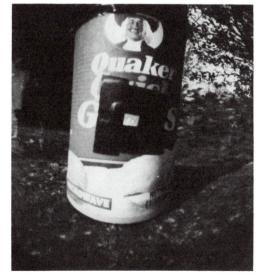

5.4a

5.4b

Figures 5.4a, b Pinhole Photographs (paper negative and positive print) of Quaker Quick Grits Box Pinhole Camera. Note four strips of black electrical tape hold metal with pinhole onto front of box; also black electrical tape seals top of box. Under the piece of tape sealing the top of the box are two strips of masking tape so that the box won't tear when the black tape is removed after each exposure. Another grits pinhole camera was used to make these photographs. Exposure time was forty-five seconds in the sun with the grits box one foot away from the camera. Photographs by author.

Figure 5.5a © Tom Fuller, Home-Made Comparator. A lens photo, 1991. From the collection of the photographer.

Figure 5.5b © *Tom Fuller*, View of Pinhole Through Comparator. *A lens photo, 1991. From the collection of the photographer.*

available. The inexpensive pie-pan aluminum is very similar to the expensive brass, in both workability and gauge. (Aluminum from a soft drink can is also approximately .002 gauge, but it is very hard and more difficult to use.)

After getting the metal you want for pinholes, cut out a one-inch square. Under this square place a sheet of cardboard like the kind that comes on the back of a writing pad, as this will make the best working surface for "drilling" the pinhole. Get a small sewing needle—I'm not suggesting a certain numbered needle size, since they are hard to find. (Numbered needle shaft diameters are shown in Figure 5.21a.) Tape a piece of masking tape across the eyed end of the needle. You are doing this so that the eyed part of the needle doesn't press into your finger when making the pinhole. Now take the needle and hold it in the center of the piece of one-inch square metal and spin the metal, while you hold the point of the needle against it. The metal should be on top of the cardboard. With some amount of pressure and spinning, you will see the needle begin to drill a hole into the metal. Spinning the metal will keep the hole round. Continue spinning until the needle

point sticks through the metal about 1/8 of an inch. The hole you have made will be approximately a little under .5mm. The optimum-size pinhole for this $3^{1}/_{2}$ " focal length box is .35mm or .0138 in. When drilling a pinhole, it is better to have the pinhole slightly too small than too large.

With a piece of #600 grit emery paper, sand off the burr that remains on the side of the metal where the needle point penetrated. We will call this the back side of the metal. Sand the front side of the metal, which will help to thin the metal and make the hole sharper. The thinner the metal, the less diffraction bounces off the edge of the metal—what you don't want is a pinhole that is like a tunnel. Now clean out the sanded metal that has been trapped in the pinhole by placing the needle in the pinhole and spinning it gently.

If you have access to a small hand comparator, use it to measure the pinhole or try using Tom Fuller's home-made comparator (Figures 5.5a, 5.5b). Fuller explains:

The pinhole plate to be measured is placed on a light box, a thin steel rule is laid over it, and an 8x loupe is set on top. Pieces of thin cardboard are used to shim the stack so that the transparent base of the magnifier rests evenly. I move the pinhole so that it can be seen through the exact center of the lens, then jog the rule slightly so that one of its graduation marks meets the left edge of the hole. I then read the diameter by merely counting the number of rule marks. Hardly a patentable idea, but it works. The drawback is that the thickness of the rule introduces some error, making the hole appear smaller than it really is, but you can learn to estimate this difference. Examine a hole of known size to see what it measures on your rule. ¹

The photograph [Figure 5.5b] shows a hole that is about 1.5mm in diameter. If you use this technique, buy a rule with the finest possible graduations for best accuracy. This utility rule is graduated in full millimeters along one edge, with 1/64-inch markings along the other. Edmund Scientific #C35,321 Optician's Rule has a metric scale graduated in 1/2mm increments, and an English scale marked to 1/100 inch.²

A second method for measuring the diameter of a pinhole was devised by Jay Bender of Washington using an enlarger. Bender says:

Since most of us do not have access to 100x microscopes, and since many of us do have enlargers, a method has been devised to use the enlarger to measure pinholes. At the side of this page are two scales and calibration lines (Figures 5.6a, 5.6b). Make a [photocopy] and place Scale #1's calibration line in a negative carrier in your enlarger

Figure 5.6a © Jay Bender, Scale #1 for measuring pinholes, 1990. From the collection of the photographer.

Figure 5.6b © Jay Bender, Scale #2 for measuring pinholes, 1990. From the collection of the photographer.

5.7a

5.7b

as you would a negative. Place Scale #1 on the baseboard and project the image of the calibration line down onto the scale. By moving the enlarger head up, or down, and refocusing, make the line 5.0mm long according to the scale. Once the calibration line is 5.0mm long, when sharply focused, your enlarger is calibrated and the scale is accurate. If you find that you cannot get the line to 5.0mm long, even with your enlarger all the way up, switch to a shorter focal length enlarging lens or use Scale #2 and calibration line.

Now place your pinhole in the negative carrier (tape or some support may be needed to suspend it there) and project the tiny round spot onto the scale. Focus it carefully and measure it on the scale. Simple! Obviously, the smaller the pinhole, the less accurate your measurement will be.

Put a grain focuser at the baseboard and line up the image of the pinhole in it. Voila! You have a 100x (or thereabouts) microscope! You can see if your pinhole is clean, round, and free from burrs.³

Mounting the Pinhole

With a sharp single-edged razor blade or mat knife, cut a 1/2-inch square hole in the center of the front of the box. Make sure the cardboard and paper is cut cleanly; otherwise leftover material will block some of the image entering the box. Using black vinyl electrical tape, tape the pinhole onto the outside of the box. (Black vinyl electrical tape is lightproof.) As you are doing this, look into the inside of the box to see that the pinhole is placed in the center of the cut opening. The back of the metal should go in toward the box. Cut an extra piece of tape to act as a shutter over the pinhole.

Before loading the camera, take a strip of masking tape and encircle the container just below the edge on the lid. Also encircle the edge of the lid with masking tape. These two surfaces will then give you an area around which to run black electrical tape, stopping any light leaks that may occur with a loose top. (If you don't tape

Figures 5.7a, b Pinhole photographs (paper negative and positive print) illustrating reflective fogged strip across center of glossy RC paper. Note: This will usually happen when using glossy-surfaced paper as a negative. This reflective area is one of the most common mistakes that happens when first making pinhole images. With a one-minute exposure in the sun, the camera was placed on its side approximately ten feet from the tree. Photographs by author.

this area with masking tape, the electrical tape will tear into the paper on the box each time it is removed.)

Painting the Inside of the Camera Black

The grits or cornmeal box comes with a brown interior, which does not need to be painted black when using 5" x 8" photographic paper; if film is used, the inside should be spraypainted with flat black. If you want to be assured of non-reflectivity, particularly useful if you are using film, use *ultra* flat black. Any object or box that is being transformed into a pinhole camera should be painted black if the interior is white or reflective. When in doubt, paint it. Generally, the back of the pinhole metal (facing inside the camera) does not need to be painted black; however, if you do want darken it, use black photographic tape or a black felt-tip marker to cover most of the area. Do not allow paint in the pinhole.

LOADING THE PINHOLE CAMERA

In a darkroom under a red or yellow safe light, load your camera with a 5" x 8" piece of photographic paper. (Use a paper cutter to cut 5" x 8" sheets from 8" x 10" sheets.) The best type of paper to use for negatives is an RC multigrade mat-surfaced paper. Why RC? Because it dries perfectly flat for making positive contact prints from your negative. Why multigrade? Because it works best both on gray days and in sunshine. Why mat-surfaced? Because it doesn't produce a reflected fogged strip the way shiny surfaced papers do (Figures 5.7a, 5.7b) when curved inside a pinhole camera made from a grits, cornmeal, or oatmeal box.

When loading, curve the photographic paper around the inside of the box opposite the pinhole. The emulsion side should face the pinhole. Generally, it is difficult to distinguish the emulsion side of RC multigrade mat-surfaced paper from the non-emulsion side, although the emulsion side has a slightly shinier surface. Kodak packs their black and white paper emulsion side up in the box. So does Ilford; however, Ilford flips the top sheet so its non-emulsion side is up. Figures 5.8a and 5.8b illustrate what happens when photographic paper is put in correctly and backwards, respectively.

Make sure the black electrical tape is over the pinhole, acting as a shutter. After the camera is loaded, seal the top with black electrical tape. You are now ready to make a photograph.

Figure 5.8a Pinhole photograph (paper negative) illustrating photographic paper loaded correctly with emulsion side toward the pinhole. A one-minute exposure with a hazy bright sky. Photograph by author.

Figure 5.8b Pinhole photograph (paper negative) illustrating photographic paper loaded incorrectly. Paper was put in backwards with emulsion side away from pinhole. A one-minute exposure with a hazy bright sky. Photograph by author.

MAKING A PHOTOGRAPH

There are certain "don'ts" to making a pinhole photograph for the first time. These "don'ts" can be experimented with later, for many unusual results come from breaking the rules. But for now, it is important to see if the camera is working and to get an idea of exposure times.

- 1. Don't have the sun directly on the pinhole when exposing (Figure 5.9).
- 2. Don't hold the camera in your hand, for exposure time and sharpness should be considered first. Set the camera on a wall, the ground, or some other solid base. If it's windy, use a weight on top to hold it steady (Figures 5.10a, 5.10b).
- 3. Don't photograph into total shade—for example, near a tree that is completely in the shade. It's best to try to photograph where there is brightness, partial shade, and shadow, all in the same image.
- 4. Don't try to photograph indoors while making your first images, as inside exposures can be very long and hard to estimate.
- 5. Don't place the camera too far from the subject you are photographing. Generally, you should be much closer than you would be with a lens camera (Figures 5.11a, 5.11b, 5.11c).

To expose, simply remove the shutter tape. The image will be a very wide angle. Use a watch or count seconds so that you can repeat, lengthen, or shorten the time on your next exposures. With the size pinhole described earlier, your grits- or cornmeal-box camera should make an image outside in full sun in about thirty to forty-five seconds; if it's cloudy or overcast, exposure should be one to three minutes, depending on just how dark it is. As the sun goes down in the afternoon, exposure times lengthen. A little bit of rain won't hurt this camera, so don't be afraid to try it for about a two- to three-minute exposure in the rain. Moving objects will not image, unless they are moving very, very, slowly—if you walk in front of a thirty-second exposure, you won't appear in the image. If you want to make an image with a "ghost" (Figure 5.12), you have to remain motionless in the image for at least half of the exposure time, depending on the background.

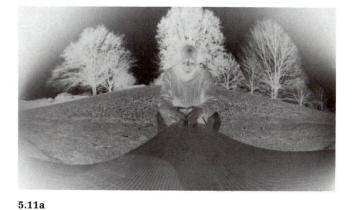

5.9

5.10a

5.11b

5.11c

5.10b

Figure 5.9 Pinhole photograph (paper negative) illustrating the sun on the pinhole. The camera was placed on the ground with the sun shining directly onto the front of the camera. Even with this short exposure of twenty-five seconds, the image is overexposed. Because of its brightness, the sun becomes the solarized dot in the center. Feathery streaks on left and right sides of image are places where the sun has defracted light off the edge of the pinhole. Photograph by author.

Figure 5.10a Pinhole photograph (paper negative) illustrating hand-held camera. Twenty-five-second exposure in sun. Photograph by author.

Figure 5.10b Pinhole photograph (paper negative) illustrating camera placed firm. Twenty-five–second exposure in sun. Photograph by author.

Figures 5.11a, b, c Pinhole photographs (paper negatives) illustrating distances between camera and subject: (a) six feet from subject; (b) four feet from subject; (c) two feet from subject. All exposures are thirty seconds in full sun. Note how bench looks curved because photographic paper is wrapped around inside of camera. Photographs by author.

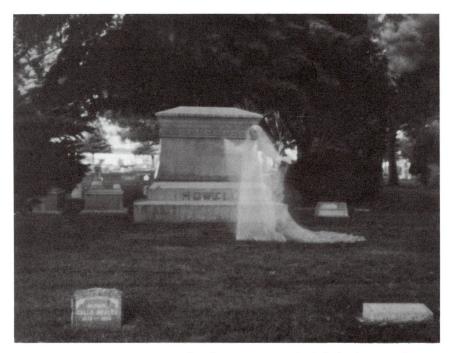

Figure 5.12 © Stanley R. Page, The Ghost. An 8" x 10" pinhole photograph, 1978. From the collection at Pinhole Resource.

Back in the darkroom, develop your paper as you would any black-and-white RC paper. (Probably two minutes in the developer, thirty seconds in a stop bath, and three minutes in the fixer.) The resulting image will be a paper negative that you can see develop in the tray. Usually the darkest area to show up first will be the sky; areas that remain light are the deep shadows.

It is easy to make contact-print positives from your negative since RC paper dries flat. To do this, simply place your negative with the image side down on top of an unexposed piece of photographic paper with its emulsion side up. Both should be pressed together under a piece of glass or in a contact-print frame. If they are not pressed tightly, the image will be blurred. Expose for about five seconds under an enlarger with its lens wide open, making sure the circle of light covers the paper area. Different photographic papers can be used for positive prints, as RC mat paper is certainly not the best for tonal values in positives.

Since this camera only makes one image at a time, you might consider carrying more than one box—I've seen a person carry as many as ten boxes at a time, all carried in a basket, each marked as it was exposed!

If the camera is angled slightly toward the ground, the horizon line becomes more distorted (Color Plate 5.13). Note that the water appears silky because the exposure time is long.

When photographic film is used in a grits or a cornmeal box, exposure times are shortened to a few seconds. Because film is so much more light-sensitive than paper, the camera must be taped with black electrical tape along the thinner seams that curl up both outside and inside the container to make it more light tight. These seams are visible on the inside and can be felt as a slight indentation under the paper on the outside. The camera must also be painted with ultra flat black spray paint if using film.

ADDITIONAL MISTAKES

If there is a light leak in your pinhole camera, the paper negative will over-expose and will be black when developed (Figure 5.14a). One way to check if your camera leaks light is to load it with photographic paper, place the black tape shutter over the pinhole, and then place the camera in the sun for five minutes. Develop the paper; if it turns gray or black, the camera leaks light.

If the cardboard in the area where the pinhole is mounted is not cut cleanly, there may be a flap that partially blocks some of the image (Figure 5.14b). The cardboard should be cut clean at least 1/4 inch away from the pinhole.

Sometimes when drilling a pinhole, you may accidentally drill two pinholes very close to one another, resulting in an image that looks blurred (Figure 5.14c). This can be checked by looking at your pinhole through a magnifying glass.

Figure 5.14a Pinhole photograph (paper negative) illustrating light leak in the bottom of a grits-box camera. Note that the photographic paper solarizes near the light leak. Photograph by author.

Figure 5.14b Pinhole photograph (paper negative) illustrating cardboard flap partially blocking pinhole. This occurs when cardboard behind the pinhole is not cut clean or totally removed; cardboard should be cut clean at least 1/4 inch away from pinhole. See Figure 5.38 for an unblocked version of this image. A forty-five–second exposure in full sun. Photograph by author.

Figure 5.14c Pinhole photograph (paper negative) illustrating two pinholes accidentally drilled close to one another. Each pinhole is 1/2mm in diameter and placed 1mm apart. A fifteen-second exposure in full sun. Photograph by author.

5.14a

5.14b

5.14c

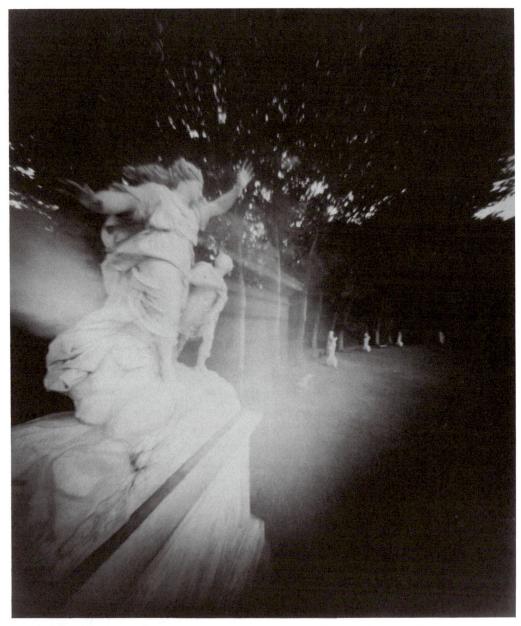

Figure 5.15 © Adam Füss, Untitled. A 20" x 24" pinhole photograph, 1986. The camera was placed on a high light stand, which moved in the wind causing some blurring of the image. Collection of the photographer.

ADDITIONAL POSSIBILITIES

You might want to make use of blur caused by the wind slightly shaking your camera. In Figure 5.15, Adam Füss placed his camera high on a light stand. While the paper was being exposed, the wind caused enough camera movement to add an interesting motion blur to the image. Another type of motion blur can be created by holding the camera by hand. Linda Hackett's image in Color Plate 5.16 was made by opening the shutter while cross-country skiing.

If you use a short exposure time, the sun can be photographed. In a black-and-white image, feathery streaks will appear (Figure 5.17); in a color image, spectral rainbows will appear. In Diana Keller's *Sun Drawing and Landscape* (Figure 5.18), first the land-scape was photographed briefly, then the camera was turned in a circular motion, the sun causing the white streak. Since long exposure times are usually an integral part of pinhole photography, many possibilities are available.

Figure 5.17 Pinhole photograph (paper negative) illustrating sun on pinhole. If a short exposure time is used, the sun can be photographed. Note that the two clouds under the sun and feathery streaks across the sun are made from the pinhole's diffraction (sun bouncing off the edge of the pinhole). A five-second exposure into direct sun. Photograph by author.

Figure 5.18 © Diana Keller, Sun Drawing and Landscape. A 5"x 8" pinhole photograph, 1988. The white streak is a line made by the sun when the camera was moved. From the collection at Pinhole Resource.

Figure 5.19 Pinhole photograph (positive print) illustrating ability of the pinhole camera to photograph very close to the object. A four-minute exposure in full sun. Photograph by author.

In the close up of George Washington on a one dollar bill (Figure 5.19), the bill was taped 1/4 inch in front of the pinhole. The camera was then set on the ground with the sun on the dollar bill. The printing on both the front and back of the bill show up in the image because the sun makes it transluscent. Note that the lines across Washington's face are actually from the back of the dollar bill. The image Grandma Becomes the Moon on the dedication page at the beginning of this book was made from a 1919 photograph taped over the pinhole like the Washington photograph. In the old photograph of my grandmother, her face was approximately 1/4-inch wide. The pinhole camera was able to enlarge it to 10 inches across-a 40x magnification!

Unpredictable solarization can result when using outdated Polaroid materials (Figure 5.20).

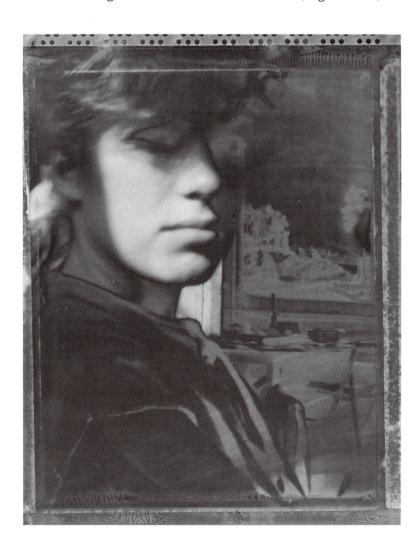

Figure 5.20 © Pinky Bass, Untitled Portrait. A 4" x 5" Polaroid pinhole photograph, Type 55, 1986. Note that unpredictable solarization (see the subject's eye) can occur when using outdated Polaroid materials and subjecting them to long exposure times. From the collection at Pinhole Resource.

OPTIMAL PINHOLE FORMULAS

The larger the pinhole, the more light will enter.

Light intensity decreases the further it travels from the pinhole. For instance, a 4-inch focal distance takes more time to expose than a 3-inch focal distance, and so on, given the same size pinhole.

For every focal length, there is an optimal pinhole diameter. A chart of focal distances and corresponding optimal-sized pinholes has been provided by Robert Mikrut and Kenneth A. Connors (Figure 5.21b). Needle shaft diameters are shown in Figure 5.21a. The longer the focal length, the larger the pinhole should be. An example of an optimally sharp pinhole image can be seen in Figure 1.19. If the pinhole is too large for the focal length, the image will be blurry. If the pinhole is very, very small, the image will also be blurry. (It is possible, however, to photograph a very bright object, like the sun, with an almost invisible pinhole—so small a pinhole that it would otherwise produce no image if it were used to photograph just the landscape.)

A formula can be supplied for making pinholes. Any number of slightly differing formulas have been calculated since Lord Rayleigh's formula from the 1880s. The one suggested here is by Bob Dome of Washington, as follows:

$$A = \sqrt{55} F$$

where A equals the aperture diameter in thousandths of an inch, and F equals the focal length in inches. An example: You're converting an old box camera and want to use a focal length of 4 inches. The square root of 220 (55 x 4) is 14.8, so the optimal size pinhole diameter is 14.8 thousandths of an inch or .0148 inch.

For the curious, here is the evolution of the aperture diameter formula just presented. Most formulas I've seen for determining an optimum size pinhole are of the following general form:

$$R = \sqrt{WCF}$$

where

R = radius of the aperture,

W = wavelength of light,

C = a constant factor, usually a decimal fraction between 1/2 and 1.

and

F = focal length.

To be useful, the formula just given relies on one's choice of wavelength (ranging from about 15 to 30 millionths of an inch) and one's choice of the constant factor. After studying the work of many researchers, especially Ken Connors, I decided upon a wavelength as multiplied by a chosen constant and arrived at the following:

Figure 5.21a Needle shaft diameters.

 $R = \sqrt{.00001375F}$

where

R =Radius of the aperture in inches,

and

F = Focal length in inches.

But most pinhole experimenters want to know the diameter of the aperture, not the radius, so I rewrote the formula again:

$$A = \sqrt{(.00001375)(4) F}$$

and then, of course:

$$A = \sqrt{.000055F}$$

where A = aperture diameter in inches.

It now remained to do something about all those zeroes because they can cause entry, processing, and data retrieval problems on some handheld calculators. So:

$$A = \sqrt{55F}$$

where

A = aperture diameter in thousandths of an inch,

and, as before,

F =focal length in inches.⁴

In the last 125 years of pinhole photography, at least 50 charts suggesting pinhole diameters have been devised. One of the most curious formulas comes from M. Jules Combe of France in 1899, whose pinhole photographs were very sharp. Combe's formula is:

Multiply the diameter of the hole in thousandths of an inch by itself, then by four, and divide the result by one hundred and twenty-seven. This gives the camera extension in inches.

Example: I will take the case of the hole made by a No. 10 needle, which has a diameter of eighteen-thousandths of an inch.

$$18 \times 18 \times 4 = 1,296$$

$$1,296 \div 127 = 10.20$$

The distance is therefore 10.20 inches.⁵

When you need to calculate the f/stop of your pinhole, simply divide your focal length by the pinhole diameter.

<u>-</u> 1u	Troouse Driags a						
Needle #'s that Correspond to Pinhole Diameters Although it is rarely possible to find numbered needles, here is a chart in both inches and millimeters:							
Needl	e						
Diameter							
(Inches) Needle #							
0.010 15							
0.012 13							
0.014 12							
0.018 10							
0.021 9							
0.024 8							
0.027 7							
0.030 6							
0.034 5							
0.037 4							
0.040 3							
0.043 2							
0.046 1							
Needle							
Diameter							
	(mm) Needle #						
0.25	15						
	0.30 13						
0.36 12							

Diamet	er
<u>(mm)</u>	Needle #
0.25	15
0.30	13
0.36	12
0.46	10
0.53	9
0.61	8
0.69	7
0.76	6
0.86	5
0.94	4
1.02	3
1.09	2
1.17	1
I	
1	

Pinholes Increment	10		0.037	0.037 used in function	nction								
Focal Length(mm)	Pinhole Diam. (mm)	Pinhole Diam.(in)	f-stop	H	ime-Rel. Focal Focal to f/64 Length(in) Length(ft)	Focal Length(ft)	Focal Length(mm)	Pinhole Diam.(mm)	Pinhole Diam.(in)	f-stop	Time-Rel. to f/64 Le	<pre>fime-Rel. Focal to f/64 Length(in) Length(ft)</pre>	Focal Length(ft)
10	0.1170	9700.0	85		0.39	0.03	510	0.8356	0.0329	610	8.06	20.08	1.67
20	0.1655	0.0065	121		0.79	0.07	520	0.8437	0.0332	616	92.6	20.47	1.71
30	0.2027	0.0080	171		1.10	0.10	540	0.8518	0.0335	622	94.5	20.87	1.74
20	0.2616	0.0103	191	6.8	1.97	0.16	550	0.8677	0.0342	634	98.1	21.65	1.80
09	0.2866	0.0113	209		2.36	0.20	260	0.8756	0.0345	049	100.0	22.05	1.84
70	0.3096	0.0122	226)	2.76	0.23	570	0.8834	0.0348	645	101.6	22.44	1.87
80	0.3309	0.0130	242		3.15	0.26	580	0.8911	0.0351	651	103.5	22.83	1.90
06	0.3510	0.0138	256		3.54	0.30	590	0.8987	0.0354	929	105.1	23.23	1.94
100	0.3700	0.0146	270		3.94	0.33	009	0.9063	0.0357	662	107.0	23.62	1.97
110	0.3881	0.0153	283		4.33	0.36	610	0.9138	0.0360	899	108.9	24.02	2.00
120	0.4053	0.0160	296		4.72	0.39	620	0.9213	0.0363	673	110.6	24.41	2.03
140	0.4219	0.0166	308	23.2	5.12	0.43	630	0.928/	0.0366	678	112.2	24.80	2.07
- 150	0.4532	0.0178	331)	5.91	01.0	650	0.000	0.0363	680	115 0	25.20	2.10
160	0.4680	0.0184	342		6.30	0.52	099	0.9505	0.0374	769	117.6	25.98	2.17
170	0.4824	0.0190	352		69.9	0.56	670	0.9577	0.0377	700	119.6	26.38	2.20
180	0.4964	0.0195	363		7.09	0.59	089	0.9648	0.0380	705	121.3	26.77	2.23
190	0.5100	0.0201	373		7.48	0.62	069	0.9719	0.0383	710	123.1	27.17	2.26
200	0.5233	0.0206	382		7.87	99.0	710	0.9789	0.0385	715	124.8	27.56	2.30
017	0.5362	0.0211	392	37.5	8.27	0.69	720	0.9859	0.0388	720	126.6	27.95	2.33
230	0.5411	0.0216	401	39.3	8.66	0.72	730	0.9928	0.0391	725	128.3	28.35	2.36
240	0.5732	0.0226	410	41.0	90.6	0.73	740	1.0065	0.0396	735	130.1	20.14	2.40
250	0.5850	0.0230	427		9.84	0.82	750	1.0133	0.0399	740	133.7	29.53	2.46
260	0.5966	0.0235	436	4.94	10.24	0.85	260	1.0200	0.0402	745	135.5	29.92	2.49
270	0.6080	0.0239	777	48.1	10.63	0.89	770	1.0267	0.0404	750	137.3	30.31	2.53
230	0.6191	0.0244	452	6.64	11.02	0.92	780	1.0334	0.0407	755	139.2	30.71	2.56
290	0.6301	0.0248	094	51.7	11.42	0.95	790	1.0400	0.0409	760	141.0	31.10	2.59
300	0.6409	0.0252	468	53.5	11.81	0.98	800	1.0465	0.0412	764	142.5	31.50	2.62
320	0.6513	0.0256	4/6	55.3	12.20	1.02	820	1.0330	0.0415	77.	144.4	31.89	2.66
330	0.6721	0.0265	463	58.9	12.99	50.1	830	1.0660	0.0420	779	148.2	32.20	2.69
340	0.6822	0.0269	7498	60.5	13.39	1.12	840	1.0724	0.0422	783	149.7	33.67	2.76
320	0.6922	0.0273	206	62.5	13.78	1.15	820	1.0787	0.0425	788	151.6	33.46	2.79
360	0.7020	0.0276	513	64.3	14.17	1.18	860	1.0851	0.0427	793	153.5	33.86	2.82
3/0	0./11/	0.0280	520	0.99	14.57	1.21	0/8	1.0913	0.0430	197	155.1	34.25	2.85
380	0.7207	0.0284	22/	8.79	14.96	1.25	000	1 1038	0.0432	802	157.0	34.65	2.89
007	0.7400	0.0288	541	21.5	15.35	1.28	006	1.1100	0.0433	806	150.6	35.04	2.92
410	0.7492	0.0295	547	73.0	16.14	1.35	910	1.1161	0.0439	815	162.2	35.83	2 90
420	0.7583	0.0299	554	74.9	16.54	1.38	920	1.1223	0.0442	820	164.2	36.22	3.02
430	0.7672	0.0302	260	9.92	16.93	1.41	930	1.1283	0.0444	824	165.8	36.61	3.05
044	0.7761	0.0306	267	78.5	17.32	1.44	046	1.1344	0.0447	829	167.8	37.01	3.08
450	0.7849	0.0309	573	80.2	17.72	1.48	950	1.1404	0.0449	833	169.4	37.40	3.12
094	0.7936	0.0312	280	82.1	18.11	1.51	096	1.1464	0.0451	837	171.0	37.80	3.15
0/4	0.8021	0.0316	286	83.8	18.50	1.54	0/6	1.1524	0.0454	842	173.1	38.19	3.18
064	0.8190	0.0319	592	85.6	18.90	1.57	066	1.1642	0.0458	846	174.7	38.58	3.22
200	0.8273	0.0326	604	89.1	19.69	1.64	1000	1.1700	0.0461	855	178.5	39.37	3.23
													;

Figure 5.21b © Robert Mikrut and Kenneth A. Connors, pinhole calculations from 10mm to 1000mm focal lengths.

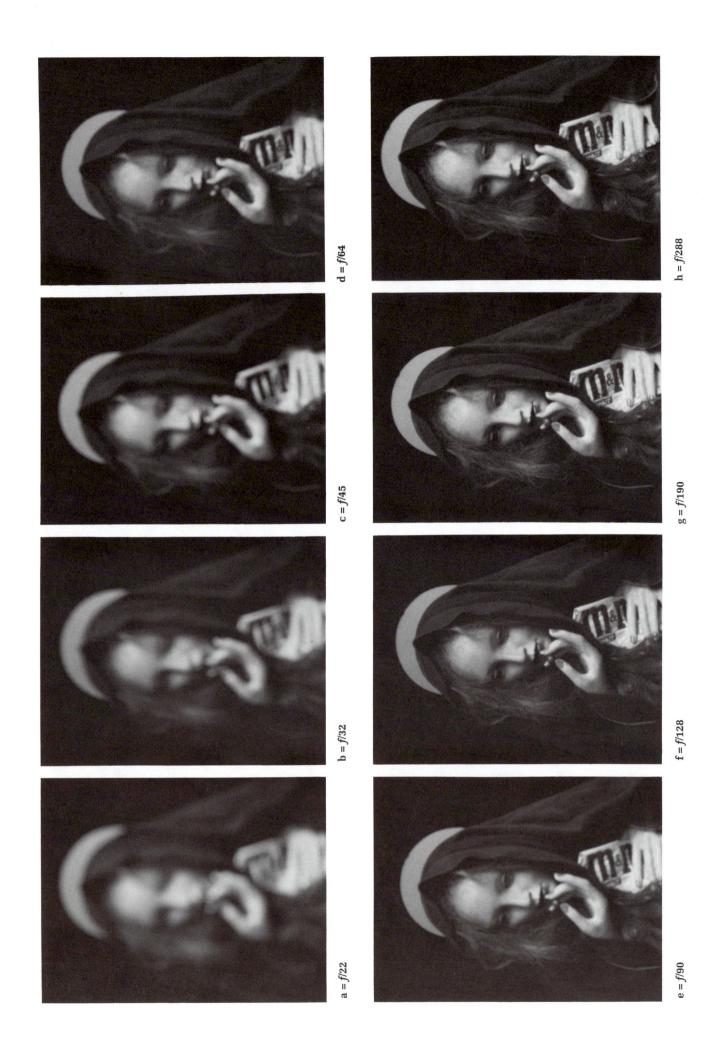

MAKING A PINHOLE TURRET

Using a pinhole turret is one of the best ways to produce a set of images showing varying degrees of definition, from blurry to sharp (Figures 5.22a–h). Jim Moninger of New York has made several turret designs and explains his procedure:

I tackled the problem of how to use a whole range of tiny drilled pinholes conveniently enough to vary and select the level of sharpness I want. For this I simply revived a feature not uncommon to some of the early commercially produced pinhole and other cameras; something still used on some enlargers and movie cameras: The Turret. By drilling my selection of pinholes on a single disc of .002" brass in a circular configuration, I can easily rig a device that will allow me to quickly "dial in" almost any number of different apertures. I've been using a Speed Graphic Press Camera for most of my pinhole work. One of the advantages of a press or field camera is that it enables the shooter to draw the bellows in and out for various focal lengths. Another is that pinhole devices can be fixed to removable lensboards. Instead of building a whole camera, it can be easier to adapt one for experimental photography. [Figure 5.23a] shows my Speed Graphic with a pinhole turret built into a lensboard. [Figure 5.23b] is a sketch of the design.

To make it I drew two circles on a sheet of .002" brass: one to mark the diameter of the disc and another inside to mark the circle on which to drill the pinholes. I then divided the disc so that eight evenly spaced pinholes could be drilled at marked locations. After selecting the sizes of the pinholes desired, I carefully drilled them. Next I drilled a plastic disc with eight holes which would line up with the pinholes. This was stuck to the brass disc with rubber

Figures 5.22a—h © Jim Moninger, Postmodern Saint: Our Lady of the Immaculate Confection, 1991. Illustrations on page 120 show eight degrees of sharpness. Focal length is 2¹/₄ inches; pinholes are mounted in a Super Speed Graphic. From the collection of the photographer.

Figure 5.23a © Jim Moninger, Speed Graphic with Turret Attached. A lens photo from the collection of the photographer.

Figure 5.23b © *Jim Moninger*, Sketch of Pinhole Turret. *From the collection of the photographer*.

5.23a

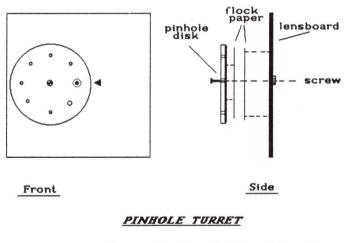

for Press, Field and View Cameras

5.23b

cement. This plastic disc serves as a retainer to keep the brass disc flat and to provide a "dial" to change apertures. A lensboard was drilled in the center for the light path of the pinholes. Another hole was drilled off center to secure the disc at its center. The holes are carefully placed so that the pinholes on the rotating disc will line up one at a time with the center hole on the lensboard. In order to avoid light leaking between the disc and the lensboard, I pressed discs of black self-stick flock paper (paper felt, available at art supply stores) to the back of the brass disc and to the face of the lensboard. The turret was fastened to the lens board with a small machine screw. The threads on this had to be filed down just below the head so that they wouldn't chew up the center hole in the turret. The nut was tightened enough to allow free rotation of the disc while holding a tight connection with the lensboard. Once adjusted, I permanently fixed its position with epoxy. For this project I was primarily interested in wide angle work in the field so I planned to use the minimum bellows draw for most of the pictures shot with this pinhole turret. The fixed focal length enabled me to calculate specific f/stop values for the holes. I was also able to adjust the pinhole sizes so that they were close to one f/stop apart and could be easily used with a light meter and adjusted for various conditions of light intensity and the desired level of softness.6

Optimal sharpness is seldom the first requirement for most pinhole photographers; in fact most pinhole images are made with considerably less definition than an optimal pinhole would achieve. Some pinhole photographers choose to make an oversized or irregularly shaped pinhole in various materials such as aluminum foil, which is generally difficult to use anyway, for optimal pinholes. Patrik Ryane of California works with aluminum foil taped over the opening of a 35mm Nikon and changes the shape and size of the aperture for various images and moods. In fact, Ryane even tapes over the view finder, forcing himself to rely more on an intuitive moment. Thomas Kellner of Germany uses a very enlarged pinhole for his expressive portraits (Color Plate 5.24).

PINHOLE CAMERA GEOMETRIES

Depth of Field

Most people who are aware of pinhole imagery think of a pinhole image as having infinite depth of field. Everything from the closest object to the most distant object is in the same relative focus (Figure 5.25). The only exception is distant objects at 100 yards or more; those objects will be less sharp because of particles in the atmosphere.

Photographing onto a Flat Film Plane

A pinhole casts a usable circular image of approximately 125 degrees onto a flat film plane. The image will fade from the center outwards because the focal distance increases toward the edges, resulting in a decrease in light intensity (Figure 5.26). Some pinhole photographers choose to show most of the image, including its falloff toward the edge (see Color Plate 5.34). If the center of the image is over-exposed, then the image will be cast at a greater angle than 125 degrees; likewise, if the center of the image is under-exposed, then the image will be cast at less than a 125-degree angle.

Figure 5.26 Drawing by author illustrating how light intensity decreases as focal length increases.

Figure 5.25 © Marianne Neuber, Hole in Wall. A 16" \times 20" pinhole photograph, 1992. From the collection of the photographer.

5.27a

5.27b

5.27c

Figures 5.27a, b, c © Robert Simmons, Old Mission, 1991. Three 4" x 5" pinhole photographs made with Lenseless Cameras of Santa Barbara, 1991: (a) 75mm (3-inch) wide-angle camera, two-second exposure with ISO 400 Tri-X film; (b) 150mm (6-inch) 1 to 1 camera, four-second exposure with ISO 400 Tri-X film; (c) 225mm (9-inch) telephoto camera, eight-second exposure with ISO 400 Tri-X film.

Image size increases as the focal length increases. One example of how the image will increase in size as the focal distance increases can be seen in Figures 5.27a, 5.27b, and 5.27c made from the commercial Lenseless Camera of Santa Barbara (Figure 5.28) with focal lengths of 3 inches (75mm), 6 inches (150mm) 1:1 normal, which is equal to the angle that a person's eyes see, and 9 inches (225mm). All three cameras use 4" x 5" film holders so that the 3-inch focal length acts as a wide-angle, the 6-inch is normal and the 9-inch looks to be telephoto. Even though the image increases in size with distance, what is really happening in the 6-inch and 9-inch cameras is that most of the image is outside the film holder. In other words, most of the image is past the film edge and therefore, not recorded. If each camera took a larger film size, as the focal length increased, all three images would appear to be more wide-angle.

Walter Boye, the designer of the Lenseless Camera of Santa Barbara, gives the following instructions for designing 1:1 pinhole cameras:

If you take the diagonal measure of whatever format you're using and make that the focal length of the camera you're constructing, you will have a 1:1 camera. For instance, using 4" x 5" film holders on a 150mm (6-inch camera), this focal length will be 1:1 or normal. The basis of this is the human eye. The diagonal measure of the receptors on the back of the eye equals the diameter of the eye. And this is the basis of the 1:1 relationship. Anything less than the diagonal measure of the format will be wide-angle. Anything longer will be telephoto. For the optimum diameter of the pinhole, if you take the square root of the focal length in inches and divide by 141, you'll arrive at the optimum diameter pinhole.

An image can be made to look panoramic simply by cropping it long and thin, or by using a camera that takes a long strip of film (Color Plate 5.29).

A pinhole camera can be made with an extremely long focal length to create a "telephoto" image. One such camera was made by Jim Jones of Missouri to photograph the sun during solar eclipses (Figure 5.30a). His camera was constructed from a ten-foot-long piece of plastic pipe (Figure 5.30b). Jones explains his camera:

The solar eclipse camera was made of a 3-inch plastic pipe with a pinhole and shutter at one end and an improvised springback for a 4" x 5" filmholder at the other. In use, the

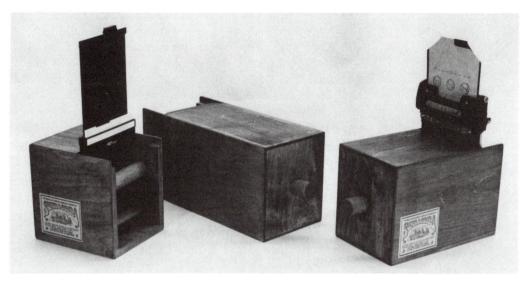

Figure 5.28 Lenseless cameras of Santa Barbara in three focal lengths. A lens photo, 1990. From the collection at Pinhole Resource.

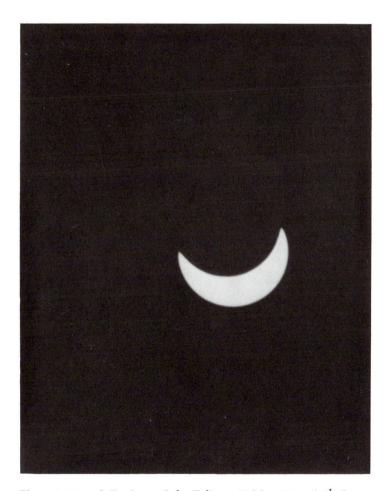

Figure 5.30a © Jim Jones, Solar Eclipse, 30 May 1984. A $3^1/4$ " x $4^1/4$ " pinhole photograph. From the collection at Pinhole Resource.

Figure 5.30b © *Jim Jones*, Self-Portrait with Solar Eclipse Camera, 1984. A lens photo from the collection at Pinhole Resource.

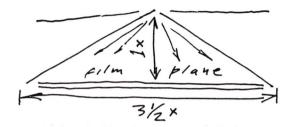

Figure 5.31 Drawing illustrating the image-diameter-to-focal-length ratio: image diameter is approximately $3^{1}/_{2}$ times the size of any given focal length. Drawing by the author.

camera is pointed at the sun so that the shadow of the front is centered on the back. A string attached to the shutter runs the length of the camera for convenient operation. A self-cocking shutter from old folding cameras usually has adequate speeds. 1/100 of a second with a .070" pinhole worked on outdated Kodalith film developed in Dektol.⁸

A 1-inch focal length produces approximately a $3\frac{1}{2}$ -inch diameter circular image. A 2-inch focal length produces approximately a 7-inch diameter circular image. This becomes a useful ratio: *image diameter is* $3\frac{1}{2}$ *times the size of any given focal length* (Figure 5.31). This ratio is valuable

in making multiple pinhole cameras, where each image might slightly overlap the next. The amount of overlap can vary according to each photographer's need (Figure 5.32, Color Plate 5.33a, and Figure 5.33b).

If the flat film plane is exactly parallel to the object being photographed, there is no linear distortion in the image. However, the image may look distorted at its edges, simply because we are not accustomed to seeing as wide an angle as a pinhole can photograph (Color Plate 5.34). If we view only the center area of the image, it will not look distorted. Many pinhole photographs taken on a flat film plane show only the central part of the image, the rest of the circular image has been allowed to fall off the light-sensitive area (Figure 5.35 and Color Plate 5.36). This subject has been extensively researched and photographed by Maurice Pirenne in *Optics, Painting, and Photography* (Cambridge University Press, 1970).

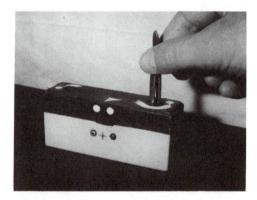

Figure 5.33b © Paolo Gioli, Microcamera StereoStenopeica, 1986. This camera was used to photograph the stereo image shown in Color Plate 5.33a. A lens photo. From the collection at Pinhole Resource.

Figure 5.32 © Jeff Korte, Freshwater Fishing Hall of Fame, 1989. A 30" x 30" pinhole photograph. From the collection of the photographer.

Figure 5.35 © Marianne Engberg, Staircase in Mary's Tomb (Jerusalem). A 9-inch diameter pinhole photograph, 1984. From the collection at Pinhole Resource. The photographer comments, "Standing at the foot of the steps in Mary's Tomb, with the light pouring down from above, touching and caressing each step, I felt the mystery of the place and knew I wanted to photograph it. It was difficult to imagine the place without people, who kept coming down the steps, but I knew that they would not be visible in my shot. I wanted a shot that would capture the beauty and stillness of the place. This can only be achieved with a pinhole box."

Figure 5.37 Drawing illustrating photographic image reaching around inside grits box. Drawing by author.

Photographing onto a Curved Film Plane

A curved film plane produces a distorted image. Why? Because the image has been captured on a curved surface and is being viewed flat on a piece of photographic paper. If viewed curved, as it had been originally photographed, it would not be distorted. But to make it perfectly undistorted, one would have to use only one eye and place it at the position of the pinhole.

Using a *concave* curved container (like a small grits box), a pinhole casts an image of approximately 160 degrees onto photographic

paper that has been almost completely wrapped around the inside of the container—the paper and the image reaching almost to the pinhole (Figure 5.37). A pinhole will photograph this wide an angle inside a curved container simply because the photographic paper is being curved back toward the pinhole where the light intensity is strongest; however, image size near the pinhole is small and increases in size as the paper curves toward the back of the container (Figure 5.38). This explains why a cylindrical container makes an elliptical shaped image, if the paper or film is long enough. Ilan Wolff of Holland utilizes concave curved distortion in his images (Figures 5.39a, 5.39b).

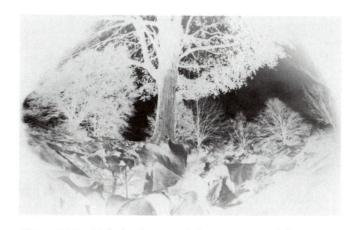

Figure 5.38 Pinhole photograph (paper negative) illustrating image shape when paper is wrapped almost completely around inside a cylinder. A forty-five–second exposure in full sun. Photograph by author.

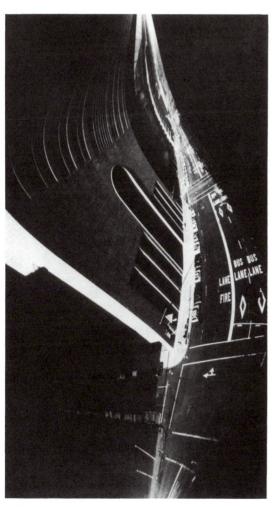

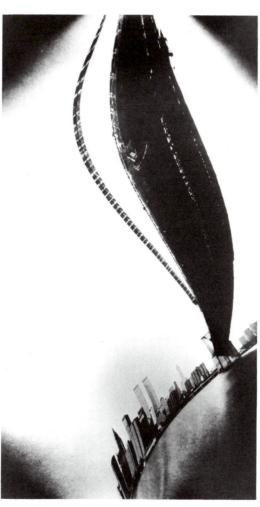

Figure 5.39a © Ilan Wolff, NYC. A 6" x 11" pinhole photograph, 1987. From the collection of the photographer.

Figure 5.39b © Ilan Wolff,
Brooklyn Bridge.
A 6" x 11" pinhole
photograph, 1987.
From the collection
of the photographer.

5.39a

5.39b

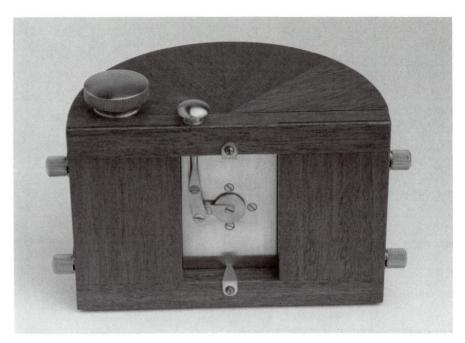

Figure 5.40 © Kurt Mottweiler, Curved Back 120 Roll Film Pinhole Camera, 1990. A lens photo from the collection of the photographer.

Figure 5.41 Drawing illustrating a pinhole image going onto a convex film plane. Drawing by author.

Cutting a cylinder in half (Figure 5.40) creates a pinhole camera with even exposure across the negative, since the focal distance is constant. However, because this camera is curved, it does produce a distorted image—one that will cover almost 180 degrees when using a very sharp pinhole in very thin material. Kurt Mottweiler's "Curved Back 120 Roll Film Camera" is an example of this kind of camera.

Photographing onto a convex curved surface forces the image to fade at its edge quicker, since the light intensity is

Figure 5.42 Drawing illustrating a six-pinhole camera. Drawing by author.

image to fade at its edge quicker, since the light intensity is decreasing rapidly around the curve (Figure 5.41). This fading can be advantageous, particularly when multiple pinholes are used and photographic film or paper is wrapped around an inner cylinder. A camera can be devised using six pinholes, each hole casting an image where 60 degrees is captured onto the cylinder. Each image fades proportionally into the one next to it, so that in the overall total image there is an even exposure (Figure 5.42). Where one image is coming in at 70 percent light intensity, the one overlapping it at that spot is coming in at 30 percent; 80 percent and 20 percent; 90 percent and 10 percent, and so on. Pinholes numbering more or less than six can also be used around an inner cylinder. When using six pinholes, each one capturing 60 degrees of image, a ratio can be given for structuring any size camera: focal distance = the radius of the inner cylinder (Color Plate 5.43, and see also Figures 3.6a, 3.6b, and 3.6c).

Photographing onto an Anamorphic Flat Film Plane

In anamorphic photography, the film plane is radically angled to the pinhole (Figure 5.44). Images can be produced with the film plane almost perpendicular to the pinhole. However, light falloff would be severe. An everyday example of an anamorphic plane can be seen while driving through a school zone. The elongated letters "SCHOOL" are painted on the pavement. When viewed upon approach, the letters are visibly foreshortened, therefore readable.

Anamorphic images with a radically angled film plane can be seen only in their original form by being viewed with one eye from the place where the pinhole would have been. Figures 5.45a and 5.45b show how distortion increases as the film plane angle increases. Gillian Brown's painted image in Figure 6.4b is also an anamorph, as is Leonardo's drawing in Figure 2.10. Working in anamorphs is truly an unexplored area of pinhole photography.

Figure 5.44 Drawing illustrating anamorphosis where photographic film or paper is severely angled away from pinhole. Drawing by author.

5.45a 5.45b

Figure 5.46a © Robert Lang, Panoramic Camera, 1979. A lens photo from the collection at Pinhole Resource.

Photographing onto a Moving Film Plane or Rotating the Camera

Rotating the camera or moving the film plane creates panoramas. Robert Lang of New York has made several exceptional panoramic cameras. His first camera, from 1979, used a periscope structure made out of plumbing pipe rotated by a motor and belt drive system. The film and container were stationary while the pinhole periscope moved. Of this camera and its resulting image (Figures 5.46a, 5.46b), Lang says:

In my camera, which must be darkroom loaded, an entire roll of 120 film fits in a slot around the inside surface of the drum. The structure in the middle is a periscope with the pinhole mounted horizontally between the mirrors. The periscope structure is rotated by motor and belt drive system. The bottom section of the periscope is fitted with a slit which scans the film, producing the panoramic images. The mirrors are front surfaced aluminized glass which I made myself since I have access to vacuum metalization equipment. The pinhole size was calculated using the criteria set forth by Sayanagi (Journal of the Optical Society of America, Vol. 57, No. 9, Sept. 1967). The camera produces images that are foreshortened in the horizontal direction since the distance from the pinhole to the mirror and then to the film plane is greater than the radius of the drum. The camera is remarkably free of banding (vertical stripes) which tends to plague continuous scanning panoramic cameras. 10

Figure 5.46b © Robert Lang, My Cars and I, 1979. A 2" x 30" 330-degree panorama. From the collection at Pinhole Resource.

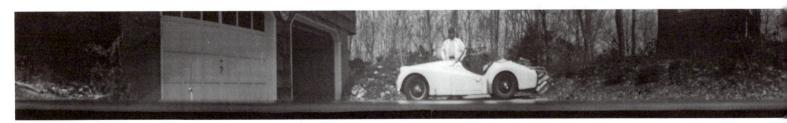

EXPOSURE TIMES

There are many ways to calculate exposure times. Whatever works for you is best. I am reminded of James Thurber's *Many Moons*, a story I often read to my children. In the story, the King asks the Royal Wizard, the Royal Mathematician, and the Lord High Chamberlain the distance to the moon and what material it is made of. Each of the three has a completely different answer. The King then asks the Court Jester which one has given the right answer. The Court Jester replies each is a wise man; therefore, *all their answers must be correct!* This philosophy applies to exposure times—however you go about it is best. Here are several different methods.

For myself, I use the trial-and-error method for exposure. After making a camera, I try it out and arrive at an exposure time. Since pinhole has a wide latitude, I can usually guess fairly well. I've done pinhole for a number of years, so most often my memory bank has enough in it to work. I've never used a light meter. The most difficult exposures to measure without a light meter, at least for me, are ones in low-light situations or where light is fading rapidly, for instance at dusk.

Nancy Spencer explains her exposure method:

I generally use Tri-X film which I rate at ISO 200. I use this rating because I think that if you over-expose Tri-X, the shadow detail is better. I use a Gossen Luna-Pro meter, set at ISO 200. I then point the meter at a Kodak 18 percent gray card placed as closely as possible and in the same light as my subject. I turn on the meter, turn the dial until the needle is on zero, and then read the exposure value (EV), sometimes also referred to as the exposure index. The EV is a chart, available on most handheld meters, which has numbers from 19 to -4. In bright sunlight in New Mexico in the summer, the EV is 16 or slightly higher. On the East Coast in bright sunlight in the summer, the EV is usually around 15. I have worked out a chart, which I have recorded on the back of my gray card. Through tests, I have decided that 2 seconds is a good exposure time for EV 16 with Tri-X film and a $1\frac{1}{2}$ " Santa Barbara Camera. I have then worked out the other EV numbers from 16 to 11, with 11 being the darkest lighting situation attempted outdoors. For example, at EV 15, I expose for 4 seconds, at EV 14 for 10 seconds, etc.

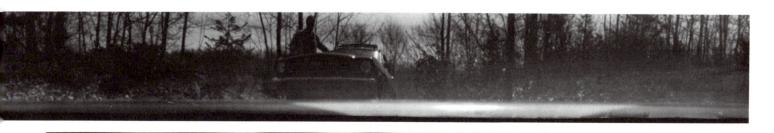

With this method, you don't have to know your f/stop, pinhole diameter, or focal length. You simply measure the amount of light available and learn through trial and error how your film, camera, and developer will react to this lighting situation. In the normal range of lighting situations outdoors, I usually work in the EV 16 to EV 11 range, which amounts to six different exposure times. You will have to run new tests if you use a different size camera. I suggest you work out your own times, taking into consideration type of film, developer and developing times, and reciprocity. 11

Claire Messimer, of Pennsylvania, explains her exposure method (note that quite a bit of time is added for reciprocity):

I use a handheld meter and use the f/22 stop as a base reading. Using a formula that I found in an old *Popular Photography* (January 1988, "Pinhole Pointers," p. 53), I use an f/22 factor of 188x. Example: f/22 at 1/2 second = 188/2 = 94 seconds = 1 minute, 34 seconds (with reciprocity = 4 minutes). I have figured a whole scale that I have taped to the top of the camera.

Ektachrome ISO 100-4" x 5" film

1 second = 8 minutes

1/2 sec. = 4 min.

1/4 sec. = 1 min., 30 sec.

1/8 sec. = 40 sec. 1/15 sec. = 17 sec. 1/30 sec. = 8.3 sec.

1/60 sec. = 3.6 sec.

Most of my exposures are between 1/2 second (4 minutes) and 1/15 second (17 seconds) outdoors. These are only base figures—sometimes I add a little more or less depending on the day. The longest I exposed this for was 20 minutes, 30 seconds. 12

Michael and Nancy Gasperi, of Wisconsin, have supplied the following information and chart on exposure times, illustrated in Figure 5.47a:

It seems unnatural to use a light meter for determining exposure in pinhole photography because of the basic simplicity of the pinhole versus the complexity of an electronic exposure meter. Besides, most meters don't offer f/numbers even close to the range encountered with pinhole work. Scaling of meter results is of little help because the film emulsion is being pushed well beyond the range for which it was designed.

This article provides a method for determining exposure by environmental observation. It is roughly based on the little instruction sheet that was included with film until recently. It had five typical shooting situations and the f/number to use for each. This assumed the film ISO rating and a fixed shutter speed.

Figure 5.47a Exposure Guide for Pinhole Photography. © 1988 Michael and Nancy Gasperi.

Exposure Time

				Вхрози	ic iiiie			
Exposure				IS	0			
Condition	f/	16	32	64	125	200	320	400
Bright or	150	4.1	1.6	1	1/2	1/4	1/8	1/8
Hazy Sun	200	9.2	3.5	1.3	1/2	1/2	1/4	1/4
on	250	17	6.5	2.5	1	1/2	1/2	1/4
Light Sand	300	29	11	4.1	1.6	1	1/2	1/2
or Snow	350	44	17	6.3	2.5	1.3	1	1/2
	400	1.1M	24	9.2	3.6	1.9	1	1
	450	1.5M	34	13	5	2.6	1.3	1
					Ü		1.5	1
Bright or	150	12	4.5	1.7	1	1/2	1/4	1/4
Hazy Sun	200	26	10	3.8	1.5	1	1/2	1/2
(Distinct	250	49	19	7.1	2.8	1.4	1	1
Shadows)	300	1.3M	31	12	4.6	2.4	1.2	1
	350	2.1M	48	18	7.1	3.7	1.9	1.4
	400	3M	1.1M	26	10	5.3	2.8	2
	450	4.2M	1.6M	37	14	7.4	3.8	2.8
TAT 1 TT	1.50							
Weak, Hazy	150	29	11	4.1	1.6	1	1/2	1/2
Sun (Soft	200	1M	24	9.2	3.6	1.9	1	1
Shadows)	250	2M	45	17	6.7	3.5	1.8	1.3
	300	3.3M	1.3M	29	11	5.8	3	2.2
	350	5.1M	2M	44	17	9	4.6	3.4
	400	7.5M	2.8M	1M	25	13	6.7	4.9
	450	10M	3.9M	1.5M	35	18	9.4	6.9
Cloudy	150	1.3M	30	11	4.4	2.3	1.2	1
Bright (No	200	2.9M	1.1M	25	9.8	5.1	2.6	1
Shadows)	250	5.4M	2M	47	18	9.5		1.9
Siladows)	300	9M	3.4M	1.3M	31		4.9	3.6
		9M 14M		2M		16	8.2	6
	350		5.3M 7.7M		47	24	13	9.2
	400	20M		2.9M	1.1M	35	18	13
	450	28M	11M	4M	1.6M	49	25	19
Open Shade	150	3.3M	1.3M	29	11	5.8	3	2.2
or Heavy	200	7.4M	2.8M	1M	25	13	6.7	4.9
Overcast	250	14M	5.3M	2M	47	24	13	9.2
	300	23M	8.8M	3.5M	1.3M	41	21	15
	350	36M	14M	5.1M	2M	1M	32	24
	400	52M	20M	7.4M	2.9M	1.5M	47	34
	450	1.2H	27M	10M	4M	2.1M	1M	48
						2.1141	1141	10
Early A.M.	150	9M	3.4M	1.3M	31	16	8.2	6
or	200	20M	7.7M	2.9M	1.1M	35	18	13
Late P.M.	250	38M	14M	5.4M	2.1M	1.1M	34	25
	300	1H	24M	9M	3.5M	1.9M	1M	42
	350	1.6H	37M	14M	5.4M	2.8M	1.5M	1M
	400	2.3H	53M	20M	7.9M	4.1M	2.1M	1.5M
	450	3.3H	1.2H	28M	11M	5.7M	3M	2.1M

All times in seconds unless noted. M = minutes, H = hours.

For most pinhole photography, the f/number is fixed by camera design. It is determined by dividing the distance of the pinhole to the film by the diameter of the pinhole. Usually it turns out to be many hundreds. The only exposure control is time once a film has been selected.

Equation 1 [Figure 5.47b] is the relationship needed to transform one set of exposures to another equivalent set. It assumes that the film has the property of reciprocity. This is true for the range of exposures that would be expected for lens photography (less than one second), but pinhole work usually requires exposure times where the relationship fails. Equation 2 [Figure 5.47c] is used to correct for reciprocity failure. After plotting several correction tables on log-log paper, a straight line fit was made and equation 2 determined.

$$Time_{correct} = 18^{1.4 \text{ LOG (Time}_{new)}}$$

Figure 5.47b Equation 1.

$$\label{eq:time_new} \mbox{Time}_{new} \ = \ \mbox{Time}_{base} \, \left(\frac{f_{new}}{f_{base}} \right)^{\! 2} \, \frac{\mbox{ISO}_{base}}{\mbox{ISO}_{new}}$$

Figure 5.47c Equation 2.

Equation 1 was used to convert the guide exposures from a typical instruction sheet to a range suitable for pinhole work. Where the exposure time exceeded one second, equation 2 was used to correct the exposure time. The table was created by using the equations for seven f/numbers and seven film ISO ratings for six exposure conditions.

At any given time, the photographer is only interested in six numbers from the table. The f/number is fixed from the camera and the ISO is fixed by the film. For example, if an f/300 camera is being used with ISO 64 film, the six conditions lead to times of: 4.1 seconds, 12 seconds, 29 seconds, 1.3 minutes, 3.5 minutes and 9 minutes. If your camera f/number is between the ones on the chart, average the time values for the f/number cases above and below it.

If you work with paper negatives, then you should use the ISO 16 column. Paper doesn't really have an ISO rating and there are many different speeds available. For a fast black-and-white resin coated paper, the numbers are very reasonable.

Your ability to judge lighting conditions and time the exposure can lead to error. It is a good idea to bracket important shots with more and less time. Times less than half a second indicate that a shutter probably needs to be used. Most indicate that a tripod is required.¹³

ADDITIONAL TECHNICAL INFORMATION

Filters

Adding a filter means increasing the exposure time (Color Plate 5.49a). Many pinhole photographers who use outdoor color film in daylight do not use filters.

Ilfochrome Classic paper used directly in the camera for photographing outdoors can be filtered with an 85B filter to change tungsten light to daylight, with additional filters added to completely correct the color. Examples of filtered Ilfochrome Classic are shown in the images by Willie Anne Wright in Color Plates 4.14 and 5.34 and Howard E. Williams in Color Plate 5.50. Williams, of Florida, gives the following information on filtering Ilfochrome Classic (referred to in his statement as Cibachrome, its former name):

Cibachrome paper is not designed to be exposed in sunlight. The "color temperature" of sunlight at noon is 5400 K. Converting daylight to tungsten by using an 85B filter in exposing Cibachrome in a pinhole camera is just the beginning. The inherent color balance of Cibachrome differs from batch to batch and box to box. Therefore it is possible that using an 85B filter might still result in a print which is a little too warm (yellow) or a little too cool (blue). This can be remedied with additional filters called light-balancing filters (filter series 81 and 82). These filters allow you to adjust the color temperature, cooler or warmer, in increments as little as 100 degrees K.

The other critical element of pinhole Cibachrome is how long to expose the image. Compared to photographic films, Cibachrome paper is incredibly slow with an effective film speed of ISO 1. The focal length of the camera being used, the diameter of the pinhole, the number of filters added for color correction, and the time of day the exposure is being made all affect exposure time. When purchasing Cibachrome paper try and match, as closely as possible, the color code of one box to another. This will keep you from having to start over from scratch each time you test for exposure and color correction from one box of paper to another. To keep your color and exposure tests consistent, photograph during the middle of the day, in bright sun with little or no clouds. The color temperature of sunlight early in the morning and late in the afternoon is different from that of sunlight at midday. Cloud cover also affects color temperature. 14

With Ilfochrome Classic placed directly in a pinhole camera, but unfiltered, the color balance can shift toward blue (Color Plate 4.4b), magenta (Color Plate 4.15), or green (Color Plate 6.7), or it can be fairly accurate. Generally it is best to slightly under-expose, rather than slightly over-expose.

A simple way to add a filter holder and a "snap cap" shutter (Figure 5.48) has been designed by Joseph Jakusz of Nevada. Some pinhole photographers find it useful to add

Figure 5.48 © Joseph Jakusz, Filter Holder and Snap-cap for a Pinhole Camera. Lens photo, 1992. From the collection of the photographer.

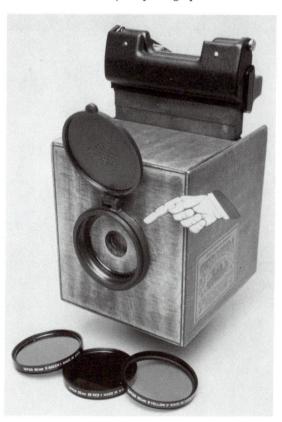

Figure 5.51 © Eric Renner, Red Pepper Natural Safelight Pinhole Camera for use with black-and-white photographic paper, 1987. A lens photo by Russ Young. From the collection at Pinhole Resource.

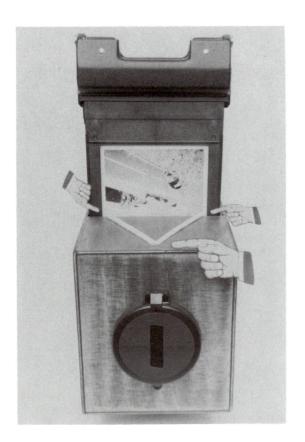

filters to lengthen the exposure time when shooting in black and white or to change subject contrast. Jakusz explains:

I bought a 58 to 62mm step-up adapter ring and ground off the 58mm male threads. This left a nice flat surface on the back of the ring, which I then glued to the front of the camera with a smear of 5 Minute Epoxy. For those times when you want a busy street to appear devoid of traffic, the 62mm female threads will accept several filters in a stack without vignetting. More often, though, I'll just use a #25 Red to darken the blue sky on black and white film or a polarizer to kill a bothersome reflection. My Fast Cap is a 62mm W. A. (wide angle) hinged and spring-loaded lens cap. It threads onto the adapter ring or on top of whatever filter I'm using, pops open with the touch of a finger to begin an exposure, then securely snaps shut to end it.15

Viewfinders

To help visualize the boundaries of the image, a simple sighting mechanism can be added to the top and both sides of your camera (particularly easy to use if your camera is rectangular or square) by drawing straight lines on the outside of the camera that extend from the pinhole to the edge of the film plane (Figure 5.52). Everything within the created triangle will image.

Adapting Lens Cameras to Pinhole

Almost every lens camera, including a Polaroid, can be fitted with a pinhole. For 35mm cameras with interchangeable lenses, simply use a body cap. If the cap is not too thick, drill a very small pinhole in it; if thick, then a large hole must be drilled and a pinhole in shim stock or aluminum added. Using fast film, the camera can be held by hand. A second alternative would be simply to use a pinhole taped over the lens opening. Commercial pinhole mounts for Leica's are available from Dominique Stroobant (address in the list of suppliers in the appendix). Even the classic plastic "Diana" will work for pinhole photography if the lens is removed and a pinhole added.

Figure 5.52 © *Joseph Jakusz*, Placing Sight Lines on a Pinhole Camera. *Lens photo, 1992. From the collection of the photographer.*

ADDITIONAL HINTS FOR BUILDING PINHOLE CAMERAS

Many pinhole cameras have been constructed of matboard, which works best when doubled. White glue can be used to hold two sheets together. Weight these sheets with heavy books against a flat surface such as a tabletop while drying. Very rigid corners can be made with doubled matboard using the construction detail shown in Figure 5.53a. Light trap tops can be made similar to the construction detail shown in Figure 5.53b.

Just about anything can be made into a light-tight camera; even vehicles have been made into portable cameras and darkrooms. Peggy Ann Jones made her Dasher stationwagon into "Auto-Focus." Jo Babcock and Pinky Bass have turned vans into touring cameras; others have used truck bodies for even larger imagery.

NOTES

- 1. Tom Fuller, letter to the author, 5 December 1991.
- 2 Ibid
- 3. Jay Bender, The Pinhole Photography Kit: The Complete Guide to Lensless Photography (self-published, 1990), 16.
- 4. Bob Dome, letter to the author, 5 November 1991, 5-6.
- 5. M. Jules Combe, "Pinhole Photography," *Photography* 12(20 December 1900):842.
- 6. Jim Moninger, "Variable Aperture Pinhole Photography," *Pinhole Journal*, 7(3):5–6.
- 7. Walter Boye, letter to the author, 22 November 1991.
- 8. Jim Jones, "Artist's Statement," Pinhole Journal 2(2):2.
- 9. Marianne Engberg, "Artist's Statement," Pinhole Journal 1(1):24.
- 10. Robert Lang, "Artist's Statement," Pinhole Journal 2(1):23.
- 11. Nancy Spencer, "Making a Simple Pinhole Camera," *Pinhole Journal* 8(1):16.
- 12. Claire Messimer, "Artist's Statement," Pinhole Journal 7(2):14.
- Michael and Nancy Gasperi, "Letter to the Editor," Pinhole Journal 5(1): inside front cover.
- 14. Howard E. Williams, "In-Camera Pinhole Cibachromes," *Pinhole Journal* 8(1):18–19.
- 15. Jakusz, 20.

Figure 5.53a Construction detail of overlapping matboard corners. Drawing by author.

Figure 5.53b Construction detail of matboard light trap. Drawing by author.

Has anyone ever brought up the idea that pinhole photography is four dimensional? The thought has been gnawing at me, lately. You know that standard photos, no matter how good they may be, are two dimensional. Stereo photography, so called three-dimensional photography, adds the illusion of depth, but it's only an illusion. The 3-D image that jumps out at you, is only focused on one point. The third dimension is depth, and our eyes see in 3-D because they can refocus on any given point, in any given view, and thus see all points clearly. The pinhole records all points of any given view with equal clarity, thus, while the image may not leap off the paper, we can look at any good pinhole photo and see any point, foreground to infinity, with equal sharpness. I'd consider that 3-D, wouldn't you? Which brings us to the fourth dimension, time. Pinhole exposures are always based on time. They may take a few seconds, or a few minutes, or a few hours, but they're always determined by the passage of time. If the subject is stationary—a rock, a building, etc., the results are clear and sharp (time stands still). If, however, the subject is fluid, such as water, or clouds, the pinhole will record that as softness or blur, how much, is determined by the amount of movement, or the duration of exposure. What brought all this on was seeing George Peer's Lake Superior Series—these are what I'd call good examples of four dimensional photography [Figure 6.1].

6

Kent Nunamaker personal letter to the author, 1991

Transforming the Pinhole Image: Extensions and Alternatives

Using a variety of techniques, many photographers alter the pinhole image. Bruce Habegger of New York uses 35mm Polachrome slide film. When the print is enlarged, the color in Polachrome separates into minute dots, reminiscent of a post-Impressionist Seurat painting (see Color Plates 5.33a and 6.2). Sam Wang of South Carolina scans pinhole imagery into a computer; the dot matrix in Wang's printout also breaks the continuous tone (Color Plate 6.3).

Gillian Brown of Maryland creates anamorphic installations. In her seated figure (a painting of Professor Jeff Weiss from the Rochester Institute of Technology), Brown forces the viewer to first see Weiss by looking through a hole placed at eye level in the door to his faculty office. In this view, he looks as if he is really there. Upon entering the office, it becomes apparent he is nothing more than a life-size anamorph painted onto the chair, lamp, desk, and floor (Color Plates 6.4a, 6.4b). Of this piece, Brown says:

I covered the window in this office with black mat board with a hole at eye level the size of a 35mm contact print. Through this hole one could see the painted installation. Or the hole could be blocked with

a 35mm contact print of the scene within. Both the life-size installation and the small contact print in some sense filled the same space. The faculty member was painted ever-present at an ever-vacant desk. Many students worked on the painting and also executed art works which could be found upon opening drawers or flipping the blinds.¹

Jay Bender makes pinhole video (Color Plate 6.5). He explains:

Well, you unscrew the lens and the problem with doing pinhole video is the speed of pinholes. They're too slow for video unless you can get the pinhole very, very close to the little exciter tube in the camera. There's a number of cameras you wouldn't be able to do it with, because there's too much junk out in front that you'd have to saw away. But with the camera that I have [an old Panasonic] you can unscrew the lens—and then I've got a little plastic piece which is actually off an old Datsun. It fits in there just perfectly; it's actually recessed in about 1/2" and I've got the pinhole mounted in that little plastic piece. The pinhole is about 1/16th inch away from the exciter tube—which is pretty close. The area that senses light is so small; even at that close distance it's about a normal focal length. . . . The pinhole is the smallest one I've ever drilled. It is .12mm and it's hard to measure. It's hard to drill a hole that small—it's like the very tip of the smallest beading needle you can find.²

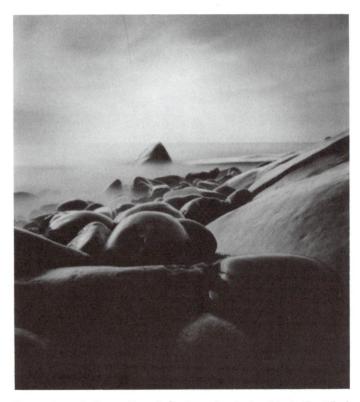

Figure 6.1 © George Peer, Lake Superior Series #1. A 4" x 5" pinhole photograph, 1989. From the collection at Pinhole Resource.

Bobbe Besold of New Mexico uses pinhole as a starting point for her Van Dyke prints, which are then painted with watercolor, pastel, gouache, and pencil. Reid Wood of Ohio uses a photocopier to transform gelatin silver pinhole images into stamp-size mail art (Color Plate 6.6).

SLIT IMAGING

Pinhole photography has many curious relatives. All are pinhole phenomena; however, to use a terrible pun—they do stretch the point! First, if we take a pinhole and elongate it by turning it into a slit, this apparently crude aperture will still produce an image of very reasonable quality. If the image is too blurred, the slit may be too large for the focal length. In many of my cameras, I have consciously preferred to see a crude aperture, even an aperture that looks like a gash rather than a refined slit, produce a degraded image rather than have a sharp aperture produce a sharp image. For example, in one portrait camera, I used a slit in a rose petal as an aperture. To do this, I taped the petal over a large hole and loaded the camera. When ready to photograph, I slit the petal and made the image (Color Plate 6.7). Each image required a new petal, and each petal had a very different slit, which seemed to correspond to the lines along the petal. I am always surprised such an unsophisticated aperture works so well!

A series of single slit images can be seen in Color Plate 6.8. In this long hallway camera obscura, Harry Littell covered a row of windows, except for horizontal slits, which acted as apertures for each window. The images from these apertures were rear-projected onto a long translucent screen and then viewed from the front. Color Plate 6.8 is actually a series of upside-down images. Sky, street, and moving cars are easy to see if you turn the figure upside down.

Slit photography, which dates back to the late 1800s, seems to be first mentioned by William H. Pickering:

The pinhole principle may also be used for another purpose, more amusing, perhaps, than artistic, which was first suggested to me by Mr. J. R. Edmands. Let us substitute for the lens a narrow vertical slit, about three inches long by one-fiftieth of an inch wide, made by pasting two strips of black paper side by side. About two inches behind this arrange a horizontal slit of the same dimensions. Two inches behind this place the sensitive plate. The apparatus is analogous to two cylindrical lenses of different foci placed at right angles, but is more readily adjusted. If an exposure is now made we shall find everything distorted to twice the size horizontally that it is vertically. By turning the camera on its side we get a vertical distortion. By inclining the slits at different angles variously distorted pictures may be obtained.³

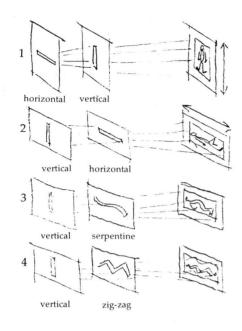

Figure 6.9a © Doris Markley, Slit Drawings, 1987. From the collection at Pinhole Resource.

Pickering's dimensions are perfectly useful today. A combination of two slits, one placed vertically and one placed horizontally (as Pickering suggests), will produce images (Figures 6.9b, 6.9c) that are distorted in a similar manner to those shown in the drawing in Figure 6.9a by Doris Markley of Philadelphia.

What was once known as the "World's Largest Pinhole Camera" (Figure 6.10) was nothing less than a huge concrete room with two rectangular air vents. Each vent acted as a large slit aperture. Measured separately, each vent was one foot wide by two feet long and cast a fifty-foot-long image of one of the Bay Bridge's suspension towers, while under construction in 1930. Of course these two images were completely accidental. Fortunately, someone was observant enough to see them! The 115-foot-square room, where these images were projected, was designed to be an anchor tower, not a camera. After the bridge was completed, this tower room was removed. So much for the "World's Largest Pinhole Camera." It, too, was disposable. The moral to this story is that a hole as large as 1' x 2' will make an image—as long as the focal length is correct.

Figure 6.9b © Doris Markley, Untitled, 1987. A 4" x 5" slit photograph (vertical front slit, horizontal back slit). From the collection at Pinhole Resource.

Figure 6.9c © Doris Markley, Untitled, 1987. A 4" x 5" slit photograph (horizontal front slit, vertical back slit). From the collection at Pinhole Resource.

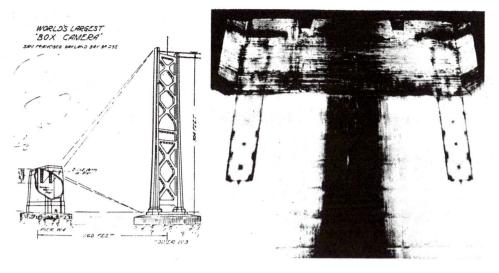

Figure 6.10 © World's Largest Pinhole Camera, photograph by Gabriel Moulin Studios, circa 1930. From the collection of Gayle Smalley.

ZONE PLATES

Lord Rayleigh was the first to design a zone plate, which can be placed over a very large pinhole. Fresnel half-wave diffraction zones have been rendered opaque, so that destructive interference of waves from adjacent zones does not take place; instead, the waves passing through the remaining transparent zones constructively interfere, with a consequent large increase in amplitude of the optical disturbance. A zone plate image can be exposed in much less time, sometimes 1/10 the time of a pinhole image, because a zone plate operates at a lower f number. (For a comparison of pinhole and zone plate images, see Claire Messimer's photographs in Color Plates 5.49a and 5.49b.) Zone plates tend to produce a "softer focus" image than a pinhole, and every focal length requires a specific diameter zone plate. In his research diary of 11 April 1871, Lord Rayleigh's entry reads:

The Experiment of blocking out the odd Hughens' zones so as to increase light at centre succeeded very well and could be shown in quite a short space. The negatives should not be varnished. I have little doubt that the number of zones blocked might be advantageously increased much beyond what I used (15). No great accuracy is required in filling in the odd zones with black.⁵

Figure 6.11a © Drawing of enlarged zone plate by Kenneth A. Connors, 1988.

Kenneth Connors has researched zone plates for many years and was the first to make them commercially available to pinhole photographers through Pinhole Resource. Connors explains the preliminary drawing (Figure 6.11a) and completed photographic reduction for a zone plate:

The classical preparation of a zone plate begins with the drawing of concentric rings having radii proportional to the square roots of the integers; alternate zones are blackened, and a photographic reduction is made on high-contrast film. This film negative serves as a zone plate.

The degree of photographic reduction required to produce a zone plate with desired focal length is readily calculated. For the copy camera set-up the following equations are applicable

$$F = f(1 + 1/M)$$

$$U = f(1 + M)$$

$$M = U/F$$

where M is the ratio object-to-image size as recorded on the negative, f is the focal length of the copy lens, F is the lens-to-film distance, and U is the object-to-lens distance. It may be necessary to carry out the reduction in two steps. 6

Richard Vallon of Louisiana, one of the photographers to use Connors's zone plates, at present produces short-focal-length zone plates (75mm), also available through Pinhole Resource. Vallon gives the following observations on the use of zone plates:

The Zone Plate User's Guide for Pinhole Photographers

by Richard Vallon

A zone plate can be thought of as a modified pinhole which consists of a pinhole surrounded by alternating concentric clear and darkened rings. An actual zone plate is a frame of high-contrast 35mm lithographic film with the center clear "pinhole" and surrounding clear circles comprised of transparent film base; alternating circles and surrounding areas are opaque exposed film emulsion.

Imaging Theory

Before I explain how a zone plate works, first let us review how the simple pinhole images things. A point which I will refer to as "p" [Figure 6.11b] reflects light rays through a pinhole at which point diffraction (a slight spreading of the light rays caused by passing near the edge of the pinhole) occurs. The light rays continue on and form a slightly "blurry" image of point "p" on the film plane inside of the pinhole camera. Pinholes do not gather light; they only allow the

light that passes through them to reach the film plane and form an image. The simple lens [Figure 6.11c] works by bending all of the light rays that reach it from point "p" and bringing these rays into focus to form an image of point "p" at the film plane. The entire surface of the lens gathers the rays of light coming from point "p" transmitting a tremendous amount more light to the film plane than the pinhole. Lensless photographers are well aware of the shortcomings of lenses which have limited depth of focus, produce overly sharp images and can be broken if dropped from a sufficient height.

How the Zone Plate Works

Like the simple lens, the zone plate gathers light. Unlike the pinhole, the zone plate actually uses diffraction to help form images. Remember, diffraction is a contributing factor that limits the sharpness of pinhole photographs. [Figure 6.11d] depicts how the zone plate uses diffraction to gather light. Light from point "p" enters the central "pinhole" in the zone plate and passes on to form an image of point p at the film plane. In this respect the zone plate forms images the same way that a pinhole does. The outer clear circles of the zone plate diffract the light coming from point "p" bending this light and bringing it into focus at the film plane. The clear zones are spaced so that the diffracted light that would not contribute to forming an image of point p is can-

celled by a phenomenon known as destructive interference, in which the stray light rays (waves) collide and neutralize each other. In this way zone plates gather more light than pinholes and form images. Because zone plate apertures are tiny, they possess the same tremendous depth of focus for which pinhole imagery is known.

Zone plates make photographs which depict objects with pinhole sharpness and a soft halo of light surrounding the edges of these objects. When reproduced as an illustration as seen in these pages, the halo effect is well depicted but the dot pattern is not fine enough to display how sharp these images actually are. Zone plate and pinhole images both "benefit" from various types of distortion. The widest angled zone plates for a given format possess pincushion distortion, which is caused when a flat piece of film is used in the camera; the corners of this film are further from the zone plate than the center of the film. The corners of images made with the widest angle zone plates will be darker than the center and also less sharp. Curving the film plane laterally will greatly lessen these aforementioned distortions when using the wider angled focal length zone plates.

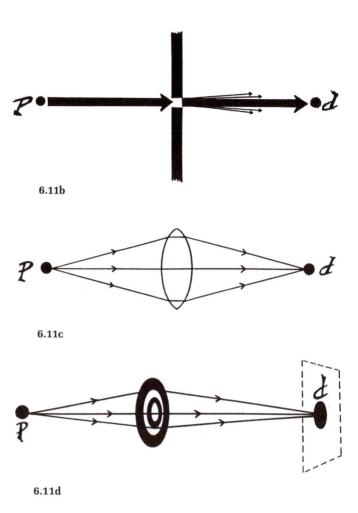

Figure 6.11b © Drawing of pinhole diffraction by Michael Chaney, 1992.

Figure 6.11c © Drawing of lens refraction by Michael Chaney, 1992.

Figure 6.11d © Drawing of zone plate with diffraction by Michael Chaney, 1992.

Figure 6.12a © Richard Vallon, Still Life of Fruit, 1991. A 4" x 5" zone plate photograph from an under-exposed TMAX 400 negative; exposure two minutes under available room light. From the collection at Pinhole Resource.

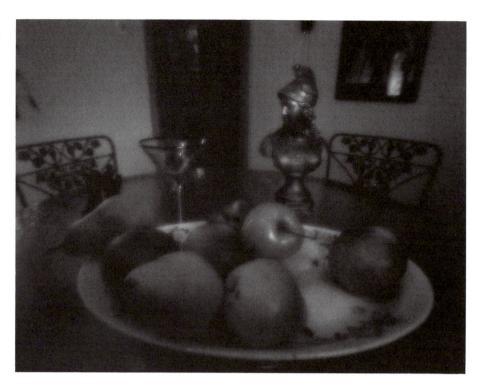

Images and Techniques

For those of you who have a pinhole camera that accepts 4" x 5" sheet film holders, a 4" x 5" Polaroid instant sheet film holder is a delightful convenience. Polaroid type 55P/N film produces an instant black-and-white print that allows you to check your results and also provides an instant negative. The instant negative is "fixed" in a strong (relatively harmless) sodium sulfite solution and then washed and dried normally. The Polaroid print looks best when it is exposed at a rating of 50 ISO, but to produce a good, fully exposed negative, the 55P/N material should be rated at 32 ISO. A good strategy when working with this material is that if the print looks properly exposed, then the negative is under-exposed. If this is the case and I want a good instant negative for printing later, I put another sheet of film in the holder and give it twice the exposure. If the print is over-exposed (too light), I fix the 55P/N negative that was made with it in the sulfite solution and study the image to see if it is properly exposed, composed, etc. Polaroid Type 52 instant sheet film is an ISO 400 speed black-and-white print material that is good for previewing results when working with 400-speed sheet films. The other 4" x 5" sheet film that I use is Kodak TMAX 400 black-and-white negative film, which is used in low-light situations and also with the flashing technique described later. I rate TMAX 400 at a speed of 200 and develop it in D-76 diluted 1-1.

Zone Plates and the Close Flashing Technique

The zone plate is so much faster than imaging with a pinhole that I feel it can open new vistas to lensless photographers, enabling them to photograph in much lower lighting conditions than with a pinhole

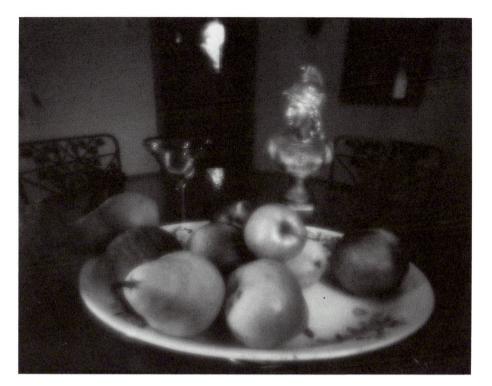

Figure 6.12b © Richard Vallon, Still Life of Fruit, 1991. A 4" x 5" zone plate photograph; 75mm macro zone plate on a Santa Barbara Camera. Print from a TMAX 400 negative while using the flashing technique and incorporating the same available room lighting in Figure 6.12a. The closest pear is about five inches from the zone plate. From the collection at Pinhole Resource.

alone; hour-long exposures become minutes and minute-long exposures become seconds. Using a technique that I call "close flashing," you can photograph a small still life at night, using only a small battery powered flash as a light source.

I used a Vivitar 283 four penlight battery electronic flash with a variable power module set to 1/4 power to make the photographs in [Figure 6.12a] and [Figure 6.12b]. I constructed a black cardboard hood which I taped to the head of the flash to prevent stray light from spilling directly into the camera. Holding the flash approximately six inches from the subject, I would fire the flash numerous times to light each section of the still life. The fruit in [Figure 6.12b] was flashed about six times. After checking the result of the flashing using the Polaroid Type 52 ISO 400 film, I then made the final exposures on TMAX 400 film. These recommendations are only a starting point and if you cannot make Polaroid tests, I suggest you bracket your flashes and keep careful notes to perfect your technique. The flashing technique combined with the zone plate allows you to make lensless photographs at night or inside on those rainy days.

Choosing a Zone Plate

For those of you interested in making the overall sharpest photographs using the zone plate, the normal or slightly wide angle zone plates for a given format will be your best choice. The "halo" glow effect is minimized in the wide angle zone plates and maximized in the telephoto zone plate for a given format. Zone plates are not as forgiving as pinholes in that it is important when using a camera with a set focal length, such as the Santa Barbara Camera, that you use the zone plate that matches the focal length of the camera to get the sharpest

photographs. I also strongly recommend the use of a "lens" hood for both pinhole and zone plate cameras. For those of you not familiar with large format, here is a table to help you choose a zone plate:

Film Format	ilm Format Telephoto		Wide Angle		
4" x 5"	300, 240, 210mm	150mm	120, 90, 75mm, also in macro focus 6" to 6'		
5" x 7"	300, 240mm	210mm	150, 120, 90mm		
8" x 10"	_	300mm	240, 210, 150mm		

The zone plate apertures sold through Pinhole Resource transmit about ten times more light to the film plane than an optimal pinhole of the same focal length. For convenience, the [preceding] table lists wide angle zone plates that have sufficient covering power (the ability to form an image across the entire film plane) for a given format. When printing negatives made from wide angle zone plates, it is necessary to burn in the center of the image because it has received more light than the edges. The wide angle zone plates are faster (transmit more light) than the normal zone plate for a given focal length, the fastest being the 75mm zone plate for the 4" x 5" format. When you order a zone plate from Pinhole Resource, the f/stop is listed on the outside of the envelope. Those who use a view camera with a zone plate will find that the image on the ground glass is bright enough to focus on such subjects as tree limbs against a bright sky. To do closeup work with a view camera, you can focus on the image of the filament of a clear light bulb placed at the distance of the macro subject.⁸

Russ Young of New Mexico, who has spent several years making zone plate photographs, gives additional specifics on zone plates:

Some Practical Hints for Zone Plate Photographers

by Russ Young

A pinhole is a "nothing" or rather, a tiny hole in an opaque support. A zone plate, however, is a "something"; in our case, an image made on a specialized black-and-white film. As such, there are concerns unique to zone plates that must be addressed by the photographer for successful shooting.

The film our zone plates are on can never be either perfectly opaque or perfectly transparent. After processing, all film will have some residual silver left in even the unexposed areas; this acts to scatter the light coming through the relatively clear areas of the zone plates, decreasing contrast and resolution. Nothing can be done to avoid this. Additionally, the light must pass through the plastic base of the film. Although it looks like a perfect surface to our eyes, it does not approach "optical quality" glass. The result? It will distort, to some degree, the light passing through it. Also, since it has two surfaces (front and back), some proportion of the light is lost reflecting off of them (just like an uncoated lens), and some hits the negative as scattered

light. Again, this lowers contrast and nothing practical can be done to solve it. Furthermore, a fixed proportion of the light passing through a zone plate does not contribute to the image; this also lowers the contrast. Because we cannot solve these problems, we must do everything possible to ensure that nothing else lowers contrast, resolution or definition any further. The remainder of this article gives some practical pointers on making the best of zone plates, both by minimizing their shortcomings and by accentuating their unique character.

Mounting the Zone Plate

No matter how dense it may look to our eyes, the darkest negative will still pass some amount of light. This is true of the area on the film surrounding the zone plates. To prevent unwanted light from leaking onto your film (producing fog), a zone plate must be mounted over a SLIGHTLY larger hole on an opaque support. An easy support to purchase and to drill is "shim brass" which is available at any auto parts store. It comes in several thicknesses, any of which will work except for the thinnest (.001"). I generally use .003" or .005" brass. Use a drill to make a hole ever so slightly larger than the diameter of the zone plate. Listed below are the appropriate sizes of fractional drills (with better fitting but harder to obtain "number drills" in parentheses):

Zone plate	Drill	Drill size			
75mm	5/64"	(#50)			
120mm	3/32"	(#42)			
150mm	7/64"	(#37)			
210mm	1/8"				
240mm	9/64"				
300mm	5/32"	(#27)			

Tape the zone plate onto the brass plate, on the side facing into the camera body. The matte side of the zone plate should face inside. Mask the zone plate negative with flat black photo tape until not much more shows than the zone plate itself. Unless you cover most of the negative with the tape (similar to blackening a pinhole), it will be an additional reflecting surface inside of your camera. Now mount it on your camera the same way you might mount a pinhole. If possible, use a lens hood or some other device to shade the zone plate; this prevents highly undesirable flare (and resulting low contrast) on the negative. You can easily construct a shade using a small box or tin can painted ultra flat black on the interior.

Cleanliness

Like any other surface, a zone plate attracts dust, lint and finger-prints, all of which seriously degrade the image. Do your best to keep it clean. Mine are regularly dusted with an extremely soft brush and blown off with canned air to remove stubborn particles. A fingerprint can be removed with film cleaner and lens cleaning tissue but do it very gently—a scratch can ruin a zone plate.

Figure 6.13a © Russ Young, Aspen Stand, 1991. A 5" x 7" zone plate photograph, 120mm zone plate. From the collection at Pinhole Resource.

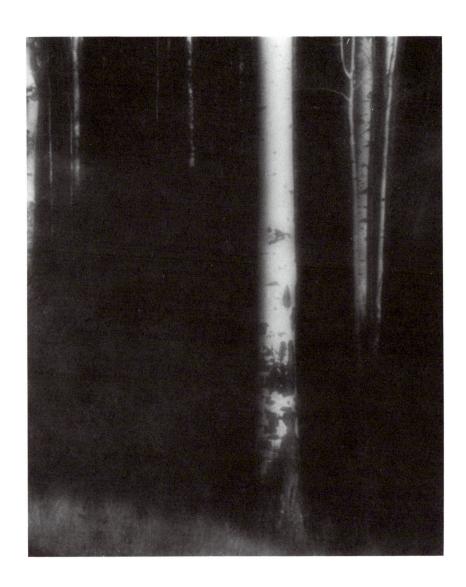

The Camera Interior

Virtually any camera can be adapted to use zone plates. If you have made your own camera or are using a commercially manufactured pinhole camera, you should always paint the interior with ultra flat black paint (not just flat black which is too reflective for photographic purposes). Most major brands of spray paint have this color and there is no substitute!

Focus

What? Focus? Yes, you should focus a zone plate. Zone plates operate at around f/90 to f/128 and as such, they have less depth of field than a pinhole. Hence, you should focus particularly if the subject is fairly close. Because zone plates pass so much more light than pinholes, focusing usually is not difficult. After letting my pupil dilate for a few seconds, I have no problems seeing the image through a single lens reflex camera (using a rubber eye cup around the viewfinder really

helps). If you are using a view camera with a ground glass, a Fresnel lens on the ground glass will brighten the image considerably; be sure your dark cloth is both large enough and opaque enough to exclude all unwanted light. If you are using the Pinhole Resource 75mm "close up" zone plate on the Santa Barbara Camera, you do not have to make any focus adjustments for relatively close work—it has been done for you.

Composition

Like pinholes, the resolution of zone plates is low when compared to a lens. Zone plates have better resolution than pinholes but poorer definition; hence, strong compositions generally include masses of lights and darks rather than relying on textures or details. Take advantage of the wonderful "glow" intrinsic to zone plates! This is best achieved by placing a light subject against a dark background [Figure 6.13a].

One enormous advantage of zone plates is their relative speed, approximately f/100. Although this may seem extremely slow to a lens photographer (but only one stop slower than the f/64 of Edward Weston), it is many times faster than a pinhole of comparable focal length. Fast enough, for instance, to take photos at night or indoors, in seconds or a couple of minutes. Since there is no real reason to use fine grain film to preserve detail, ISO 400 films provide a comfortable level of sensitivity without objectionable grain.

Pinpoint highlights (such as water droplets [Color Plate 6.13b] or glare on a fender) will produce a facsimile image of the zone plate. Depending on your viewpoint, this can either be distracting or magical.

If you include the light source itself [Figure 6.13c], the result will be a large area of over-exposure around the light which I consider fairly unappealing.

Figure 6.13c © Russ Young, Main Street, Trinidad, 1991. A 5" x 7" zone plate photograph. From the collection at Pinhole Resource.

Films

A substantial problem for both pinhole and zone plate photographers is reciprocity failure. Most black-and-white films begin to experience serious reciprocity effects at exposure times of one second or more, quite common in non-lens photography. The only way to compensate for reciprocity is to increase the already lengthy exposure time. The moral: use films with improved reciprocity characteristics. The only two I can recommend are Kodak's TMAX 100 and TMAX 400. A bonus is that they are fine grained and also more panchromatic than other black-and-white films. TMAX 400 can readily be pushed to higher exposure indexes, too, but this will produce shorter tonal range images.

For color film, the low contrast nature of zone plates acts to mute the colors. If you wish to retain a reasonably normal color saturation, you need to use a contrasty film. Fuji's Reala print film answers this need admirably. Part of the lack of color saturation is also due to the marked chromatic aberration in zone plates with more than five zones (like the ones sold through Pinhole Resource).

Print film has a much broader exposure latitude than transparency (or slide) film; I would never recommend slide film for lensless photography. Print films are standardly available in speeds up to ISO 3200. The rule of thumb is that the higher the speed, the less saturated the color, which exacerbates the inherent low-contrast nature of zone plates. If you desire saturated colors, keep to ISO 400 or less films.

Figure 6.14 © Robert Mikrut, Bagscape, 1987. A $7'' \times 9^{1/2}$ " zone plate photograph. From the collection at Pinhole Resource.

Figure 6.15 © Kenneth A. Connors, Surf at Salmon Creek, CA, 1986. A $9" \times 11^3/_4"$ zone plate photograph. From the collection at Pinhole Resource.

In the Darkroom

The contrast in black-and-white films can be increased easily by increasing development time. This is the simplest remedy for the inherently low-contrast images. You can also use a more contrasty grade of printing paper (say #4 or #5), but the effect is different.

Most developers in general use today are at least partially solvent developers. These types of developer (Microdol, D-76, ID-11) yield the finest grain, but that is normally not a consideration with our techniques, since preservation of fine details is impossible. Furthermore, fine grain developers create a "mushy" grain structure that makes an already "soft" image appear even less sharp. Instead, try a high acutance developer such as Acufine or any of the pyrogallol formulas; the negative will have larger grain but the image will appear "crisper." If you are using sheet film, grain size is probably of no consequence anyway.

When you first look at a negative made using a zone plate, it will seem hopelessly "soft" and unfocused. Don't despair—it will make a far better print than the negative suggests. Definitely make contact prints rather than trying to assess the negative itself. You'll be pleasantly surprised at the outcome!⁹

NOTES

- 1. Gillian Brown, "Artist's Statement," Pinhole Journal 7(2):21.
- 2. Jay Bender, "Interview," Pinhole Journal 1(1):28.
- 3. William H. Pickering, "The Pinhole Camera," *Anthony's Photographic Bulletin* 18(11 February 1888):71–72.
- 4. Kenneth A. Connors, "Zone Plate Photography," Pinhole Journal 4(1):26.
- 5. Lord Rayleigh (John William Strutt), research notebook entry on 11 April 1871, in R. J. Strutt, *Life of John William Strutt, Third Baron Rayleigh* (Madison, Wis.: University of Wisconsin Press, 1968), 88.
- 6. Connors, 27.
- 7. For an explanation of diffraction and interference, see Gary Zukav, *The Dancing Wu Li Masters, An Overview of the New Physics* (New York: Bantam, 1984), 58–62. For a complete explanation of how zone plates work, read Kenneth A. Connors's article "Zone Plate Photography," *Pinhole Journal* 4(1):26–32.
- 8. Richard Vallon, "The Zone Plate User's Guide for Pinhole Photographers," *Pinhole Journal* 8(1):22–26.
- 9. Russ Young, "Some Practical Hints for Zone Plate Photographers," *Pinhole Journal* 8(1):27–30.

7

Brunelleschi, looking through a hole at a street in Florence, makes a depiction of it from a fixed viewpoint. . . . The photographic process is simply the invention in the 19th century of a chemical substance that could 'freeze' the image projected from the hole in the wall, as it were, onto a surface. It was the invention of the chemicals that was new, not the particular way of seeing. . . . So the photograph is, in a sense, the end of something old, not the beginning of something new.

DAVID HOCKNEY That's The Way I See It, 1993

Eye, Image, Camera, Mind: Into the 1990s

THE SHIFTING IMAGE OF REALITY

The painter/photographer David Hockney, in his statement, is expressing the mechanistic viewpoint toward the perspective produced by a camera, whether it be a pinhole camera or a lens camera. Hockney is correct; the photograph, with its built-in perception of the way we visualize one-point perspective, is indeed, the end product of the early Italian Renaissance, even though we are approaching the final years of the twentieth century. Even by using a curved-film-plane pinhole camera like a grits box that automatically distorts the image, an image is produced that reflects mid-Renaissance anamorphic one-point perspective. Our present-day pinhole camera may well be the ultimate 550-year-old Renaissance tool, while the slightly more than 150-year-old chemical process known as photography is living proof that a permanent one-point perspective image can be archivally retained.

David Hockney is asking for more. He wants another way of defining space. Cubism was the first art form to attempt to alter one-point perspective, yet even Picasso abandoned it to return to one-point perspective. Hockney challenges us to find "the beginning of something new"—to reinvestigate the altering, destruction, or natural evolvement of one-point perspective, thereby creating another visual structure. This, of course, is a fairly grand request. Hockney is well aware of the profound staying power involved in Filippo

Brunelleschi's pinhole perspective device. Every time we use a camera, every time we look at television, every time we look at a photograph in a newspaper, magazine, book, or exhibition, and every time we look at the space around us, we are involving our mind in one-point perspective derived from Brunelleschi. Truly, one-point perspective is the structured reality that holds our entire visual world together. To change that reality is a lot to ask. Possibly the only places where that structured reality falls apart are in our dreams or on a painter's two-dimensional canvas, where space is not always so necessarily rational. To change one-point perspective in a photograph, the photographer must alter the camera, seriously manipulate the photograph, or totally rearrange the object being photographed.

Yet, in a way, pinhole photography and other alternative proc-

esses have in the last twenty-five years brought a changed visual sensibility into being, although not one that breaks with one-point perspective. However, the reliance on the hard-edged, sharply focused lens image that pervaded much of the imagery of this century has receded. Often the mysterious quality inherent in pinhole imagery conveys the emotions of our dark side. This dark side is often the force behind contemporary pinhole imaging.

In 1993 Thomas Bachler of Germany wrote:

I "opened" a (still closed) pinhole camera with a pistol shot [Figure 7.1]. The picture of me has been made through the entry hole of the bullet. The bullet went through the pinhole camera and left through a hole at the back side. That is why there is a hole exactly where my eye is supposed to be. The photograph has thus been made with the help of the bullet, which at the same time destroys the most important part of the picture, my eye.¹

This, of course, is not so much a metaphor for self-destruction as a metaphor for opening one's eyes as wide as possible—to create a perfectly clear vision in artistic terms. Thomas Bachler's bullet hole camera is an intellectual achievement, not a violent act.

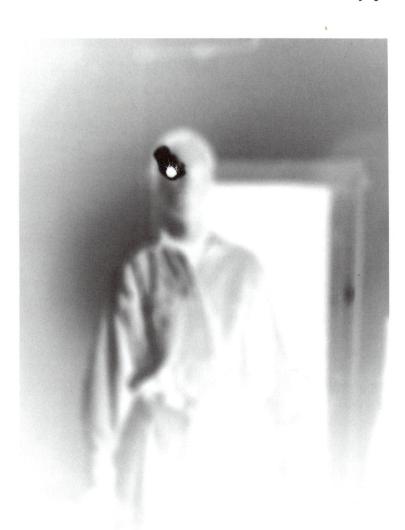

Figure 7.1 © Thomas Bachler, Shot in a Head, 1994. A 6" x 8" pistol bullet hole photograph. From the collection at Pinhole Resource.

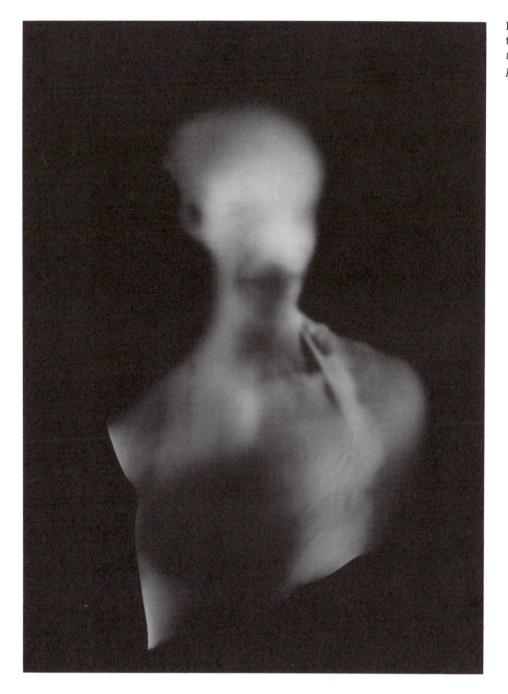

Figure 7.2 © Greg Ligman, Untitled, 1992. A 5" x 7" pinhole photograph. From the collection of the photographer.

Similarly, Greg Ligman's near-death experience and month-long memory loss forever changed his imaging vision. Ligman states:

I was recently in a very bad motorcycle accident which left me with two brain injuries. Against doctors' suggestions, I returned to school. . . . These images were used in my final exhibition at school. . . . To me, the images have a very ghost-like quality [Figure 7.2] which relates very much to my accident. I was in a coma for approximately 24 hours. The doctors did not know if I was going to live or die. I have no memory of an entire month of my life. 2

Of his series of pinhole photographs titled *Murder Sites* (Figure 7.3), Harlan Wallach writes:

In Chicago there has been a tremendous escalation of the murder rate. You hear about it and it's pretty insignificant to you. An unbelievably grisly murder took place in an alley near where I lived, and in fact, I knew people who lived in the building that this murder occurred right behind. It hit home with me. I got this idea that there are two levels to the murders—the way it's reported and intellectually perceived, and then there's the actual reality of it. These are places where people actually live and are not necessarily bad neighborhoods. So I went to the site and documented it with pinhole, and I processed the images and looked at them and it wasn't enough just to say that they were murder sites. I felt that I needed to incorporate another element. So I went back to the actual description in the city column of the newspaper. I clipped out that section, [photocopied] it, and printed it with a contact print, so that the actual article would appear on the final print. . . . I would collect the city columns for about a week. I didn't want to go back to the site too soon. I didn't want to be there that day or even the next day. I wanted a period of time to go by, either a week or longer . . . 922 murders took place in Chicago last year, that's 3 a day . . . I have photographed about 60. . . . When I combined pinhole photography with murder sites, the result seemed perfect.3

Most of us have a mental picture of the Holocaust and the Nazi extermination camps, yet few of us know, unless we've visited the sites, what they really looked like and what is left. We should thank whoever made the decision to leave hundreds of shoes still intact, for here is a true, absolutely horrid reminder of what happened here. We are transported to a dream state by Patrick Poels's manipulation of the image edges, isolating us in the center with the shoes (Figure 7.4). We know only too well where the people are who wore them. The dream is a nightmare, never to be forgotten, as Poels's image reinforces our image of the unforgettable.

Figure 7.3 © Harlan Wallach, Zdziarski Died Early . . . From the series Chicago Murder Sites: Works in Progress. An $11"x\ 14"$ pinhole photograph, 1992. From the collection of the photographer.

Patrick Poels, of Belgium, states:

This documentary series was made in several Nazi extermination camps in Poland. During trips in 1992 and 1993, I visited Auschwitz, Birkenau, Chelmno, Majdanek, Belzec, Treblinka and Sobibor. The entire series contains about 40 pictures made with a cardboard pinhole camera on Polaroid 665 film. The focal length of the camera is 25mm and the diameter of the hole is 0.2mm.

Before starting this series I dug into the necessary literature and watched many photographs and documentaries. I thought this the best way to have an idea of what I might find once I got to Poland. However, when one actually visits a camp or a former campsite, one becomes aware that 50 years after the facts, one is entering a museum. It is quiet and desolate (I even thought I could hear more birds sing outside the camp than inside). You can smell the mowed grass

Figure 7.4 © Patrick Poels, Shoes, Majdanek Nazi Extermination Camp, 1993. Pinhole photograph taken in Poland. From the collection of the photographer.

Figure 7.5 © Marnie Cardozo, Untitled, 1993. A 10" x 16" pinhole photograph. Courtesy of the Bernard Toale Gallery, Boston.

and the humid dark pinewoods in the area. So it is like archeology: you only have a few fragments or details from which you have to reconstruct the awful things that have happened here. You can only say that words are not enough for this. I could only "hang onto" a few details that moved me in a big way and served as *pars pro toto*: in Majdanek I found a child's shoe in a large heap of tens of thousands of men's and women's shoes. In Birkenau and Sobibor, I dug a couple of inches in the soil and found ashes and fragments of human bones, even a tooth. In Auschwitz I saw a photograph of a newborn, literally thrown in the corner of a room, the navel string still there. Sometimes I was relieved that, as some sort of protection, I could place my pinhole camera between these horrible places and myself.⁴

Combining the known to produce the unknown is Marnie Cardozo's gift, along with her sense of humor. At first view (Figure 7.5), I had little idea what body parts were put together to make up the strange new area within the image (the area slightly to the left and right of the vertical line) even though I could make sense out of some of the image. Everyone has had years to acknowledge the symmetry within our body—unconsciously referencing our two arms, two legs, two eyes as across from one another. Similarly we reference anything singular, like a nose, mouth, or navel always falling along an imaginary midline running from head to foot. Along the image's vertical midline, Cardozo presents us with a sense of confusion, fascination, and wonder about her newly constructed body.

Figure 7.6 © Jesseca Ferguson, In My Studio (Self/Pigskull/Rabbit), 1993. An 8" x 10" Van Dyck pinhole photograph. From the collection of the photographer.

In fact, if we hold our hands over the outside parts of the image (both right and left sides where most of the known information exists), we are left with even less information as to what produced the image.

Jesseca Ferguson of Massachusetts uses partial exposure to add a sense of life and movement to her otherwise still-life imagery. The figure is surrounded by objects, which speak mysteriously, seeming to fill her world with the surreal. As viewers we are left to ponder. I see symbols and gestures, and I am reminded of paintings by Vermeer. Of the image in Figure 7.6 Ferguson says:

Working alone in my studio, I set up objects deeply encoded (for me) with personal associations, my private mythology. The (scary) fairy tale that was my childhood continues to haunt me as I dip into and drink from what novelist Michael Ondaatje has termed "the well of memory." I am witnessing myself being photographed, as if in a dream. The existence of this particular visual (and psychological) situation is possible only through pinhole photography.⁵

Since the sensibilities inherent in pinhole's soft focus have been widely accepted by Madison Avenue (just look in any magazine for ads that are in soft focus; the amount you find is a reflection upon pinhole's acceptance), it is not surprising that in the early 90s, Art in America and Artforum published pinhole photographs on their covers, made by the New York pinhole photographer Barbara Ess. The context of photography is now so broad that all means of photographic expression are viable. Whether the image is produced by computer, lens camera, TV, video, or pinhole camera is no longer an issue. Altered imagery is a perfectly reasonable starting place—plenty of people are using pinhole cameras. What is important is the aesthetic context. In the last decade, the primal experience is one of the primary aesthetic contexts. The dark, the obscure, the earthly life-force states (including death), the demonic (Color Plate 7.7) are all in the forefront. Therefore, the "look" of Ess's image was of utmost importance. It had to be primal. That she used a pinhole camera only accentuated the novelty of her image-making process. In an interview conducted by P. C. Smith for the Art in America article, Barbara Ess states:

That my work is done with a pinhole is the least interesting part. At first I felt like a scientist; now it's just a tool that I use. But I use primal imagery, so maybe it's fitting that I use the most primitive of cameras. Since there's no viewfinder, the image is much more of a surprise—as if some outsider came and looked at earth for the first time. . . .

I do drawings before I photograph; it's like being a painter. I'm looking for something in the world that will speak. I try to photograph what can't be photographed—psychological or subjective reality, which seems more real than physical or consensual reality. It's a different idea of vision.⁶

Since primal imagery is so accessible by using pinhole cameras, likewise, it is not surprising that in December of 1993 to February of 1994 the Museum of Modern Art in New York would mount an exhibit of Steven Pippin's primal performance photographic pieces. Pippin's washing machine pinhole camera and photograph are mentioned earlier in this book in the preface. They, too, were part of the exhibition.

All Pippin's cameras are pinhole, and both camera and image are again perfect examples of the primal experience. Pippin's toilet camera received the most notoriety. As an icon, everyone loves a toilet. Immediately, this suggests an artistic assault on conventional sensibilities. That Pippin's toilet was a complete pinhole camera, with light-tight porcelain body and light-sensitive material curved underwater, only accentuated the novelty of his image-making process. The "look" of Pippin's image was of utmost importance. It had to be primal. Had he held a Nikonos (Nikon's underwater lens camera) under the water in a toilet bowl pointing it upward, his image would have never answered the aesthetic. The exhibition was intended to titillate and at the same time create wonder. Robert Evrén, Curatorial Assistant in the Department of Drawings who wrote the catalogue, observes:

In each case Pippin's instruments of choice have been the pinhole camera and paper negative, the same ones used by the inventors of photography in the early nineteenth century. In recent times, this method has been favored only by obsessive antiquarians and occasionally snoopers.⁷

Figure 7.9 © Craig Barber, Warren Street Marsh, City Above Series, 8" x 20" gold-toned Van Dyke pinhole photograph, 1990. From the collection of the photographer.

By "snoopers" Evrén is referring to a newspaper photograph he saw on a trip to London of Diana, Princess of Wales, working out at a gym. Purportedly, a pinhole camera had been installed in the ceiling to secretly take her photograph! Further he suggests that others interviewed think that newspapers in the future will eventually publish a photograph of Diana seated on a toilet.⁸

Statements by Steven Pippin are included in the catalogue such as:

The future of photography seems to rely on the progress of the camera and its ability to be continually refined, to a point whereby images will be indistinguishable from reality. Working in the opposite direction to this mentality I have become fascinated with the idea of constructing a camera whose viewpoint is not some external subject, but instead one having the capability of looking back in on itself toward its own darkness.

Pippin describes his pinhole toilet camera:

Using a large black cloak to prevent fogging, a semi-circular piece of photographic paper was formed into a cone and pushed into a toilet bowl. An attachment made from wood, rubber, and fabric was then fitted onto the toilet and inflated. A small aperture in the top of the cover projected an image of the room down into the toilet. After the exposure (approximately 40 minutes), developer was added to the cistern and heated using a small portable electric element wired to the light fitting. Once the water reached 20 degrees C the toilet was flushed, processing the image in the bowl.⁹

Joseph Jakusz of Nevada makes motion photographs that involve a tunnel vortex. In Color Plate 7.8a the tunnel is clear light, suggesting through metaphor that we have made it to the other side. In Color Plate 7.8b the tunnel remains dark, suggesting we are still traveling. That we are!

In this book we have traversed over a century and a half of photographic history and almost 6000 years of pinhole technique, from Mo Ti's first written account observing the formation of a pinhole image to present day. Yet we still find the pinhole camera a means to expressive response. This book is not meant to suggest that everything possible has been done with pinhole. Quite the opposite is true. There is much, much more to explore.

NOTES

- Thomas Bachler, personal communication with the author, 10 February 1994.
- 2. Greg Ligman, Pinhole Journal 9(1):9.
- 3. Harlan Wallach, "Chicago Murder Sites: Works in Progress," *Pinhole Journal* 8(2):9.
- 4. Patrick Poels, personal communication with the author, 6 August 1993.
- 5. Jesseca Ferguson, personal communication with the author, 23 February 1994.
- 6. P. C. Smith, "Complex Vision," Art in America (March 1993):69.
- 7. Robert Evrén, catalog notes from *Projects 44, Sarah Lucas, Steven Pippin* (New York: The Museum of Modern Art, 1993), unpaginated.
- 8. Ibid.
- 9. Steven Pippin, *The Rigmarole of Photography* (London: Institute for Contemporary Arts, 1993), 52.

List of Suppliers

Nonprofit Organizations:

Pinhole Resource
Star Route 15, Box 1355
San Lorenzo, NM 88041
(505) 536-9942
(Pinhole Journal—published three times a year; pinhole photo archive, pinhole cameras, pinholes, and other pinhole products.)

Private Individuals Selling Pinhole Products:

W. Joseph Christiansen 7586 County H Maplewood, WI 54226 (414) 856-6842 (Pinholes, drills, pin vises.)

Dominique Stroobant 11 Via Fantiscritti 1.54033 Miseglia di Carrara Italy (Lensless Leica pinhole mounts.)

Jay Bender 19619 Highway 209 Leavenworth, WA 98826 (Bender View cameras—can be ordered with pinholes.)

Kurt Mottweiler
P. O. Box 817
Rancho de Taos, NM 87557
(505) 751-3255
(120 roll film pinhole cameras)

High-Tech Suppliers:

Below are the addresses of several companies dealing in products of interest to the pinhole photographer. (List compiled by Tom Fuller.)

Edmund Scientific Company
101 East Gloucester Pike
Barrington, NJ 08007-1380
(609) 573-6260
(Tools, optics, and general scientific equipment.
Ask for their Annual Reference Catalog.)

Ealing Electro-Optics, Inc.

New Englander Industrial Park
Holliston, MA 01746
1-800-343-4912
(Manufacturers of advanced optical equipment for research and industry; they carry precision zinc, copper, and stainless steel pinhole discs.)

Melles Griot 1770 Kettering Street Irvine, CA 92714 1-800-835-2626 (Same general product line as Ealing.)

Rolyn Optics Company
706 Arrow Grand Circle
Covina, CA 91722-2199
(818) 915-5707
(Optics, tools, and precision pinholes.)

0

Index

Accommodating, 103

Alberti, Leon Battista, 26-29, 34 Alhazen. See al-Haitham, Ibn Ambassadors, The (Holbein the Younger), 37-38 Anamorphosis, 36-38, 131, 141 Anthemius of Tralles, 5 Aperture, 1 Aristotle, 4-5 Art, and pinhole, 23-38. See also Perspective democracy in, 51 diffraction camera, 25-28 intersector, 28-31 perspective device, 23-25 Artforum, 165 Art in America, 165 Art of Photography, The, 57 Astronomy, 7-9, 18-21 Babcock, Jo, 95, 139, CP 4.26 Bachler, Thomas, 68-69, 76, 158 Barbaro, Daniele, 34 Barber, Craig, 166 Basilica di San Petronio (Bologna), 7-8 Bass, Pinky, 116, 139 Bender, Jay, 107-108, 142, 169, CP 6.5 Berlin Wall, 100-101 Bernard, Denis, 76-77 Besold, Bobbe, 143 Blake, Richard, 18-19 Book of Measurements (Dürer), 35 Boraxo camera, 72 Boye, Walter, 91, 124 Brehm, Frederick, 47 Brewster, David, 38 Bromide Eggs, 70-71

6.4a-b Brunelleschi, Filippo, 6, 23-26, 158 Bullet hole camera, 158 Bullis, Larry, 73-75, 104 Camera obscura, 9, 26, 62-63 with lens, 34 Leonardo and, 33-34 rooms as, 27 Camera Obscura: A Chronicle, The (Hammond), 9 Cameras. See also Pinhole cameras Boraxo, 72 bullet hole, 158 diffraction, 25-28 earth, 78-81 eggs, 70-71 existing object, 76, 90 Glen Pinhole, 43-44 hemispheric, 76-77 Kodak Pinhole, 47 matboard, 139 matchbox, 88-89 mouth as, 68-69 needle-eye, 73-75 Pinzip, 90-91 plaster face, 68, 70 Polaroid, 73-75 refractive, 34 Santa Barbara, 90-91, 124-125, 149 scatter-hole, 19 as sculpture, 73 suitcase, 76 Tinkertov, 72 toilet, 166, 167 vehicles as, 139

washing machine, 166

Brown, Gillian, 28, 131, 141-142, CP

Cardozo, Marnie, 163 Carnell, Clarissa, 64, 84 Casanave, Martha, 96-97 Cathedral of Florence, 6-7 Center for Contemporary Arts (Santa Fe), 94 Charrier, Pierre, 88, CP 4.19b Cherry, Jim, CP 5.43 Christiansen, W. Joseph, 169 Cibachrome color paper, 137 Cimon, Paul, 88-89 Clach-a-Charra Stone, 2 Close flashing, 148-149 Coded-aperture imaging, 19-21 Color temperature, 137 Combe, M. Jules, 118 Comparators, 106-107 Concave surface, 130 Connors, Kenneth A., 55, 57, 117-119, 146, 155 Contact prints, 112 Convex surface, 128-130 Crookes, William, 38 Cutler, Bernice Halpern, 94

Darkroom, portable, 82
Davison, George, 38, 41–43
Dehors and Deslandres, 38, 43
Descartes, René, 6
Destructive interference, 147
Detroit Institute for the Arts, 28
Developers, 155
DeWitt, Rita, CP 5.36
Diana, Princess of Wales, 167
Dicke, R. H., 19
Diffraction, of light, 11–12, 107, 146–147
Fraunhoefer, 45
Fresnel halfwave, 145

Diffraction camera, 25–28 Dinnan, Terrence, 78–79 Distortion, 126–131 Dome, Bob, 117 Dominis, Antonio de, 6 Donatello, 30 Dorris, Michael, 10 Drower, Margaret, 39 Dürer, Albrecht, 34–35

Ealing ElectroOptics, Inc., 169 Earth camera, 78-81 Eclipse, solar, 1, 3, 4, 9, 124-126 Edmund Scientific Company, 169 Engberg, Marianne, 128 Enlargers, 107-108 Entrance of Saint Ignatius into Paradise (Pozzo), 36 Equinox, 7, 9 Esher, Barbra, 85, CP 4.17 Eskimos, 10 Ess, Barbara, 165 Evrén, Robert, 166-167 Exposure times, 110, 113, 115 calculating, 133–136 Exposure value (EV), 133-134 Eye, vs. pinhole, 17, 103-104

al-Farisi, Kamal al-Din, 6 Farley, Denis, CP 5.29 Fenimore, E. E., 20 Ferguson, Jesseca, 164–165 Film, 109, 113, 135-136, 150-151 Filters, 137-138 Fine Arts Museum (Long Island), 94 Fixed point, 23-36. See also Perspective Flashing, close, 148-149 Fletcher, Jeff, 70-71 Focal length, 117-121, 124-126, 149-150 Francesca, Piero della, 31, 34-35 Frank, Douglas, 67, 99 Fraunhoefer diffraction, 45 Fresnel, Augustin, 13 Frisius, Gemma, 9 F/stop, 118 Fuji Reala, 154 Fuller, Tom, 106-107 Füss, Adam, 114-115 Fuzziness. See Pictorialism

Gaetans, Sanchez, 90 Gamma rays, 18–21, CP 1.25b Gasperi, Michael, 134–136 Gasperi, Nancy, 134–136 "Generative Photography," 51 George Eastman House, 57 Gilpin, Laura, 46 Gioli, Paulo, 49–50, 59–60, 75–76, 126, CP 5.33a Giovanelli, Ronald, 9 Glen Pinhole Camera, 43–44 Gnomon, 3, 5 Gonzalez, Guillermo, 90 Gregorian calendar, 9 Gregory XIII, 7, 9 Grimaldi, Francesco, 11

Habegger, Bruce, 141, CP 6.2 Haberman, Jim, 58, 59 Hackett, Linda, 115, CP 5.16 al-Haitham, Ibn, 5-6, 26 Halo effect, 147, 149 Hammond, John, 9 Hammond, M. S., 34n Harrigan, Margaret L., CP 4.1 Hauer, Allan, 21-22 Hemispherical photography, 76-77 Hidden Images (Leeman), 24-25 Hines, Roy, 15-17 Hockney, David, 157 Holbein the Younger, 37-38 Hole Thing: A Manual of Pinhole Photography, The (Shull), 59 Holocaust, 161-162 Hoover, Richard, 14 Hugunin, James, 94-98

Ilfochrome Classic paper, 70, 83, 137 Ilford paper, 58, 109 Instamatic cartridges, 90–91 Institute of Contemporary Art (Virginia), 83 Interest, 56 Interference, of light, 11, 12–14 International Pinhole Exhibition, 94 Intersector, 28–31

Jäger, Gottfried, 49, 50–52 Jakusz, Joseph, 137–138, 168, CP 7.8a–b John Adams Toys, 91 Jones, Jim, 124–126 Jones, Peggy Ann, 73, 98, 139, CP 4.28b Julian calendar, 7, 9

Kaiser, Marcus, 100–101 Keller, Diana, 115 Kellner, Thomas, 122, CP 5.24 Kepler, Johannes, 6, 9, 86 Kodak, 41, 109, 148–149, 154 Pinhole Camera, 47 Koplos, Janet, 62–63 Korte, Jeff, 127

Land crab camera, 90

Lang, Robert, 132 Laser plasma, 21-22 Lebe, David, 49, 53, CP 3.3 Leeman, Fred, 24-25 Lenses, 103, 147 Lensless, 38 Leonardo da Vinci, 17, 31-34, 36-37, Adoration of the Magi, 33 Child's Face and an Eye, 37 Last Supper, 32 Light diffraction of, 11-12 interference of, 11, 12-14 lines of, 25 meters, 133 ray diagrams, 5-6, 34 wavelength, 117-121 wave theory of, 10-14 Ligman, Greg, 159 Lines of perspective, 25 Linked Ring, 43 Liquid Light, 70 Litho film, 82 Littell, Harry, 143, CP 6.8 "Little movies," 70 Livingston, William, 7 Lundström, Jan-Erik, 45, 47 Lyons, Nathan, 57

Madigan, Martha, 59, 61 Magnifier, pinhole as, 17 Make Your Own Working Camera kit, 91 Many Moons (Thurber), 133 Markley, Doris, 144 Marriage of Giovanni Arnolfini and Giovanni Cenami, The (Van Eyck), 30-31 Mary Magdalene, 91-92 Masaccio, The Trinity, 30 Maskell, Alfred, 38 Matboard cameras, 139 Matchbox cameras, 88-89 Maurolycus, Franciscus, 5 McKay, Elaine, CP 7.7 Melles Griot, 169 Men-an-tol stones, 2 Messimer, Claire, 134, 145, CP 5.49a-b Meyer, Cornelius, 10 Mikrut, Robert, 117-119, 154 Moninger, Jim, 120-122

Morrison, Jim, 84 Mo Ti, 3, 168 Moss, Sandy, 94-95, CP 4.25b-f Motion blur, 114-115, 168, CP 7.8a-b Mottweiler, Kurt, 130 Mouth, as camera, 68-69 Museum of Contemporary Art (Seville, Spain), 94 Museum of Modern Art (New York), 166-167

National Gallery (London), 28 Natural camera, 38. See also Pinhole cameras Nature (Rayleigh), 14-15 Nautilus, 103-104 Needle-hole, 38. See also Pinhole cameras camera, 73-75 Needles, size chart, 118 Neuber, Marianne, 123 Newton, Isaac, 11-12 Nunamaker, Kent, 141

Occluder, 17 Opticks (Newton), 11-12 Optics, pinhole, 1-10, 55-57 and Aristotle's question, 4-5 multiple, 19-21 Optics, Painting and Photography (Pirenne), 56-57, 126 Optimal pinhole diameter, 14-15, 39, 117-120

Paciola, Luca, 34 Page, Stanley R., 59, 112 Panoramic photography, 124 Papers, photographic, 70, 83, 108-109, 112 Parlodion, 19 Pawek, Karl, 51 Peep-show boxes, 27-29 Peer, George, 142 Perspective, 23-25, 30-35, 56, 157-158 Perspective cabinets, 27–28 Petrie, Flinders, 38-41 Petzval, Joseph, 14, 38 Philadelphia Museum of Art, 57-58 Photography (magazine), 41-42 Photography, pinhole, 67-68. See also Pinhole cameras; Slit imaging; Zone plates altering images, 141-143 cameras, 56-57, 68-82, 90 criticism, 59, 94-98 "don'ts," 110-114

early, 14-15, 38-41 exhibitions, 83, 94-98 and exposure, 110, 113, 133-136 filters, 137-138 gamma rays, 18-21, CP 1.25b hemispherical, 76-77 motion blur, 114-115, 168, CP 7.8a-b multiple pinholes, 55, 121-122, optimal pinhole diameter, 14-15, 39, 117-120 panoramic, 124 photographic paper, 108-109 pictorialism, 41-47 primal imagery, 165-166 printing processes, 58-59, 84, and reality, 53, 157-158 revival of, 49-66 science of, 55-57 and sharpness, 122 suppliers, 90 telephoto, 124 video, 142 x-ray, 18-19, CP 1.23 Photomnibus, 43 Physics, high-energy, 18-22 Picasso, Pablo, 157 Pickering, William H., 143-144 Pictorialism, 41-47 **Pinholes** and the eye, 17, 57 and focal length, 117-121 f/stop calculation, 118 as magnifier, 17 optimal diameter, 14-15, 39, 117-120 Pinhole cameras, 56-57, 68-82, 90. See also Photography, pinhole adapting lens cameras, 138 anamorphic photography, 131 commercial equipment, 43-44, 90-91, 138 curved film plane, 128-131 depth of field, 122 designing, 124, 139 filters, 137-138 flat film plane, 123-128 focal length, 117-121 image in, 123-138 light leaks in, 113-114

loading, 109

making, 103-109

materials, 103-104

moving film plane, 132

multiple pinhole, 126

needle sizes, 118 nonreflectivity, 108-109 optimal pinhole diameter, 14-15, 39, 117-120 painting, 109, 113 panoramic, 132 photography with, 110-113, 123-138 pinhole making, 105–108 pinhole measuring, 106-108 pinhole mounting, 108 pinhole turrets, 121-122 stacked, 88 viewfinders, 138 "World's Largest," 144-145 Pinhole Camera kit, 90-91 Pinhole Image: Eleven Photographers, The, 83 Pinhole Resource, 90, 146, 150, 169 Pinzip, 90-91 Pippin, Steven, 166-167 Pirenne, Maurice, 55-57, 126 Plakke, David, 67, 99-100 Plaster face cameras, 68, 70 Plato, 83 Poel, Patrick, 161-162 Polachrome slide film, 141 Polaroid, 116, 148-149 cameras, 73-75 Popular Photography, 58, 59 Pozzo, Fra Andrea, 36 Prince, Thomas A., 19, 21, CP 1.25b Printing processes, 58-59, 84, 112 Pugh, David, 90-91

Quarterman, Dale, 64-65

Rainbows, 6 Rayleigh, Lord, 14-15, 117, 145 RC paper, 109, 112 Ready Fotographer, 43 Reagan, Ronald, 72 Reciprocity, 134, 136, 154 Rectographic, 38 Reflectivity, 108-109 Refractive camera, 34 Renner, Eric, 49, 54-55, 59 cameras, 68, 70, 138 photographs, 3, 54-55, 116, CP 4.3b, CP 4.4b, CP 6.7 underwater photography, 85-87 Rochester Institute of Technology, 47, 141 Rogers, Catherine, 82 Rolyn Optics Company, 169 Royal Photographic Society, 42-43 Ryane, Patrik, 122

Salmoiraghi, Franco, 49, 53, CP 3.4 Sanderson, Wiley, 49, 53, 59 Santa Barbara camera, 90-91, 124-125, 149 Scatter-hole cameras, 19 Schachter, Julie, 72-73 Schwalberg, Bob, 59 Seton-Williams, M. V., 40-41 Shadow definer, 3 Shull, Jim, 59 Simkin, Phil, 57-58 Simmons, Robert, 124 Slit imaging, 143–145 Smith, Lauren, 68, 83, CP 4.15 Smith, P. C., 165 Solarization, 110-111, 116 Some Practical Hints for Zone Plate Photographers (Young), 150-155 Spectacles, pinhole, 10 Speed Graphic Press Camera, 121 Spencer, Nancy, 70, 91-94, 133-134

CP 5.13
Spiller, John, 38
Stenopaic photography, 38, 50. See also Photography, pinhole
Stones, holed, 1–2
Stork, David, 5
Stratton, Jerry, 90
Strindberg, August, 44–45, 47
Stroobant, Dominique, 59, 61–63, 78–82, 138, 169
Suitcase pinhole camera, 76
Sun, photographing, 82, 115
eclipses, 1, 3, 4, 9, 124–126

Supernovas, 19, 21, CP 1.25b

sunspots, 9

photographs, 3, 92-93, CP 4.4b,

Suppliers, pinhole equipment, 169 Swerd, F. M., 14

Takakura, T., CP 1.23 Telephoto photography, 124 Theodoric of Freiberg, 6, 86 Thomson, J. B., 38 Thorne-Thomsen, Ruth, 62, 64 Thurber, James, 133 Time, measuring, 3, 6-7 Tinkertoy camera, 72 Toilet camera, 166, 167 Tolvan Stone, 2 Toscanelli, Paolo, 6 Total internal reflection, 86 Tower of Winds (Rome), 7 The Trinity (Masaccio), 30 Tri-X film, 133 Trompe l'oeil, 36

Vallon, Richard, 146–150
Van Dyke emulsion, 82–83, 143
Van Eyck, Jan, 30–31
Van Hoogstraten, Samuel, 28–29, 36
Van Keuren, Sarah, 91, CP 4.23
Vehicles as cameras, 139
Veil, 28–31
Video, pinhole, 142
Visionary Pinhole, The (Smith), 68
Visual pyramid, 57

Wackler, Rebecca, 91–92, CP 5.13 Wallach, Harlan, 160–161 Wang, Sam, 141, CP 3.10, CP 6.3 Washing machine camera, 166 Weiss, Jeff, 141 Williams, Howard E., 137, CP 5.50 Witanowski, Bob, 90 Wiveleslie Abney, William de, 38
Wolff, Ilan, 129
Wood, John, 103, 105
Wood, Reid, 143, CP 6.6
Wood, Robert W., 13
World Famous Lenseless Camera of
Santa Barbara. See Santa
Barbara camera
Wright, Willie Anne, 83–84, 137, CP
4.14, CP 5.34

X-ray photography, 18-19, CP 1.23

Yamanaka, Nobuo, 62–63, 65 Yellow Raft in Blue Water, A (Dorris), 10 Young, Russ, 150–155, CP 6.13b Young, Thomas, 12–13

Zone plates, 145-155 adapting cameras to, 152 choosing, 149-150 close flashing, 148-149 and composition, 153 contrast, 150-151 developing, 155 film for, 150-151, 153-154 focusing, 152-153 function of, 147 imaging theory, 146–147 lens hoods, 150, 151 mounting, 151 resolution, 150-151, 153 techniques, 148-149 Zone Plate User's Guide for Pinhole Photographers (Vallon), 146-150

	a.		
		12	
		•	